Picasso

JEAN-LOUIS FERRIER

Previous page

SELF-PORTRAIT AS A GENTLEMAN

WITH WIG

1896, oil on canvas, 55,8 x 46 cm.

(22 x 18 in.)

Barcelona, Museo Picasso.

Opposite

BULL'S HEAD

Paris, spring 1942, bicycle handlebars

and saddle, 33,5 x 43,5 x 19 cm.

(13 x 17 x 7 in.)

Paris, Musée Picasso.

Page 6

NUDE

1908-1909, oil on canvas, 100 x 81 cm.

(39 x 32 in.)

Saint Petersburg, Hermitage Museum.

Cover illustration

PORTRAIT OF MARIE-THÉRÈSE

Oil on canvas.

Paris, Musée Picasso.

Photo. RMN / B. Hatala.

© FINEST SA / ÉDITIONS PIERRE TERRAIL, PARIS, 2001
25, rue Ginoux - 75015 Paris - FRANCE
ISBN 2-87939-088-5
Printed in Italy

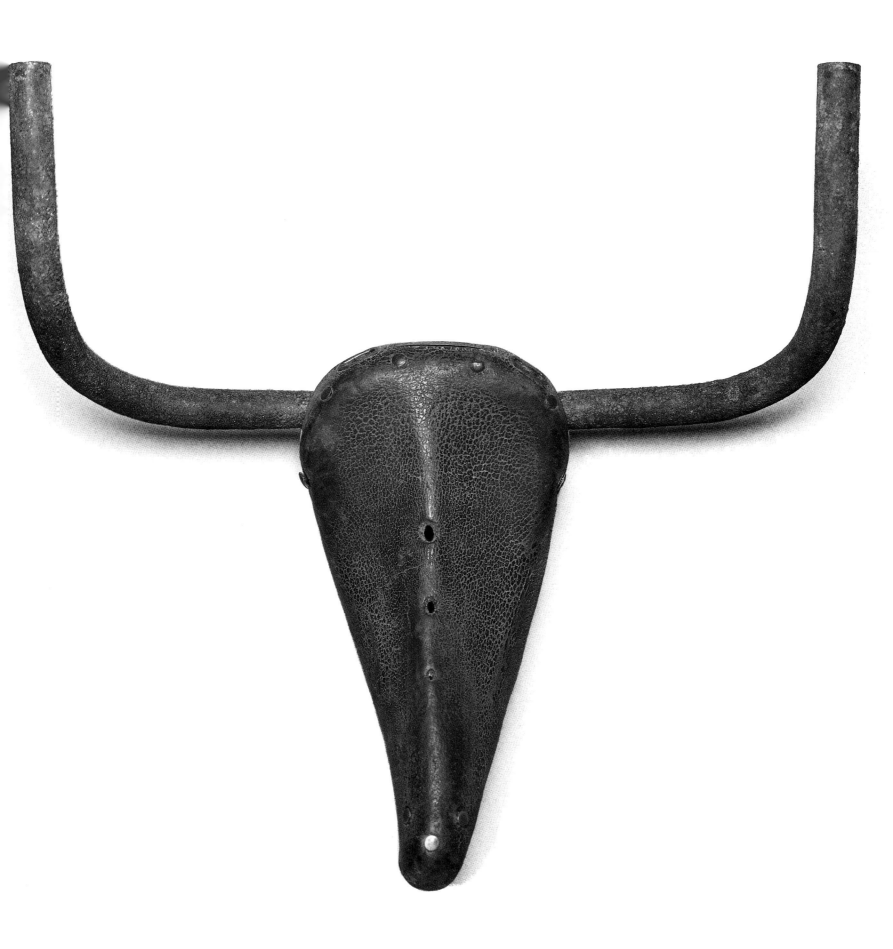

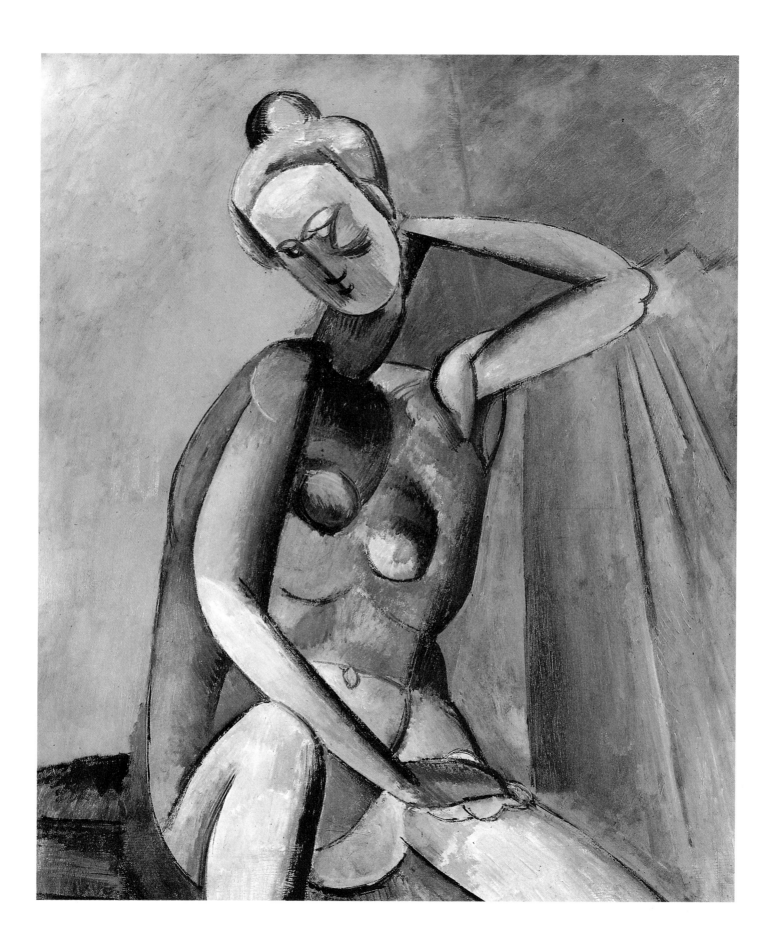

CONTENTS

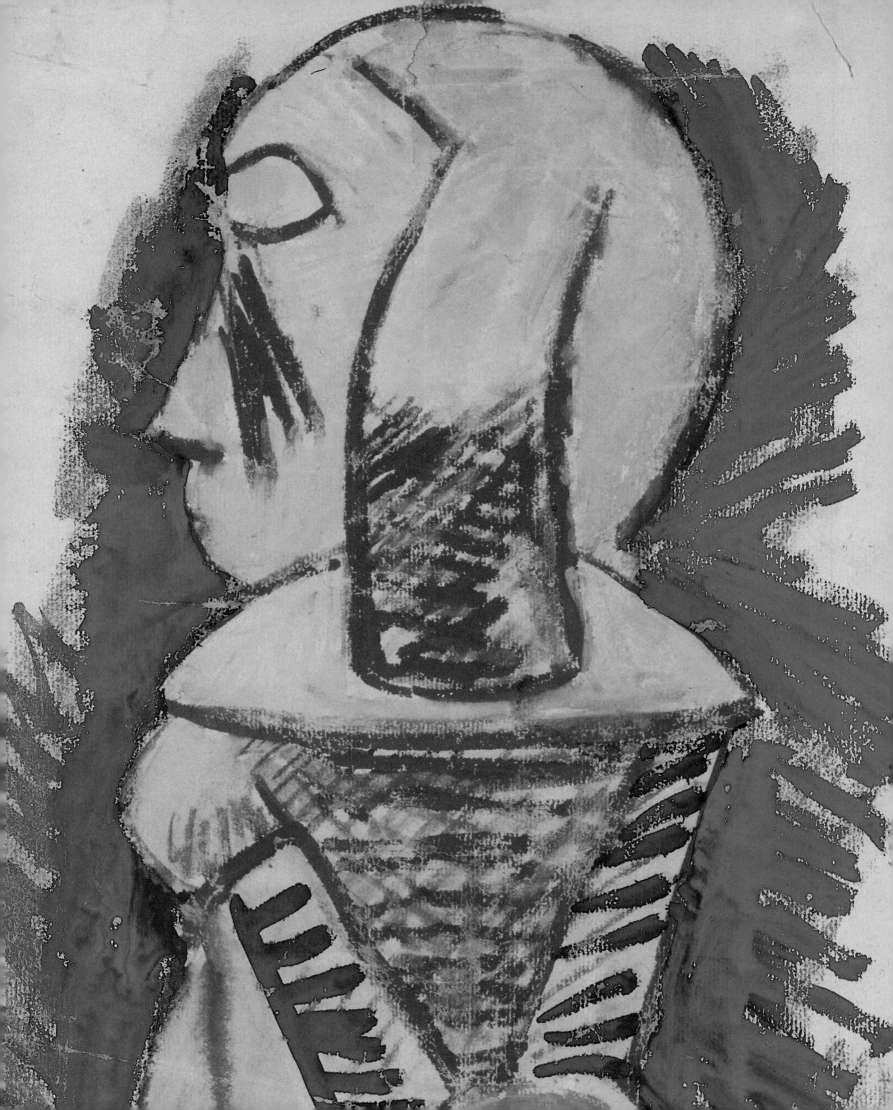

THE PRINCIPLE
OF EQUATION-PAINTING

In October 1907, a short, stocky, black-haired young man with piercing eyes could be seen roaming through the narrow streets of Montmartre, visibly prey to an extreme loneliness. He was an artist, a painter, and he was living the most portentous hours of his life. His name was Pablo Picasso. It would have surprised none of his contemporaries to have found him hanging from the rafters of his studio at 13, rue Ravignan – self-judged and executed by his own hand for the crime of having killed Beauty.

During two sessions of intense work, in February and July of that year, he had painted a major eight-foot square composition entitled *Les demoiselles d'Avignon*. This picture, which depicted five ochre-coloured female nudes posed against a parted blue curtain, was so radically iconoclastic, so totally disconcerting, that even his closest friends could not help expressing disapproval when they first saw it. Because the subject matter had been inspired by the prostitutes in a brothel in the Carrer d'Avinyo – a street in Barcelona not far from where Picasso had lived as an adolescent – Guillaume Apollinaire, no less dismayed than the others, mockingly called it the artist's «philosophical brothel.» Braque, for his part, no doubt thinking of the brawny fire-eaters who exercised their skills along boulevard de Clichy, at the foot of Montmartre hill, told him: «Look,

STANDING NUDE IN PROFILE
(detail)
1907, pastel and gouache,
62.5 x 48 cm. (25 x 19 in.)
Paris, Musée Picasso.

9

LES DEMOISELLES D'AVIGNON

Paris, June-July 1907, oil on canvas,

243.9 x 233.7 cm. (96 x 92 in.)

New York, Museum of Modern Art,

Donated by Lillie P. Bliss.

(detail p. 15).

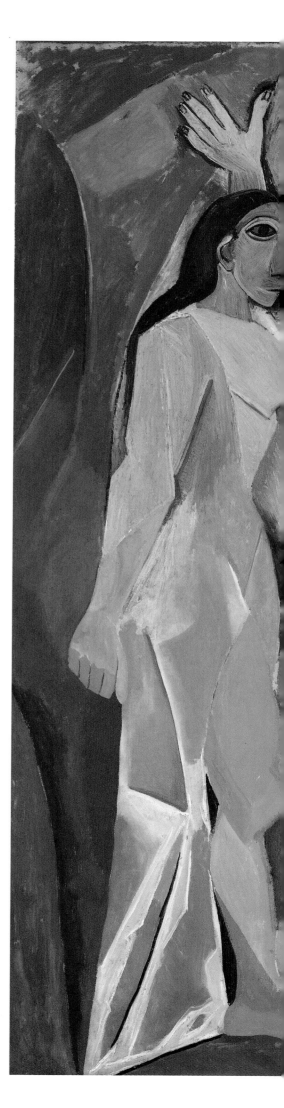

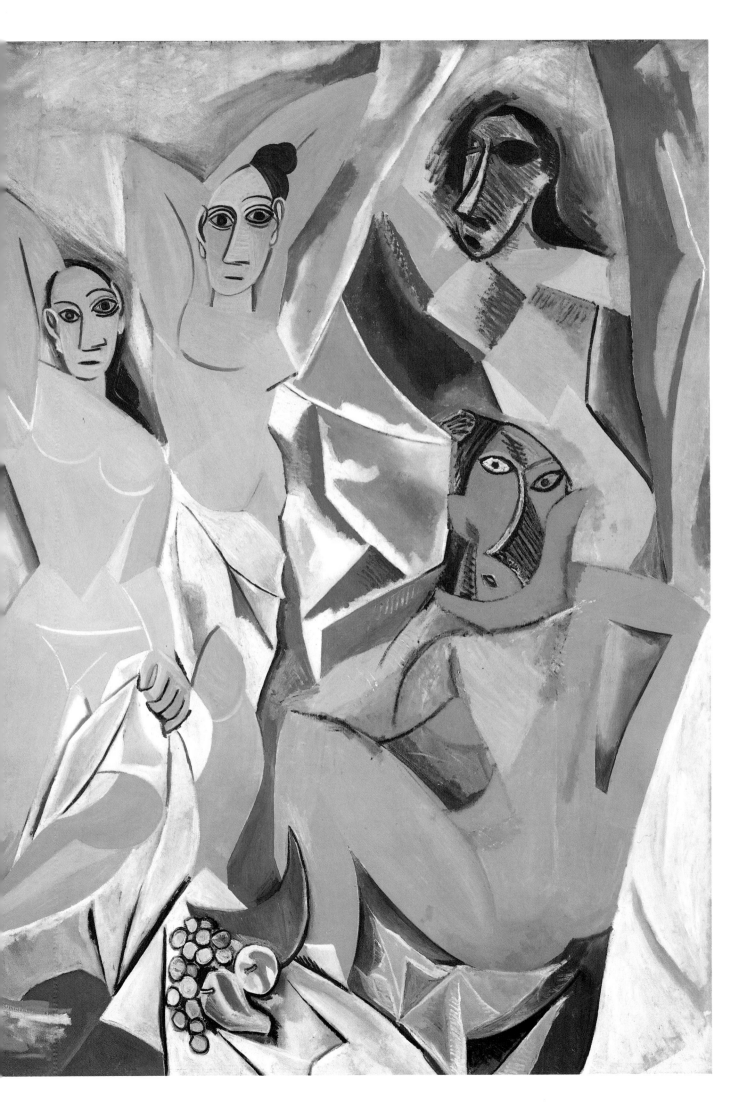

Pablo, this painting of yours, it's like making us eat tow and drink petrol to spit fire!»

Even Matisse, whose Fauve extravagance had outraged the public and critics at the Salon d'Automne two years before, called for vengeance; in his opinion, Picasso had dishonoured painting. Meanwhile, writing from Moscow, the Russian collector Sergei Ivanovich Chtchukin, who already owned a number of the artist's works, asked concernedly: «Has Picasso really gone mad?»

After having long remained rolled up and stored in the artist's various studios, this landmark picture is today the pride of the Museum of Modern Art in New York, which purchased it in 1939 for what was then the fabulous sum of 28,000 dollars. The composition was methodically prepared through scores of preliminary sketches and studies; in some of them, we see the women in the presence of a sailor and a medical student holding a skull, recalling the grim Vanitas and *memento mori* («Remember death!») paintings of the past. Ultimately, however, Picasso retained only the five female figures, yet the *Demoiselles* remains a powerful allegory combining sex, vice and death. In the final analysis, what shocked his friends and fellow-painters the most was not so much the subject matter of the painting as the way in which it had been painted.

The treatment was indeed primitive and archaic, the paint was applied in block-like masses. The five figures seemed to have been hacked and hewn into existence, standing defiantly with their massive chins, oversize ears and bulging eyes menacingly returning the viewer's gaze. They resembled the ill-fitting planks of a wooden fence through which an awesome emptiness could be glimpsed. The angular bodies pressed flat against the picture plane, overlapping like scattered playing cards, the oval faces shown frontally, yet with noses in profile, the denial of linear perspective, everything about this picture challenged the rules by which painters had been working since the Italian Renaissance. Who can blame Picasso's detractors? After careful preparation and with deliberate premeditation, he had perpetrated the perfect pictorial crime.

As we will see in his much later series inspired by Velázquez's *Las meninas* and Manet's *Déjeuner sur l'herbe*, Picasso often liked to measure his own capacities against the great masters of the past. Thus, his *Demoiselles* was the result of a dialogue with Ingres, who had recently been commemorated in Paris with a major retrospective. More specifically, he proffered his response to the tepid eroticism of Ingres' celebrated *Turkish Bath*.

This picture, which the master from Montauban painted at the end of his life, in 1862, was set in the baths of Andrinopolis as depicted by Lady Montagu, a famous eighteenth-century letter writer. She described in lavish detail the interior architecture, ornamentation, diffuse lighting, pools and water conduits, and marvelled at the beauty of the Moslem women, their noble bearing and their majestic movements. Ingres incorporated these various elements into his composition. Although considered lewd when it was first shown, the *Turkish Bath*, with its opalescent-skinned odalisques clothed only in scarves and pearls, was the finest display of indiscreet charms ever to have been put into paint. Picasso's *Demoiselles*, however, were something quite different. Not only had the scene shifted from a luxurious oriental harem to a cheap Barcelona brothel, but the genesis of the picture demonstrated both the artist's personal creative process and his disruptive methods.

The paths leading to this great synthesis were many. In the previous year, Picasso and Fernande Olivier, his mistress, spent the summer at Gosol, a sunbaked village accessible only by mule in the heart of the Pyrenees, overlooking the Valley of Andorra. The canvases he painted there showed the local peasants not as they seemed, but as they really were: with asymmetrical features, square jaws, sunken foreheads, cheekbones reduced to beige and ochre lozenges and triangles. Upon his return to Paris, Picasso bought two roughly-carved stone Iberian heads (which he would later learn had been stolen from the Louvre by Géry-Piéret, an adventurer who had become Apollinaire's secretary). The pictures from Gosol and the Iberian sculptures were major steps along the road that led to the *Demoiselles*.

There has been much debate over the role played by African sculpture: was Picasso influenced by it or not? For one thing, it was very much in vogue at the time in Parisian art circles, and the artist did not help matters much when, asked about this for the *n*th time, he declared irritably: «Negro art? Never heard of it!» But, if nothing else, the scars scoring the concave cheeks of two of the *Demoiselles* are clear proof of the opposite.

André Malraux, at the beginning of his book La *tête d'obsidienne*, quoted from a conversation he had had with Picasso in 1937, at the time when the latter was painting *Guernica* in his rue des Grands-Augustins studio. During the course of the conversation, Picasso recalled that, thirty years before, he had visited the Trocadero Museum, the future Musée de l'Homme, where haphazardly displayed collections of objects

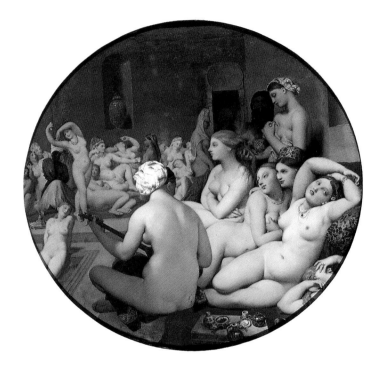

Jean Auguste Dominique Ingres

THE TURKISH BATH

1859-1863, oil on canvas,

diameter: 108 cm. (43 in.)

Paris, Musée du Louvre.

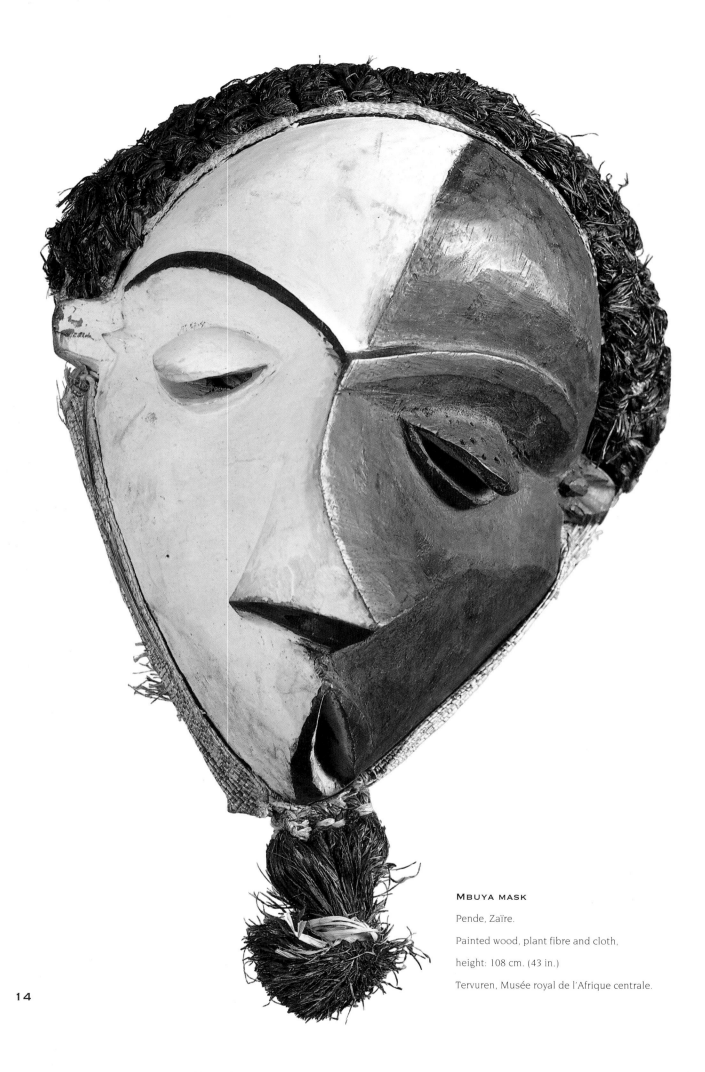

MBUYA MASK

Pende, Zaïre.

Painted wood, plant fibre and cloth,

height: 108 cm. (43 in.)

Tervuren, Musée royal de l'Afrique centrale.

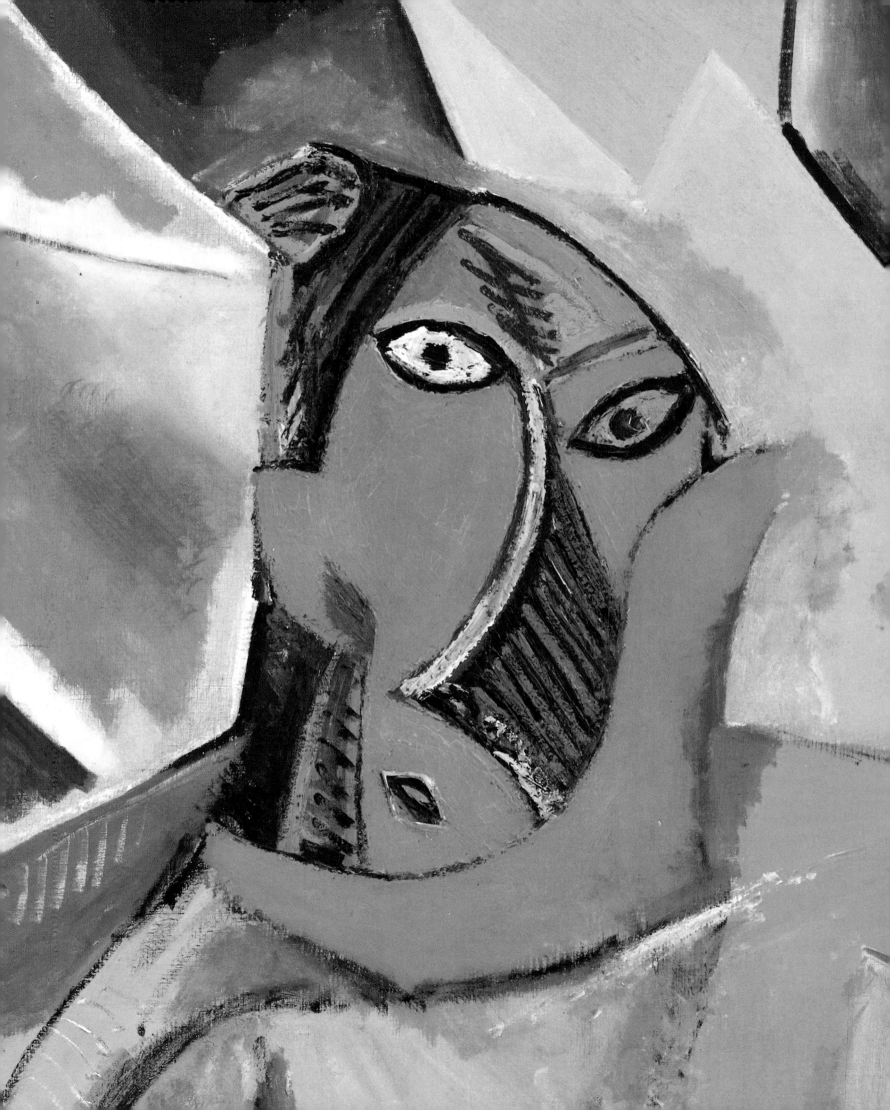

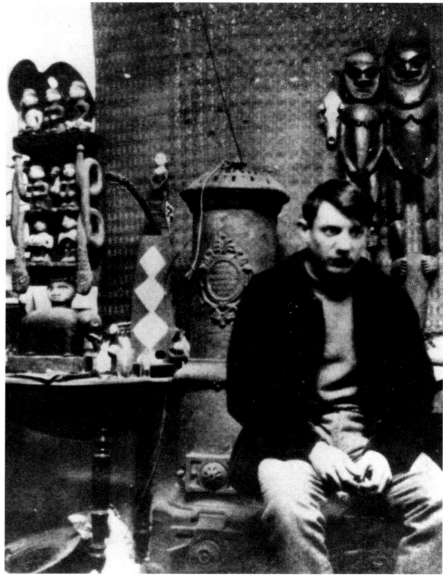

STANDING NUDE IN PROFILE

1907, pastel and gouache,

62.5 x 48 cm. (25 x 19 in.)

Paris, Musée Picasso.

Picasso in his studio at the Bateau-Lavoir in

front of African sculptures.

Paris, Musée Picasso.

from Africa could be seen. The spectacle of this disarray, and the odd smell, both disgusted and fascinated him. Here, couched in the artist's own choppy syntax, is an excerpt from this conversation:

«The masks, they were not sculptures like the others. Not a bit. They were magical things... the negroes, they were intercessors, I even learned this word then. Intercessors against all kinds of things: against dangerous spirits. I kept on looking at the fetishes... Me, too, I am against everything. Me, too, I think that everything is unknown, threatening!... I understood what the negroes used these sculptures for... They were weapons. To help people no longer remain at the mercy of spirits and to become

independent... The spirits, the unconscious (it was not yet much talked about), it's the same thing. I understood why I was a painter... The *Demoiselles d'Avignon* must have happened on that day, but not at all on account of the forms: because it was my first exorcist picture, yes!»

For artists like Matisse and Braque, the Dogon and Senufo masks were sculptures like any other, and their hieratic forms could profitably be studied as such: Matisse even compared Negro art to Egyptian art. This was also the opinion of the ethnologist and essayist Carl Einstein who, as early as the Cubist period, showed how African sculpture, unlike European statuary, played more on the articulation of volumes than on effect. The conversation recorded by Malraux indicates very clearly that, as far as Picasso was concerned, it embodied savage, incantatory forces.

Another intermediary was Paul Cézanne. It has often been said that Picasso was influenced both by the major retrospective at the 1905 Salon d'Automne and by a small picture, *Three Bathers*, which Matisse had acquired in 1899 and prominently displayed in his studio, where Picasso could have contemplated it at leisure. There is some truth to all of this, but in fact the master of Aix's influence may have intervened in a much more direct way. In that same year, 1907, Cézanne had just finished one of his three versions of the *Large Bathers*, an important work on which he had been working for seven years. A photograph showed the elderly artist seated in front of this painting, blocking the middle section, so that only the two groups of figures on the left and right sides of the composition are visible. Take these two groups of figures, bring them together into a square format, and the result would be an amazing approximation to the *Demoiselles d'Avignon*!

Yet not all of Picasso's friends reacted negatively to the scandalous quintet when it was unveiled at the Bateau-Lavoir. Daniel-Henry Kahnweiler, who later became his dealer, even wanted to buy the painting on the spot, but the artist refused to sell it, claiming that it was «not finished.» Another noted admirer was the poet André Salmon. Soon afterwards, the latter described the *Demoiselles* in these lucid terms: «They are problems in the nude, white figures on a blackboard... the positing of the principle of the equation-painting.»[1] By the time he was twenty, Picasso already had a thousand drawings and paintings to his credit. At the age of twenty-six he had his first artistic success. What could he do from then on, if not repeat himself and turn out ever more of the same?

1. André Salmon, *La jeune peinture française*, Paris, 1912.

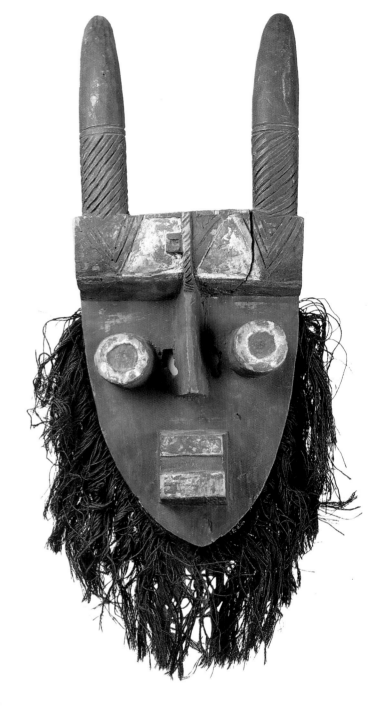

GREBO MASK

Wood, white paint, plant fibres.

Paris, Musée Picasso.

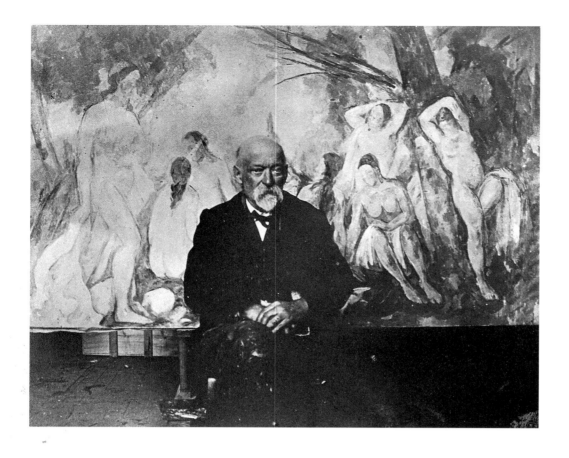

Cézanne in front of his Large Bathers.
Paris, Angel-Sirot Collection.

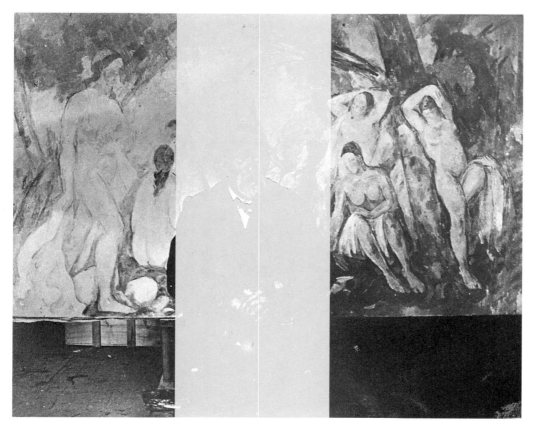

Opposite
Paul Cézanne
THREE BATHERS
1879-1882, oil on canvas,
58 x 54.5 cm. (23 x 21 in.)
Paris, Musée du Petit Palais.

To the same degree as African and Iberian sculpture, Cézanne's painting contributed to the genesis of the Demoiselles d'Avignon. Picasso was influenced by his Three Bathers (opposite), which Matisse had bought in 1899 and which he had many opportunities to see in the latter's studio. Another influence was The Large Bathers, today at the Barnes Foundation in Merion, Pennsylvania. In a photograph of this painting (above), Cézanne covers the middle part in such a way that only two groups are visible on the left and right sides of the picture. Picasso brought these two groups together in a square format and the composition for the Demoiselles was born.

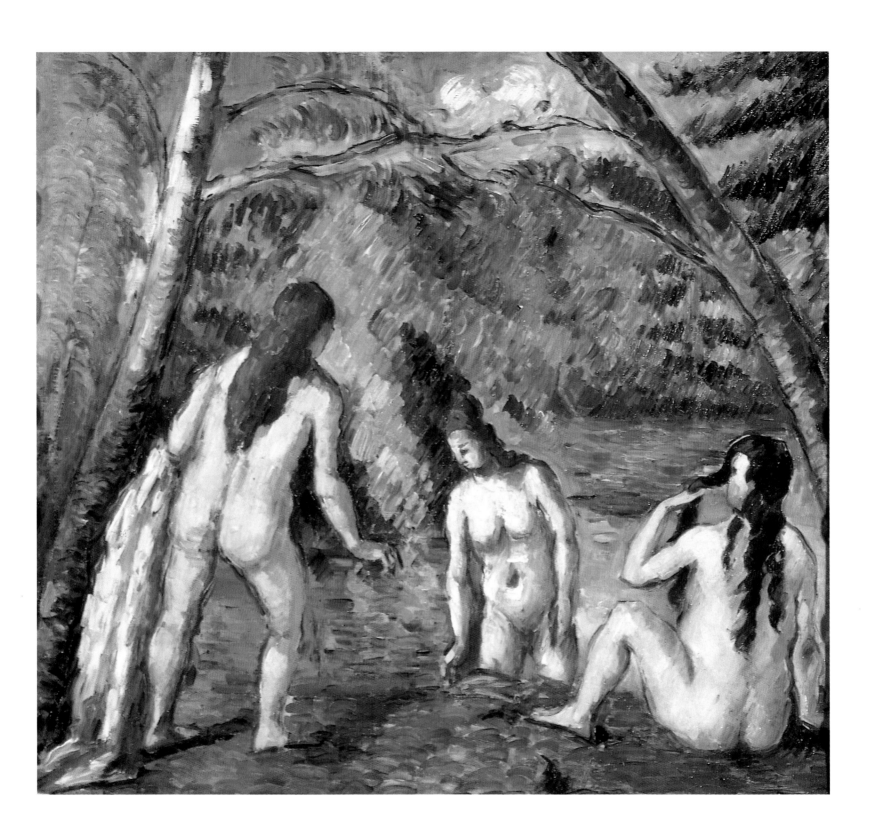

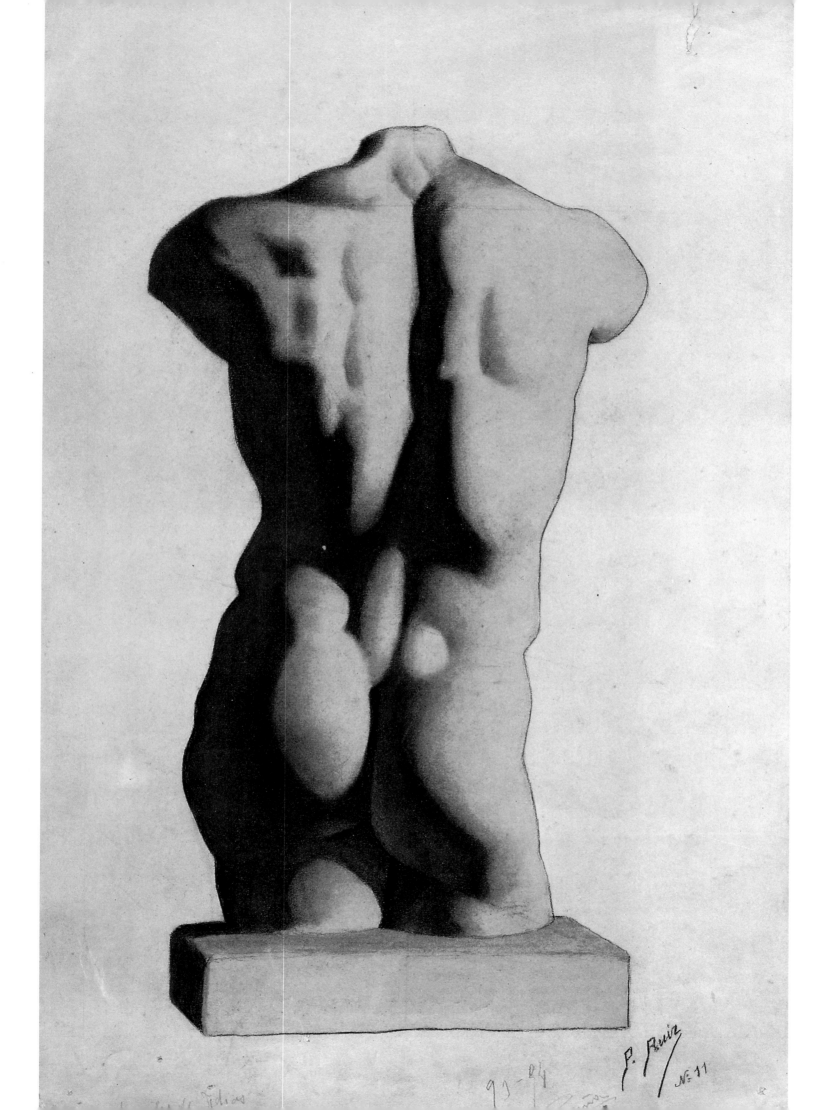

P. Ruiz

Nº 11

1

PICASSO BEFORE PICASSO

CHILDHOOD OF A GENIUS

Fact or fiction? The most vital and tumultuous artistic genius of our time, the child prodigy who grew up to become the equal of the greatest masters of the past, began his life as a stillborn baby.

When he came into the world on the evening of 25 October 1881, in Málaga, his tiny body remained motionless in spite of the usual administration of prods and slaps. The unassuming parcel of human flesh seemed anything but willing to accept its exceptional destiny. His paternal uncle, doctor Salvador Ruiz Blasco, busied himself about the body under the anxious gaze of the midwife, who, believing the child dead, did her best to comfort the mother. One has to imagine the tense drama of this scene against the background of overexcited relatives who were typically on hand for such occasions in Spain. The doctor finally resorted to drastic measures. In those days, physicians smoked large cigars, and so, after having drawn deeply on his havana, he blew the acrid smoke into the baby's face, which immediately puckered into a grimace and exploded into a howl.

Picasso was fond of telling the story of the dramatic circumstances of his birth. In the heavens, the sun and the moon were close to the

nadir. The light spreading from the midnight sky over the white houses of the city came from an unusual configuration of planets and large-magnitude stars which later inspired much speculation among astrologers. Not knowing the exact time of his birth, however, they have not been able to define the link between astral influences and the destiny of this most prodigious child[1]. On the other hand, obstetricians advocating less violent childbearing methods agree that this initial trauma could account for the predominantly dramatic nature of the painter's works.

Don José, Pablo's father, nicknamed «the Englishman» by his friends because of his distinguished stature and nonchalant manner, was very blond, while his wife, Doña Maria, was a typically short, swarthy Andalusian. He was also a painter who, in his son's words, painted «dining-room pictures» representing wild game, such as partridge and hares, or floral subjects such as lilacs, and occasionally landscapes. But his favourite subjects by far were pigeons and doves. Since he sold few works, he made ends meet by teaching drawing at the local art school, working as curator at the local museum and restoring paintings. Although an academic artist, the shy and fastidious Don José quickly noticed little Pablo's precocious talent and became a very exacting master.

Picasso, whose hatred of schools verged on phobia, thus learned how to draw before he could talk, and yet claimed never to have made any «children's art.» Instead, his father would nail dead pigeons to the walls of his studio and oblige him to draw perfect reproductions of them. One of the budding young artist's own favourite subjects, however, was the bullfight, to which he was introduced at an early age by Don José, himself a passionate aficionado.

His first picture was painted on a wood panel in 1889, when he was eight years old, and showed a *Picador*. Although the perspective was still a bit awkward, the horse on which the latter was perched had been quite well rendered. The spectators were represented by three half-figures standing behind the *calejon* surrounding the arena: a couple and a man wearing a broad-brimmed hat. The most striking thing about this little panel was the colour scheme: the ground is a violet-tinted brown, the calejon is rose-coloured with a touch of purple which handsomely sets off the picador's sumptuous yellow costume. The eyes, however, were the work of Pablo's little sister, Lola, who took a nail and poked holes into the picture.

THE LITTLE PICADOR

1889, oil on wood, 24 x 19 cm. (9 x 7 in.)

Paris, private collection.

1. Cf. Roland Penrose, *Picasso: His Life and Work*, Harper & Row, New York 1973.

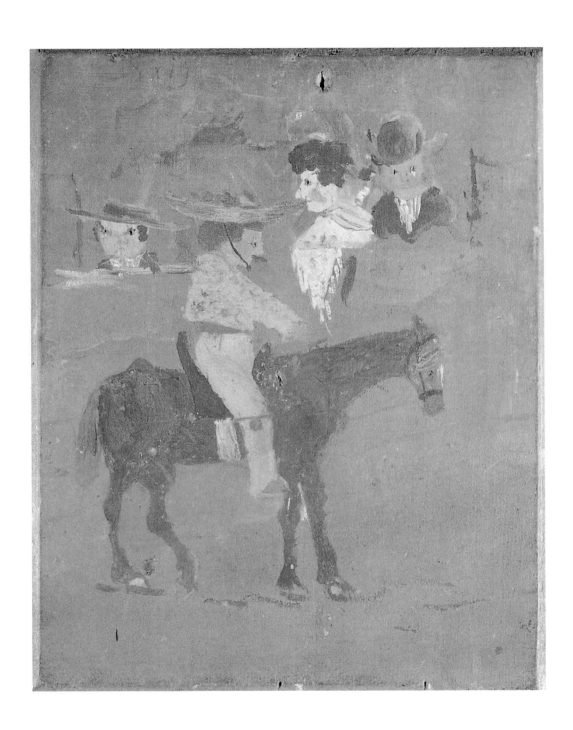

Picasso was only ten years old when the family left Málaga and moved to the less temperate climate of La Coruña, in Galicia, at the northwestern tip of the Iberian peninsula. His father, who had lost his curatorship when the provincial art museum in Málaga closed down for lack of funds, took on a new post as drawing teacher at the School of Arts and Crafts. La Coruña, being on the Atlantic coast, was often lashed by stormy winds and rain. The young Picasso stayed mostly indoors and expressed his displeasure by drawing a caricature of a group of people huddled under an umbrella, their shoulders hunched with cold, accompanied by the caption: «It has already begun to rain. This will last until summer.»

Yet it was in La Coruña that, around the age of twelve or thirteen, the artist really came into his own, and in an unexpected discipline at that: drawing after plaster casts of classical sculptures. He executed these charcoal studies of hands, feet, legs and heads exactly in the style required of art students at the time. Apart from their amazing technical virtuosity, they demonstrated, on closer inspection, a keen sense for dramatic effects of light and shadow. He also painted portraits: his sister *Lola with a Mantilla* (1894), *Man with a Bald Head* and a *Portrait of Ramón Pérez Costales*, both from 1895. The latter, an important political figure and friend of the family, had served as minister under the first Spanish Republic. The fact that Picasso first saw the forbidden republican flag at home was surely a contributing factor to his outspoken opposition to Franco during the days of *Guernica*.

One of his last pictures from La Coruña, the *Barefoot Girl* (1895), was painted after a model hired by his father to show that he now considered his son a full-fledged painter. The rather homely young girl is shown frontally, sitting in a chair, wearing a red dress with a white scarf around her shoulders, her hands worn by work, her feet strangely stumped and covered with blisters. The shapeless body seems to be gripped by an ineffable pain. This preoccupation with life's victims would find further expression in the pictures of the Blue period, and of the Gosol peasants.

Finally, Picasso moved with his family to Barcelona in 1896, when Don José was awarded a professorship at the famous *La Lonja* Academy of Fine Arts, so-called because it was located on the second floor of the same building as the «Loge», or commodity exchange. Pablo was immediately admitted into the second year of this very strict institution after having worked only one day on a drawing for which candidates usually had a month to reflect and prepare. This drawing, which shows a

HEAD OF A BALD MAN

1895, oil on canvas, 45 x 30 cm. (18 x 12 in.)

The artist's heirs.

BAREFOOT GIRL

La Coruña, early 1895, oil on canvas,

74.5 x 49.5 cm. (29 x 19 in.)

Paris, Musée Picasso

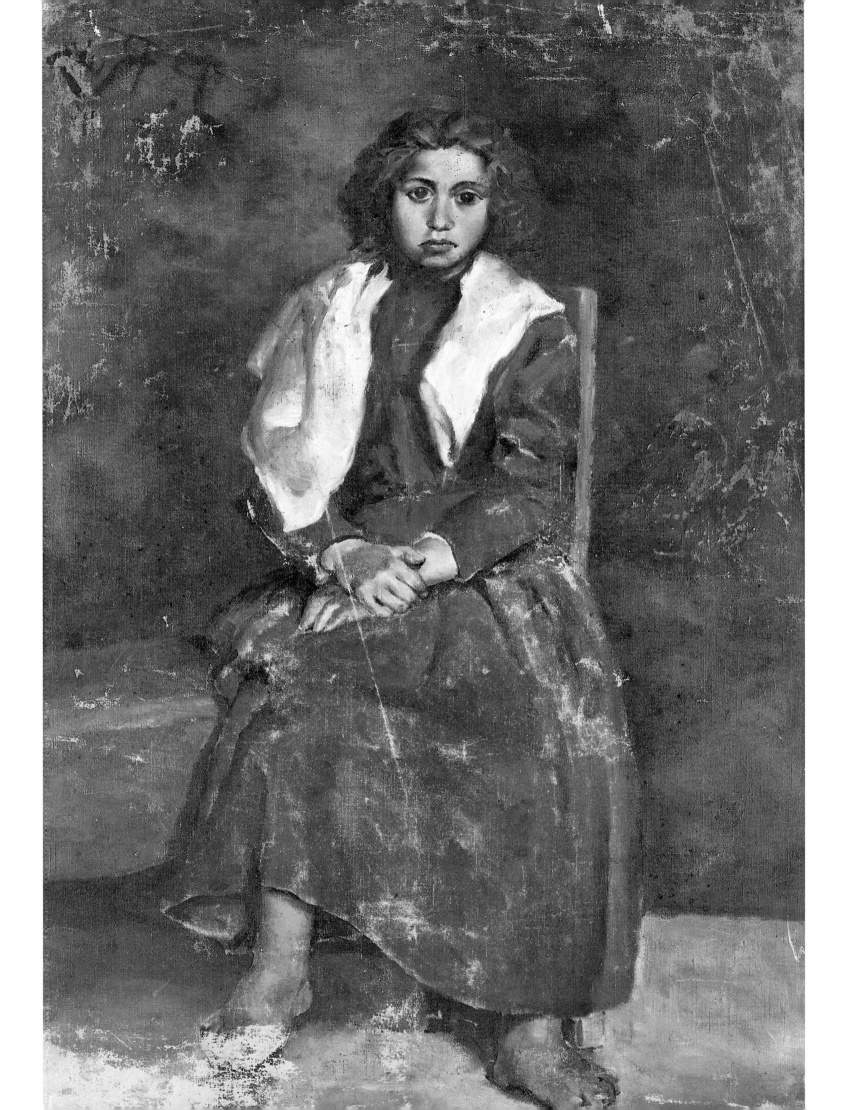

stocky male nude with a large head and knock-knees, is not among the artist's enduring masterpieces – not by a long shot. In a recent publication, John Richardson attacked the legend of the artist's precocity, saying that it was fabricated and spread by the painter's friends[1].

One wonders, though, if Richardson is being entirely sincere since he cannot be unaware of other works from this same year which displayed a remarkable maturity, such as the enigmatic *Entrance to a Cave* in a rocky landscape, or the superb, and ambiguous *Head of an Adolescent*. Leonardo da Vinci told how, as a boy, he once chanced upon a cave while wandering in the Tuscan countryside, and how he was paralyzed at the threshhold by the sudden darkness, torn between his fear and his desire to enter. This combination of fear and desire is also to be found in these two early pictures by Picasso, and especially in the second, where the impenetrable mystery is the human likeness itself.

Who am I? Who are you? Who are we? Picasso, like Rembrandt and Van Gogh before him, repeatedly questioned the mirror of his own features in a series of self-portraits which spanned his entire career. It ended with the tragic mask from 1972, painted one year before his death, in which his face was reduced to a skull, as if he had assimilated his own death while still alive. For the time being, however, he portrayed himself in various guises: with short or tousled hair, wearing a gentleman's wig, or with a Mediterranean complexion. Many years later, he would write: «Some day, there will undoubtedly be a science – it may be called the science of man – which will seek to learn about man in general through the study of the creative man. I often think about such a science and I want to leave to posterity as full a documentation as possible.»

This idea was far removed from the notion of pictures intended merely to decorate dining-room walls, and it required more than just talent or skill. Like the famous Socratic injunction, it involved self-knowledge and knowledge of others. Don José, subjugated by his son's genius, eventually gave up his own painting to become the latter's mentor. Picasso was still only sixteen years old.

SCIENCE AND CHARITY

The enigmatic *Entrance to a Cave*, set down in bold and broad brushstrokes, belonged to the tradition of fragmentary, yet definitive

1. John Richardson, A *Life of Picasso*, vol I, 1881-1906, New York 1991.

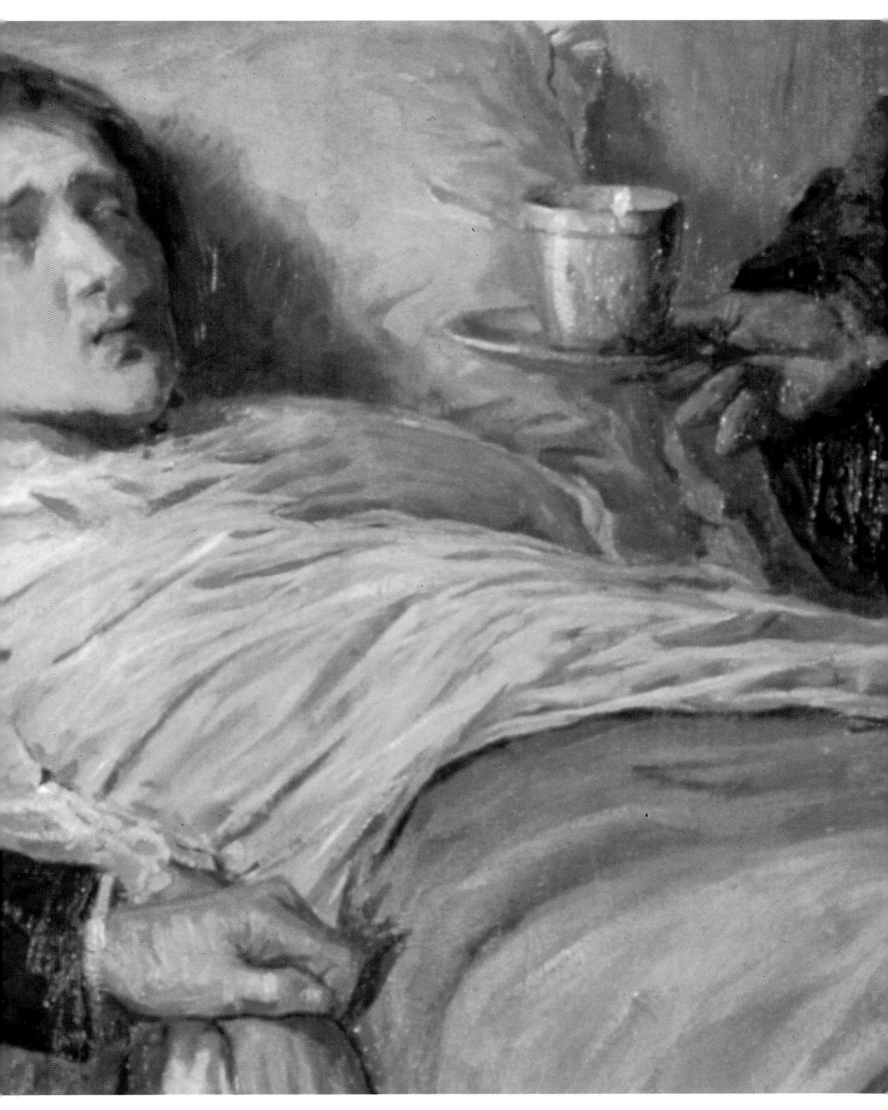

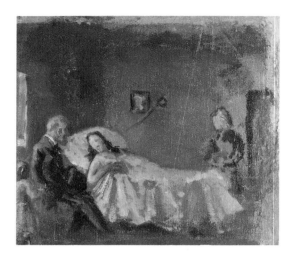

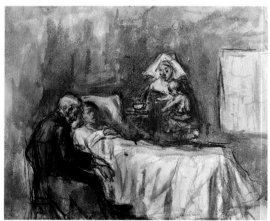

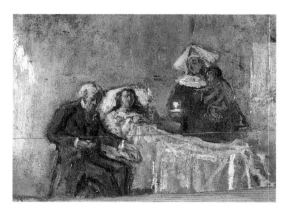

sketches often found in the work of Corot and Manet. This type of sketch differed from the working sketch, which still required completion. The distinction between the two was first formulated by Baudelaire in his review of the 1845 Salon when, speaking of the public and critics, he wrote: «These fine people... ignore the fact that there is a great difference between a *done* piece and a *finished* piece; for, generally speaking, something that is *done* is not *finished*, and something quite finished may be not done at all.» Picasso expanded on this idea almost a century later, saying that there are finished paintings that are not even begun, while others are finished «like one finishes off a horse.»

Although he had already demonstrated this principle in his own practice of painting, this was surely no recipe for success in the closing years of the nineteenth century. For an artist to stand a chance of being noticed by a jury in those days, he had to paint a history painting, which meant executing a grandiose, well-finished «machine» on some historical, religious, mythological, or social theme. Some of his works in this vein are displayed at the Museo Picasso in Barcelona, which has many of his early works; paintings like *The First Communion* (1896), which, perhaps due to his father's influence, had all the ingredients of academic art, or *Science and Charity* (1897), which was surely his best effort in this genre.

The year before, the Castilian painter Enrique Paternina, one of the leading figures in Spanish painting at the time, had caused a sensation at the national fine-arts exhibition in Madrid with *The Mother's Visit*. This painting depicted a thin, pale-featured girl lying in a hospital bed; a woman – her mother – stands at her side, holding her hand, while at the foot of the bed, a nun contemplates the scene, accompanied by a little girl whose size and age seem to identify her as the patient's younger sister. As Josep Palau i Fabre[1], the most scrupulous biographer of Picasso's early years, has pointed out, it is not unlikely that the artist saw this work or a reproduction of it and used it as a model for his *Science and Charity*, which is very similar in subject matter and handling.

The painter then proceeded to introduce some changes: the scene takes place not in the hospital, but in an ordinary bedroom, a setting he deemed more intimate and more conducive to meditation. The figure of the mother was replaced by that of a doctor taking the ailing woman's pulse; the nun has moved to the patient's bedside and, holding a small child in a nightshirt on her left arm, hands her a cup of medication or

1. Josep Palau i Fabre, *Picasso en Cataluña*, Ediciones Polifrafia S.A., Barcelona 1966.

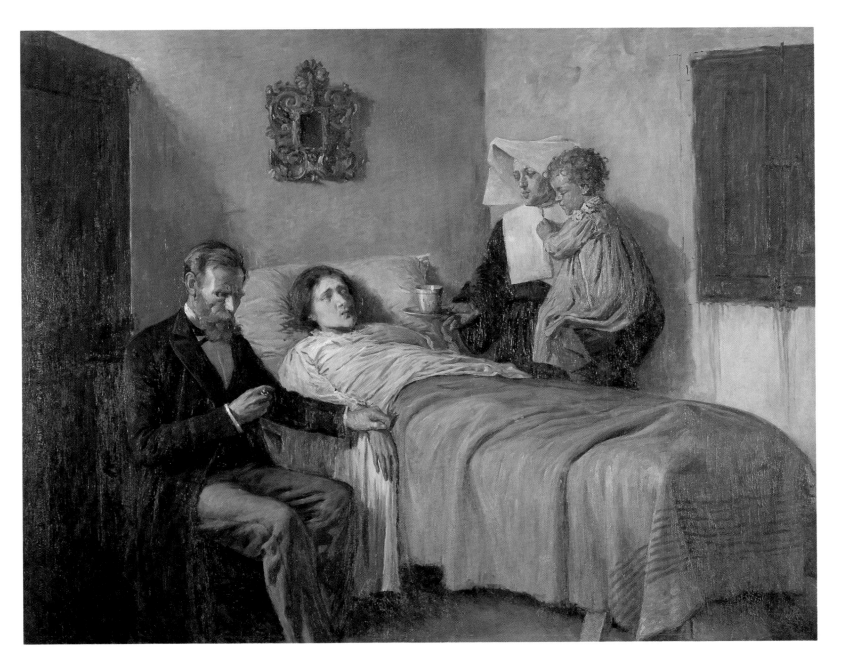

SCIENCE AND CHARITY

Barcelona, early 1897 oil on canvas,

197 x 249.5 cm. (78 x 98 in.)

Barcelona, Museo Picasso.

opposite

SCIENCE AND CHARITY

Four studies, 1896-1897.

Barcelona, Museo Picasso.

herbal tea. The figures were evidently painted from posed models. Palau i Fabre confirms the obvious when he tells us that the figure of the doctor was based on Don José, whom he strongly resembles. He also found out that the model for the sick woman was a beggar from the streets of Barcelona, while the nun was most likely a young boy dressed up in a religioius habit and cornet lent by Josefa Gonzales, a nun from Saint-Vincent-de-Paul who worked as nurse at the Asilo de la Granja.

This final version was preceded by the usual series of preparatory drawings and oil sketches: in this case, at least seven. The changes involved the position and poses of the figures: the doctor sat at the bedside from the beginning, but no longer took the patient's pulse; the sick woman lying in bed changed position several times before finding the right one; the child in the nun's arms was added only at a late stage. And so the picture gradually took shape: the facial expressions, the poses, the clothing and the furniture, at first broadly treated, became increasingly precise.

Although Picasso later confided to Kahnweiler, his art-dealer, that he had always hated the paintings from his academic period, they were to play a decisive role in his budding career. At that time, the artist was particularly fond of English Pre-Raphaelites like Rossetti or Millais, and had plans to establish himself in London when he left Spain – as he would inevitably have to do. Then it happened that one of his academic compositions, *The Last Moments*, was chosen to be exhibited in the Spanish pavilion at the 1900 Paris World's Fair. The artist made the trip to the French capital to see how his work fared in the company of the others. He stayed there with his friends, the painters Casagemas and Pallarés, from October until mid-December, then changed his initial plans: he decided to establish himself as soon as possible in the world capital of the artistic avant-garde. This finally became possible in 1904.

The habit of making preparatory drawings and sketches, which had been instilled in him at the art academy, became a lifelong practice, and he resorted to it each time that he tackled a major composition. But instead of proceeding step by step, as in a cumulative descriptive construction, with details being added and fine-tuned at each stage, he turned the academic rule inside out like a glove. His preparatory studies became «sums of destructions,» as he called them forty years later. Their purpose was to introduce perturbations, discontinuities and questions, as if the picture were being worked out in its negative spaces, in its own gaps, so to speak. I have briefly referred to this process in connection

PORTRAIT OF THE ARTIST'S FATHER
Barcelona, 1896, watercolour,
18 x 11.8 cm. (7 x 5 in.)
Barcelona, Museo Picasso.

with the *Demoiselles d'Avignon*, which was preceded by a large number of studies, and will return to it in more detail when the time comes to discuss *Guernica*.

THE BURIAL OF COUNT CASAGEMAS

The life that Picasso led during the three or four years that he was turning out academic "machines" was anything but that of a future official painter. The favorite gathering place of the new generation of artists and writers in Barcelona was a tavern called «Els Quatre Gats» – the Four Cats. This tavern, with its neo-Gothic façade, combined a restaurant and a cabaret and owed its name both to Aristide Bruant's famous *Chat Noir* cabaret in Paris and to an erstwhile disparaging remark: «There won't be four cats,» which is the literal translation of a local saying that means «There won't be a soul.» The owner and master of ceremonies, Pere Romeu, instantly recognizeable with his gaunt physique and narrow beard framing an equally narrow face, had previously worked as a gym teacher, puppeteer and garage mechanic – just the type of bizarre personage Picasso always found so appealing.

His own artistic contribution to Els Quatre Gats was a fairly non-realistic poster (1897) featuring a group of stylish clients – the women in crinolines and the men wearing top hats – seated in front of tankards of beer at a café terrasse table. In fact, the usual clientele of the tavern consisted of decadent and rowdy Bohemians. Among them were Miguel Utrillo, Maurice Utrillo's future adoptive father, who directed a literary review called *Pel i Ploma* («Brush and Pen») and performed shadowplays with piano accompaniment by Albeniz. Other habitués included the portrait-painter Ramòn Casas who decorated the interior with a huge painting representing himself and Romeu on a tandem, sporting white suits and black stockings; and Santiago Rusinol, a visionary painter who claimed the right to «derive a living from the weird and the abnormal.»

At the time, the habitués dressed in a style that could be called proletarian dandyism: black hat, broad tie, loosely fitting dark vest, and tapering trousers. This costume was inspired by the anarchist agitators who were the heroes of the working class. But the ideas and tastes of the clientele were closer to the German avant-garde, associated in Munich with «Jugendstil» and in Vienna with the «Sezession.»

For Picasso, Els Quatre Gats was a sort of home away from home: it was there that he made friends with Jaime Sabartés, his future secretary

and hagiographer, and became the inseparable companion of Carlos Casagemas, with whom he first travelled to Paris in 1900. Casagemas, who came from a very wealthy family, had quit his position as naval cadet to plunge himself into the more congenial and heady world of the arts, but without being a real artist himself. He lived with artists in a communal studio and shared their pleasures. Apart from frequent visits to the brothels in the red light district, one of their favourite diversions was «fried drawings,» a pastime which consisted of placing drawings into a frying pan, frying them and admiring the often surprising results.

In a more serious vein, Picasso painted a series of *Heads* representing intellectuals who frequented Els Quatre Gats. Their handling combines the styles of the caricaturist Steinlen, Toulouse-Lautrec and the Catalonian artist Isidro Nonell. The latter, a painter who has unjustly fallen into oblivion, was eight years older than Picasso and exerted a strong influence on his beginnings. The latter borrowed not only his subjects, but also his almost painfully bold impasto and his earthy colour schemes of subdued reds and ochres, as if seen in a half-light. He also adopted his tragic vision of society and shared his ideals: for Nonell, painting was a way of representing and defending the lot of the oppressed masses.

Be that as it may, Picasso owed his first masterpiece in the new style to a romantic tragedy. He was in Madrid in the winter of 1900-1901, when he learned that Casagemas, who had stayed behind in Paris, had committed suicide. His boon companion had fallen madly in love with a certain Germaine Gargallo, a grisette who modelled for him, but unfortunately did not reciprocate his feelings. The sad affair came to a climax on Sunday 17 February, in the Hippodrome Restaurant on boulevard de Clichy. Casagemas, who had recently taken to heavy drinking, had invited Germaine, her sister Odette and three Spanish friends to dinner. He seemed much more nervous than usual. At the end of the meal, after having placed several letters on the table – including one addressed to the Parisian police commissioner – he pulled a revolver out of his pocket, shot at Germaine, then turned it upon himself. By some miracle, the young woman was not hit, but Casagemas was mortally wounded and died in hospital that night.

Picasso, who identified his whole life with painting, could not understand how anyone could die for love of a woman. In the spring, he was back in Paris again, living in the studio left vacant by Casagemas. He painted several works, including one that shows the ill-fated lover on his deathbed, with his black hair, long nose, receding chin and a bullet hole

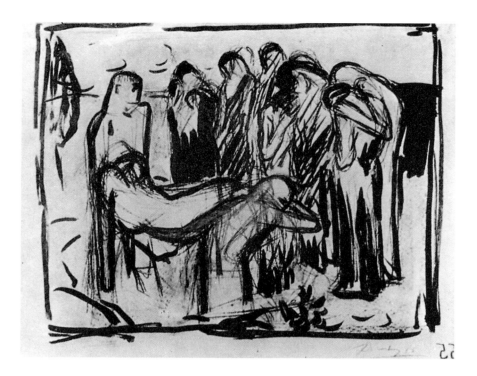

BURIAL

Study for «The Burial of Casagemas»
Paris, 1901, Indian ink, 40 x 56 cm. (16 x 22 in.)
Private collection.

in his temple. He then created a more elaborate picture, *The Burial of Casagemas* (*Evocation*), a small vertical composition recently acquired by the Musée d'Art moderne de la Ville de Paris.

This picture was preceded by a large number of preparatory drawings. This, as we know, was an indication of the importance he attached to a work. These studies show a group of pensive men, mourning women and grave-looking children. Some of the figures, drawn with insistent strokes, already have indications of light and shadow, others are still very sketchy. This group eventually appeared in the lower half of the final composition. As in El Greco's famous *Burial of Count Orgaz*, Picasso articulated the picture into two separate registers representing the terrestrial and the heavenly realms. While Casagemas' body is surrounded by a typical group of somberly-clad Iberian mourners, the heaven which Picasso imagined for him is peopled by naked courtesans, one of whom hoists the newcomer onto a white horse. Two of the women wear black stockings, and a third, red – a clear allusion to Toulouse-Lautrec's prostitutes.

The influence of El Greco was not merely limited to the pictorial organization into two superimposed worlds, but is even more evident in the manner in which he handled the painting. While he was still in Madrid, Picasso made an excursion to Toledo to see the original *Burial of Count Orgaz* in the Church of San Tomé. This majestic composition is noteworthy for its serene clarity and bold black, white and gold colour scheme. In Picasso's *Burial of Casagemas*, we see the same sense of drama and stillness, but also an intense sensuality.

THE BURIAL OF CASAGEMAS
(EVOCATION)

Paris, summer 1901, oil on canvas,
150.5 x 90.5 cm. (59 x 36 in.)
Musée d'Art moderne de la Ville de Paris.

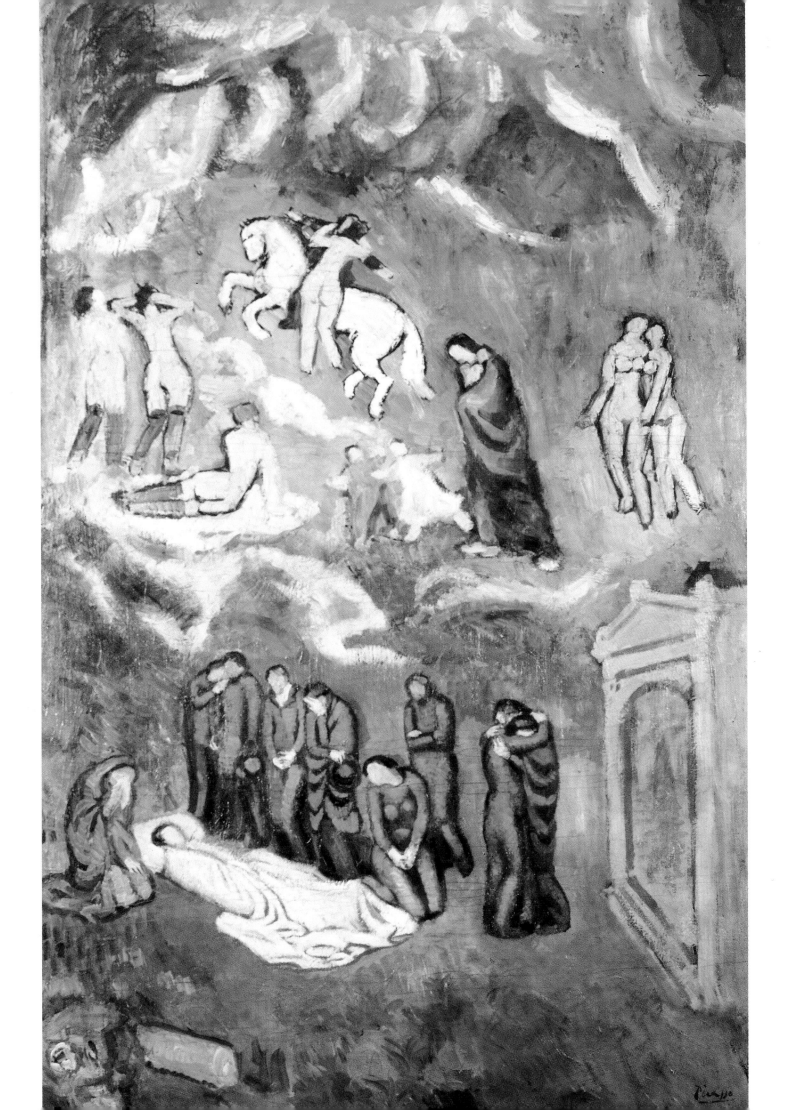

BULLFIGHT SCENE (VICTIMS)

Barcelona, spring 1901,

oil on cardboard mounted on wood,

49.5 x 64.7 cm. (19 x 25 in.)

Private collection.

On 24 June, Ambroise Vollard, Cézanne's art-dealer, opened an exhibition of Picasso's works in his gallery in rue Laffitte. This was his first major show in Paris and included no less than sixty-nine works. It was a fairly mixed selection, including works from three different periods; namely those from Barcelona, Madrid and Paris, which, although closely related in time, were very different in approach. There was also a large variety of subjects: bullfights, horse races, portraits, bouquets of flowers and nudes. Yet there was an overall stylistic coherence in the sense that two tendencies could clearly be identified: works handled mostly in broad, flat areas of colour, and works done in patterns of dots, almost in the «pointilliste» manner.

When we see these pictures, today dispersed in collections around the world, and think that they were once shown in a single exhibition, we can only be struck by their amazing diversity and power. To mention only a few examples, there was the haunting picture titled *The Wait*, which shows a morphine addict with glazed eyes in a mask-like face, wearing a scarlet corsage; or the Manet-like *Female Nude*, which shows a woman reclining on a couch, her folded legs tucked under her in a provocative pose; or two bullfight scenes, one of which is subtitled *The Victims* and shows in the foreground a horse fatally gored by the horns of the bull. All of these works were painted in the years 1900-1901. The notion of colour

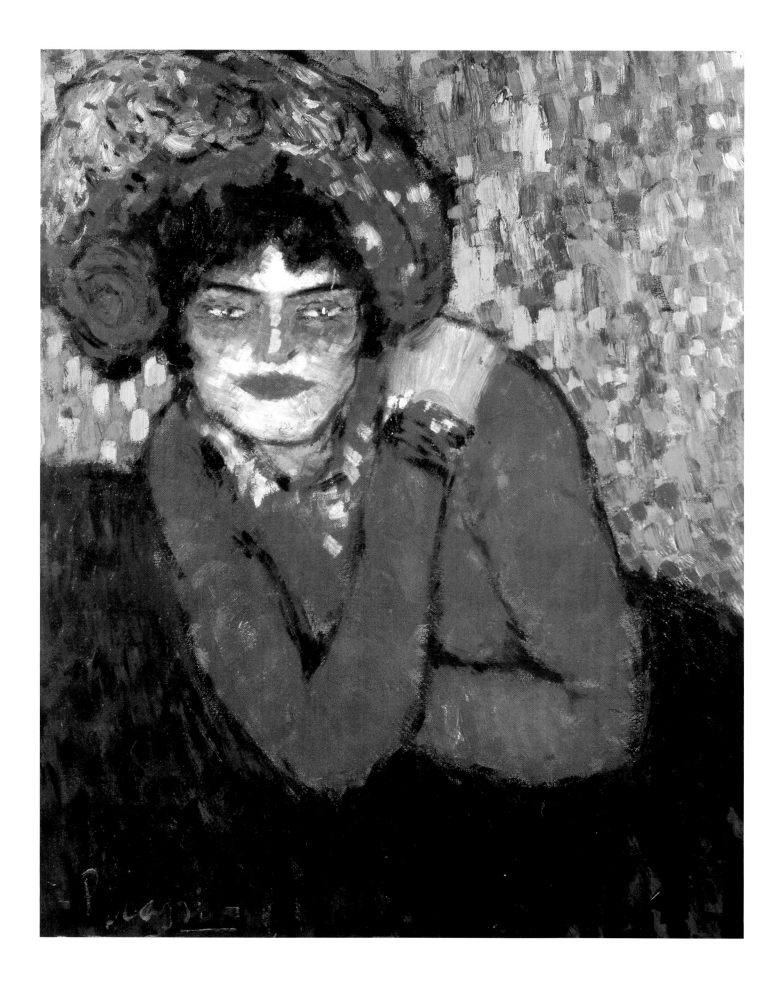

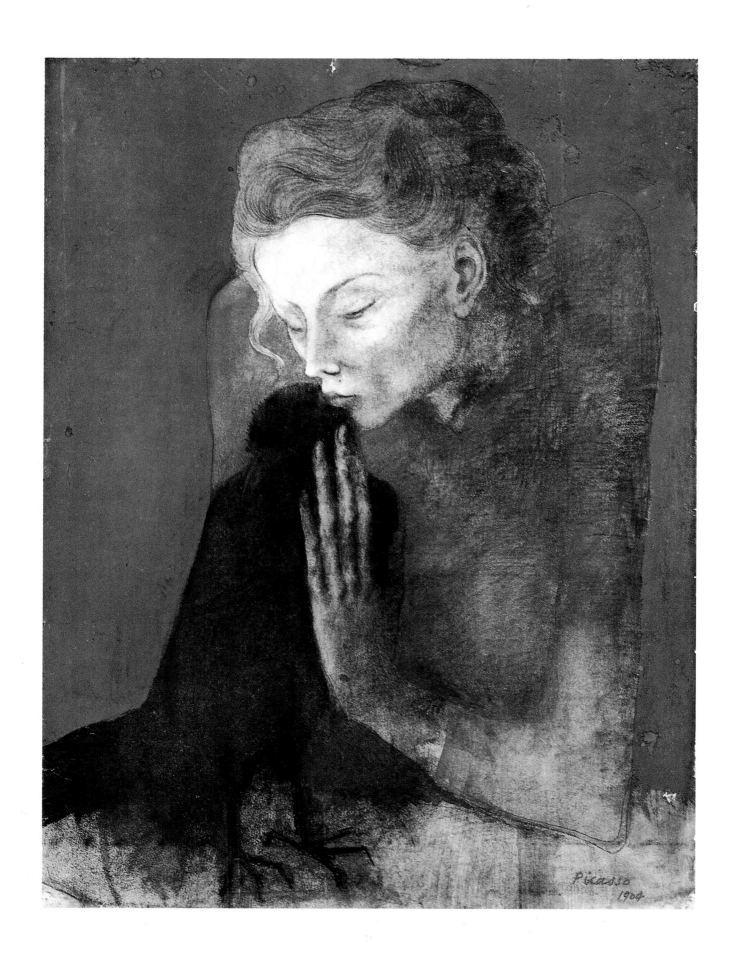

for its own sake was in the air, and while some artists, like Matisse and Derain, pushed it to its Fauvist conclusion several years later, the Malaguenian newcomer was not far behind.

However, as Vollard wrote in his *Memoirs*, Picasso's splendid exhibition met with no appreciable success, and this state of affairs was not to improve for a long time. But there is reason to believe that the shrewd art-dealer may have exaggerated on this point. In any case, the artist was in a sombre mood as he impatiently waited for the money promised by his father for his return-trip to Spain. He was also hungry and cold. In January 1902, he left Paris, returning in the autumn only to be disappointed once again, and went back home in the early days of 1903.

LIFE IN BLUE AND ROSE

By the time that Picasso established himself in the Bateau-Lavoir in Montmartre one year later, his painting style had changed considerably. When he arrived at the Gare de Montparnasse, he brought with him a stack of pictures, virtually all of which were painted in monochrome blue. The subject matter was an almost unbearable world peopled with figures of starving mothers and children, drunkards, beggars and wretches of all kinds. The bodies were elongated into stiff, cramped poses; the light effect was nothing less than apocalyptic. Bathed in a chilling, spectral blue, we are treated to such dismal spectacles as *The Blindman's Family* (1903), *Wretches by the Seaside* (1903), and *Celestina* (1904), which shows an old, embittered procuress whose one remaining eye is veiled by a cataract.

There has been much speculation about the meaning of this blue. The actual reason is simple enough: Picasso had come across a cheap stock of cobalt blue pigment and, being unable to afford other paints, made do with what was on hand. The Swiss psychologist Carl G. Jung, however, disapprovingly reviewing the painter's retrospective in Zurich for the *Neue Zürcher Zeitung* in 1932, saw it as a sign of incipient «psychic dissociation» and even schizophrenia. Picasso, famed for having always intensely scrutinized his own face, in 1901 painted a full-length *Self-portrait* which showed him bearded and with features so gaunt that he was almost unrecognizable. The image of a wounded, «black and blue» soul comes easily to mind. All rationalizations aside, the Blue Period can indeed be taken in its figurative sense, as a mortification of his being on all levels.

The Bateau-Lavoir, a rickety, makeshift studio complex in Montmartre had been given this name by Max Jacob because of its

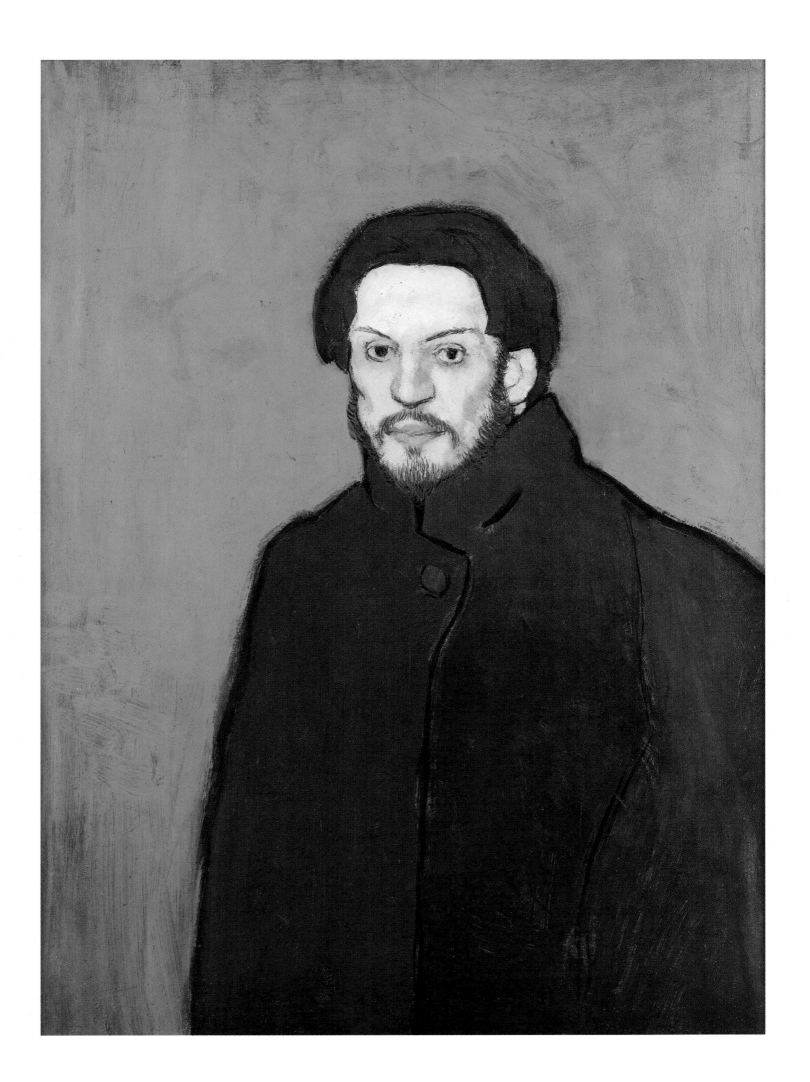

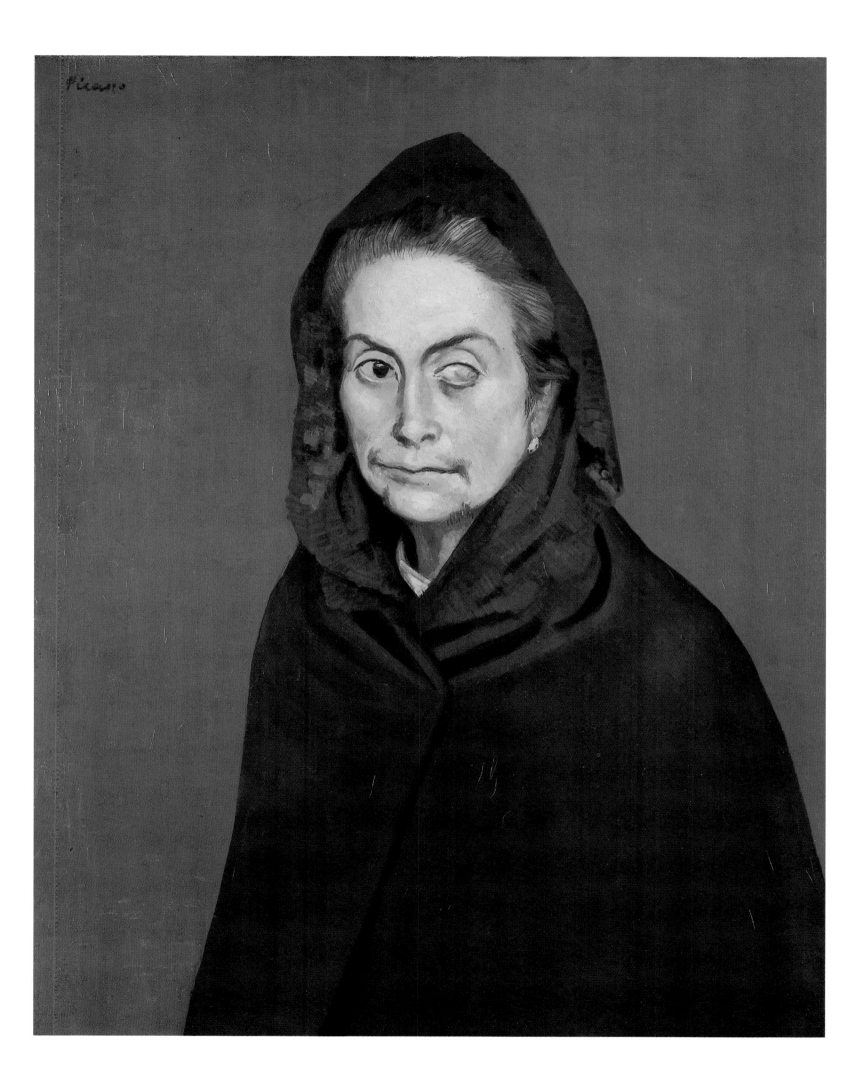

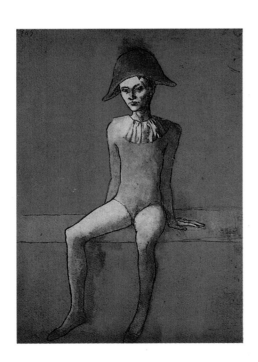

resemblance to the laundryboats that lined the riverfront in those days. Built on a steep slope, its rue Ravignan entrance had only a single story while at the rear it plunged down four stories. Its occupants, mostly down-and-out artists and poets, shared a single common faucet in the stairs: there was no gas, electricity or heating, and the wind whistled through the ill-fitting plank walls.

Picasso had a fairly roomy studio with an alcove of sorts in which he could store his materials, and which he and his friends ironically christened «the maid's room.» In order to paint undisturbed, he worked at night, holding a candle or oil lamp in one hand, his brush poised in the other, standing over the canvas laid flat on the ground. The results were these haggard, dismal and aggressive paintings.

The pictures of the Blue Period went well beyond the sphere of Picasso's immediate concerns and material condition, even if, in certain respects, they gave expression to them. Along with other artists, like Matisse and Bonnard, he shared a passion for painting, but unlike them, painting for him was a means to capture the absurdity of the human condition, in the spirit of Goya and Nonell. What was involved was not some facile *misérabilisme* or voyeurism, but a real social and metaphysical *concern* which was to motivate his art throughout his career. As for the charge of schizophrenia advanced by the Zurich psychoanalyst on the grounds that blue was the dominant colour in the paintings of the psychotic, it should be levelled not at Picasso — whose work displayed a remarkable creative coherence and power — but at the twentieth century as a whole, which has given sufficient signs of a general spiritual disintegration.

As many authors have pointed out, stylistic changes in Picasso's work were often linked to the arrival of a new woman in his life. He had barely settled in at the Bateau-Lavoir, when, during a flash summer storm, he met the statuesque Fernande Olivier. Having just rescued a kitten from the downpour, he presented it to the young woman as a gift as she was drawing water from the common faucet. Soon, the beautiful Fernande became the focus of his preoccupations. He won her over and proudly displayed her at his side when he went to Azon's and Vernin's, the two restaurants frequented by the Montmartre Bohemians. She was also a welcome change from the shady models who made the rounds of the artists' studios, or the prostitutes who had been virtually his unique sexual fare until then.

His painting, like his life, veered from blue to rose. This is not to say that Picasso ever painted truly happy subjects — except perhaps many years

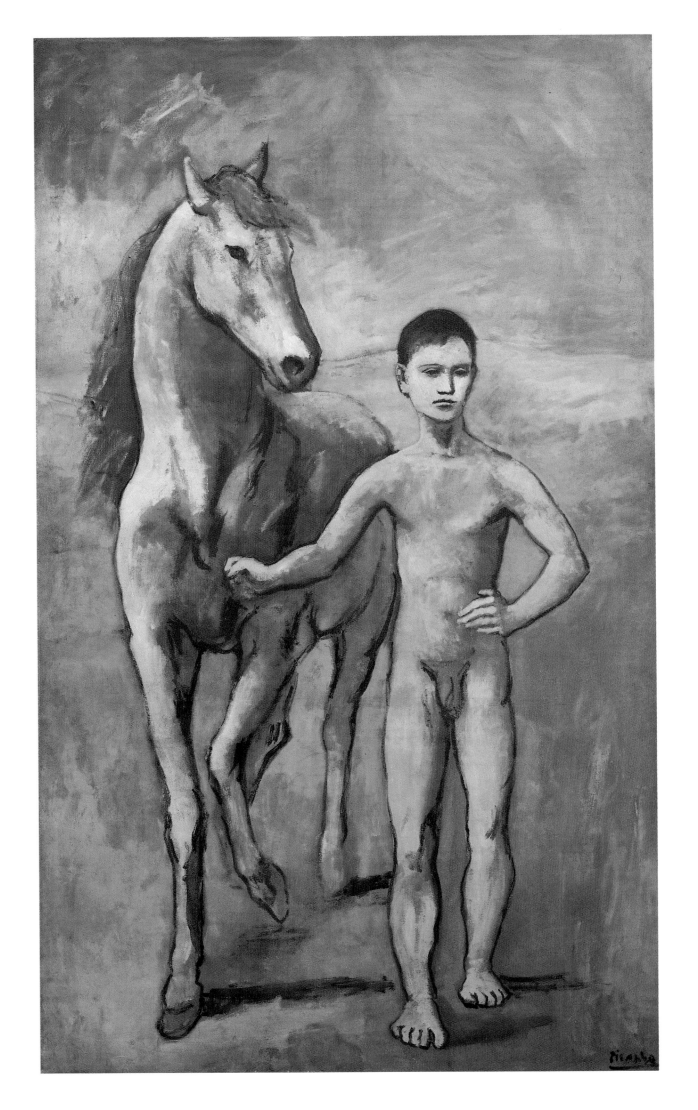

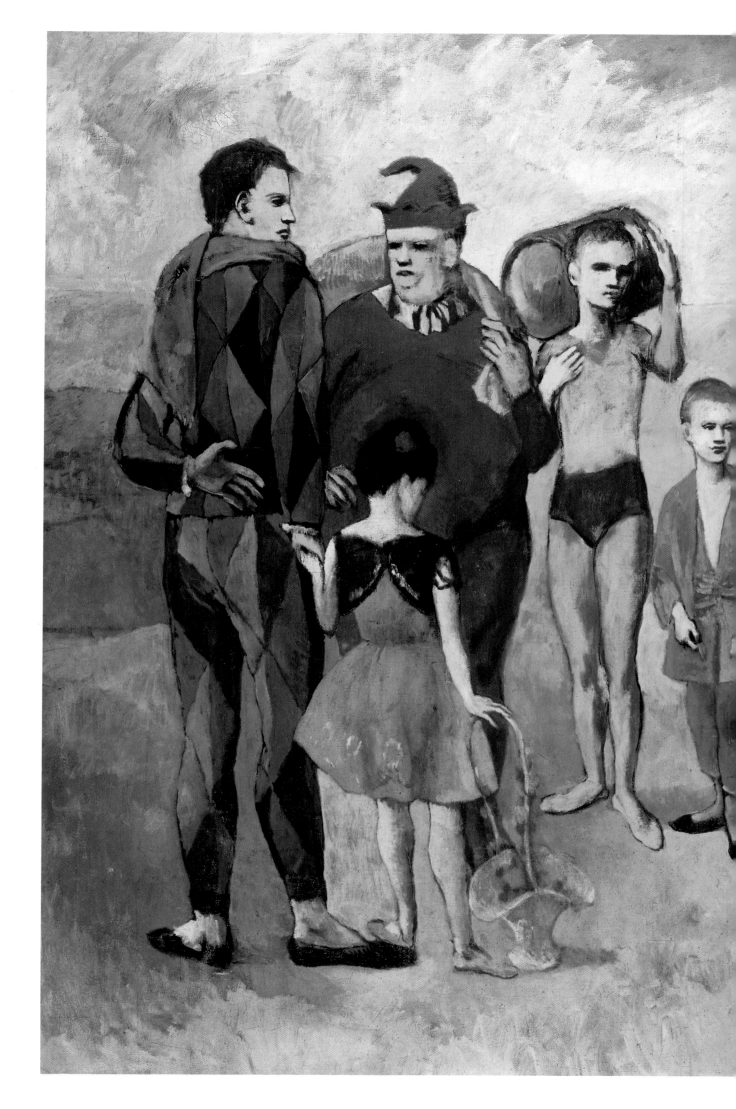

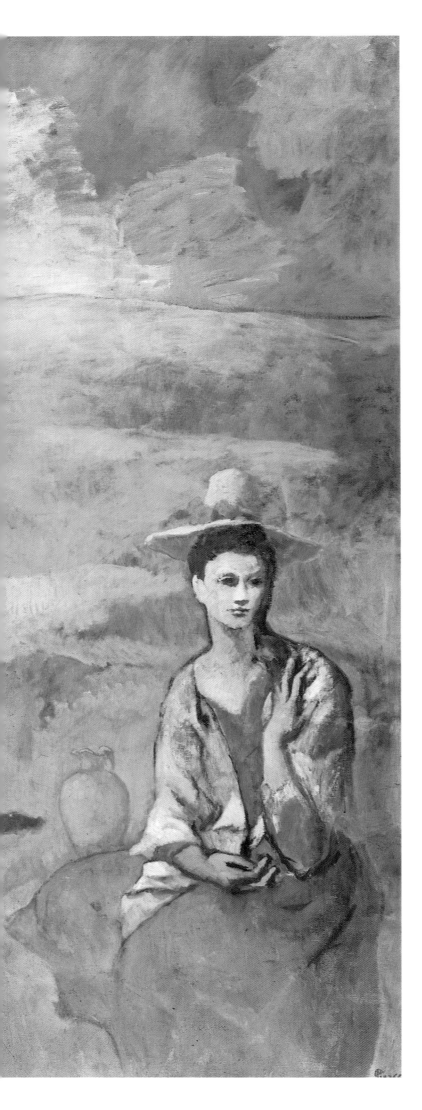

FAMILY OF SALTIMBANQUES

Paris, 1905, oil on canvas,

212.8 x 229.6 cm. (84 x 90 in.)

Washington D.C., National Gallery of Art,

Chester Dale Collection.

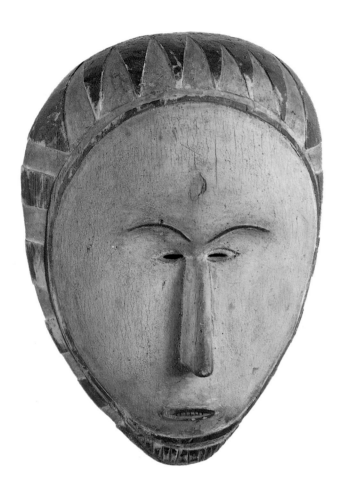

FANG MASK, Gaboon

Painted tropical wood, 42 x 28.5 x 14.7 cm.

(17 x 11 x 6 in.)

Paris, Musée national d'Art moderne.

PORTRAIT OF GERTRUDE STEIN

Paris, winter 1905-1906, autumn 1906,

oil on canvas, 99.6 x 81.3 cm. (39 x 32 in.)

New York, The Metropolitan Museum of Art.

later, when he met Françoise Gilot, who was in her twenties when he was in his sixties. At any rate, he swung over from the world of the damned to the more colourful and lyrical one of the saltimbanques, the circus people who were the natural brothers and sisters of poets and painters.

He was himself a passionate circus-goer and could be seen almost every evening at the Médrano Circus, enjoying his favourite pastimes: laughing at the clowns, marvelling at the acrobats tumbling in the spotlights, and breathing in the somewhat heady smells of the animals. The main subjects of his drawings, watercolours and paintings became muscular strong-men lifting young girls, children balancing on balls, and bareback riders poised on prancing horses. The *Acrobats*, a large-format picture featuring six figures and painted in 1905, presented a initial synthesis of his explorations.

The years of poverty and hardship were now over as Gertrude Stein, the American writer, and her brother Leo Stein, who together presided over a distinguished salon in their rue de Fleurus apartment, began to purchase one painting after another. Another keen collector was Sergei Ivanovich Chtchukin, who made regular visits from Moscow.

Then, in the following year, after his stay in Gosol, his style changed once again: Picasso eliminated the anecdotal references and focussed solely on pictorial concerns. The results were both more primitive and more direct. We can see examples of this in the famous *Portrait of Gertrude Stein* (1906), as well as in the many nudes and close-up heads of men and women that marked the decisive transition to the *Demoiselles d'Avignon*. Gertrude Stein recalled that she had had to endure no less than ninety sittings in his freezing studio, while Fernande entertained her by reading from La Fontaine's *Fables*. The story also goes that, in the end, he erased the face entirely and painted it all in one go in the sitter's absence.

If we look at this portrait closely, we can see that the handling of the face is quite different from that of the more softly-modelled folds of the dress, scarf and hands. The face is built up of distinct planes, or facets, while the hairline, eyebrows and eyesockets, and the curl of the upper lip are neatly outlined. The result was less of a face than a mask. When she saw the finished portrait, Gertrude Stein was unpleasantly surprised and remarked that it was not a very good likeness of her. Picasso retorted by saying that this was no problem, for she would ultimately come to resemble her portrait. And this is indeed what happened in the course of time, as we can see from the photographs taken of the writer in her later years. Picasso the seer had read the future in the lines of her face.

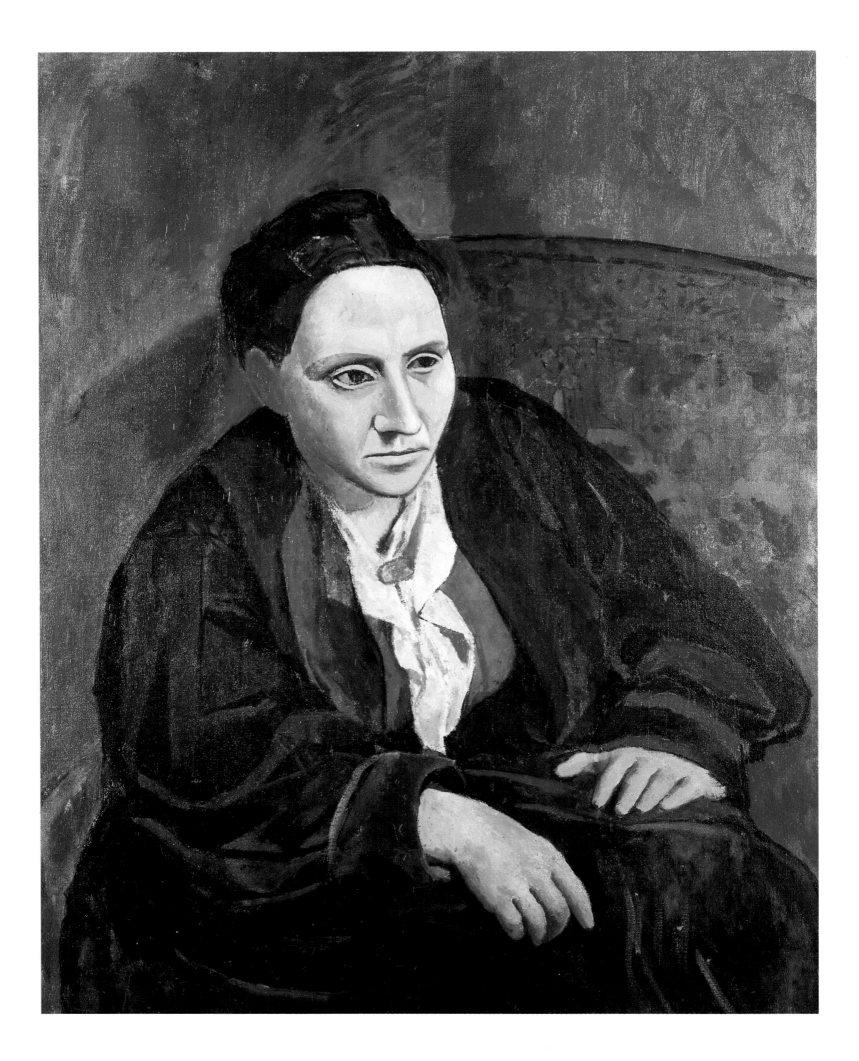

2
THE CUBIST REVOLUTION

INCIDENT IN THE MIDDLE OF THE NIGHT

The next stylistic evolution owed its name to Louis Vauxcelles, the same art critic who had coined the term «Fauvism» three years earlier. In 1908, Georges Braque submitted six paintings to the jury of the Salon d'Automne; all six were rejected because of their hieratism. When Vauxcelles next met Matisse, one of the members of the disapproving jury, he asked him what the rejected works looked like. Matisse replied, «Braque submitted pictures made up of little cubes,» and, to clarify his point, took out a piece of paper and drew two interconnected cubes. When these pictures were exhibited not long afterwards in Kahnweiler's new gallery in rue Vignon, Vauxcelles commented in *Gil Blas*: «Mr. Braque is quite a bold young man... He reduces everything, figures, sites and houses to simple geometric shapes, like cubes.» Cubism was born.

It is somewhat surprising that this esthetic development was first associated with Braque rather than Picasso, when we recall how vehemently the former had reacted to the Demoiselles d'Avignon just one year before. Picasso, moreover, had meanwhile further progressed along this path: he had just painted a series of pictures representing the Halatte Forest as compact masses of green foliage, and thus clearly

FRUITS AND GLASS

1908-1909, oil on canvas,

27 x 21 cm. (11 x 8 in.)

New York, The Museum of Modern Art,

John Hay Whitney Collection.

inaugurated his own Cubist investigations. Braque, for his part, had experienced the full brunt of the Cézannian revolution that summer at l'Estaque, near Marseilles, where his precursor had painted some of his most powerful works. To the extent that the *Demoiselles* owed a great deal to the Large Bathers, Braque had first been subjected to Cézanne's influence through them, and vice-versa.

Was Picasso offended at having been denied recognition for this stylistic invention? Most of his biographers maintain a tactful silence on this point. Many years later, however, in a ruthless barb that left no doubt as to who had worn the pants in the Cubist family, Picasso declared: «Braque was my wife... the woman who loved me the most.» Indeed, by 1908, he had a considerable artistic production behind him, while Braque, one year his junior, had only a few paintings to his credit, mostly done in the Fauve style. But Braque, having been trained as a decorator and being of a more moderate temperament, proceeded in a more circumspect manner and played the role of a regulator. In the Cubist adventure, cartesian ponderation was confronted with the tragic sense of life. The die was cast: in a collaboration that remains unique in the annals of art, over the next six years right up to the outbreak of the First World War, Cubism was to be the work of these two men.

Now, just because the still-life elements in Picasso's paintings – pitchers, fruit and bowls – consisted of assemblages of geometric volumes such as cylinders, cones and, of course, cubes, it would be mistaken to reduce the principle of Cubism to a mere simplification of pictorial forms. As with Cézanne, what was at stake above all was a titanic struggle with the world of objects. We will return to this point in due course.

Generally speaking, many Cubist compositions were inspired by such simple phenomena as the transparency of glasses and the refraction of light broken up by the glass carafes on tables in the cafés where the Montmartre artists met in the evening. Other familiar themes were landscapes, faces, and musical instruments such as violins, clarinets, mandolins and guitars, which Picasso sometimes played. After a short, so-called Cézannian phase in 1908-1909, in which forms powerfully asserted their presence, the formal elements disintegrated as the artist depicted simultaneous views of objects seen from the front, sides, back, above and below, replacing the central perspective system used since the Renaissance by a multi-levelled, non-rational space. This led to the Analytic Period, which began in 1910, and it was followed by the final

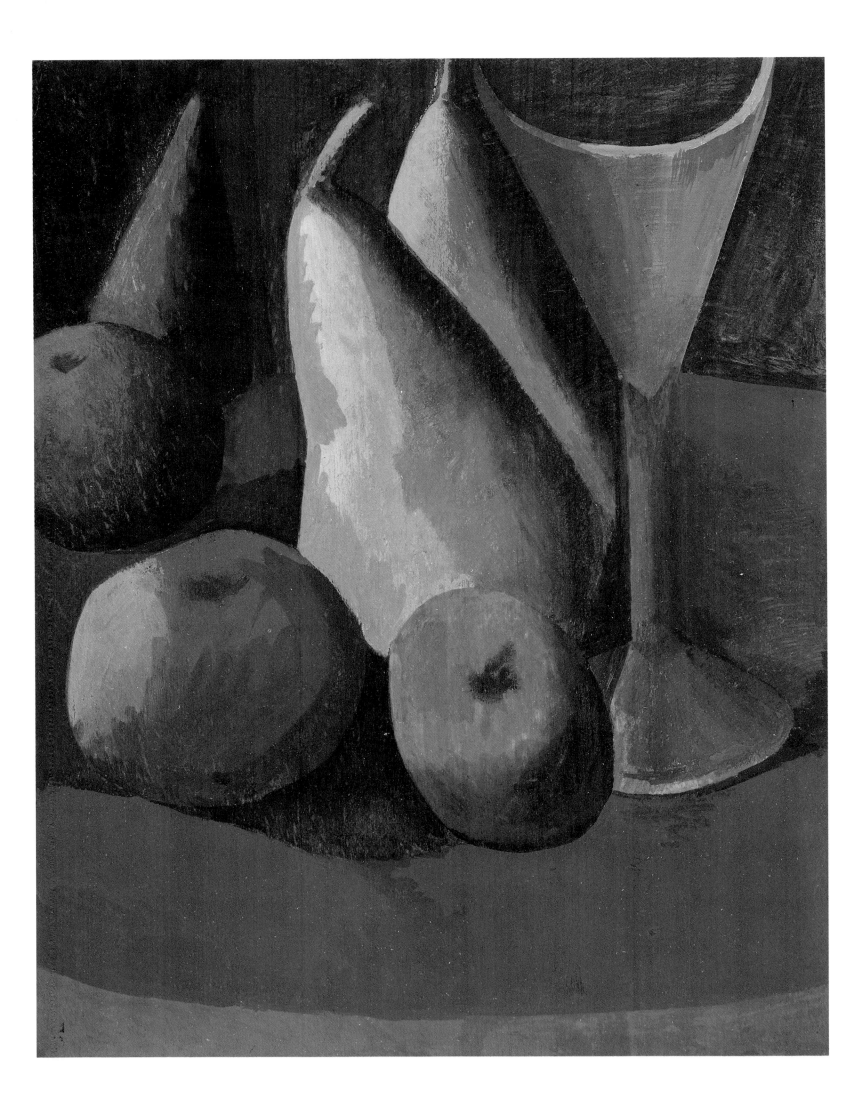

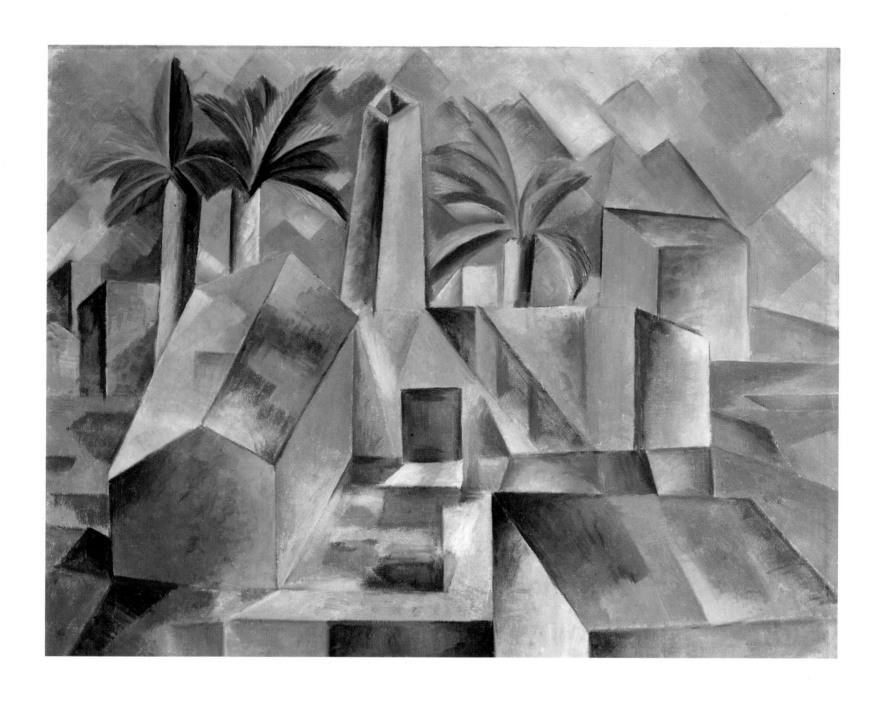

BRICK FACTORY AT TOROSA (THE FACTORY)

Horta de Ebro, summer 1909, oil on canvas,

50.7 x 60.2 cm. (20 x 24 in.)

St. Petersburg, Hermitage Museum.

PORTRAIT OF AMBROISE VOLLARD

Paris, 1910. oil on canvas,

93 x 66 cm. (37 x 26 in.)

Moscow, Pushkin Museum.

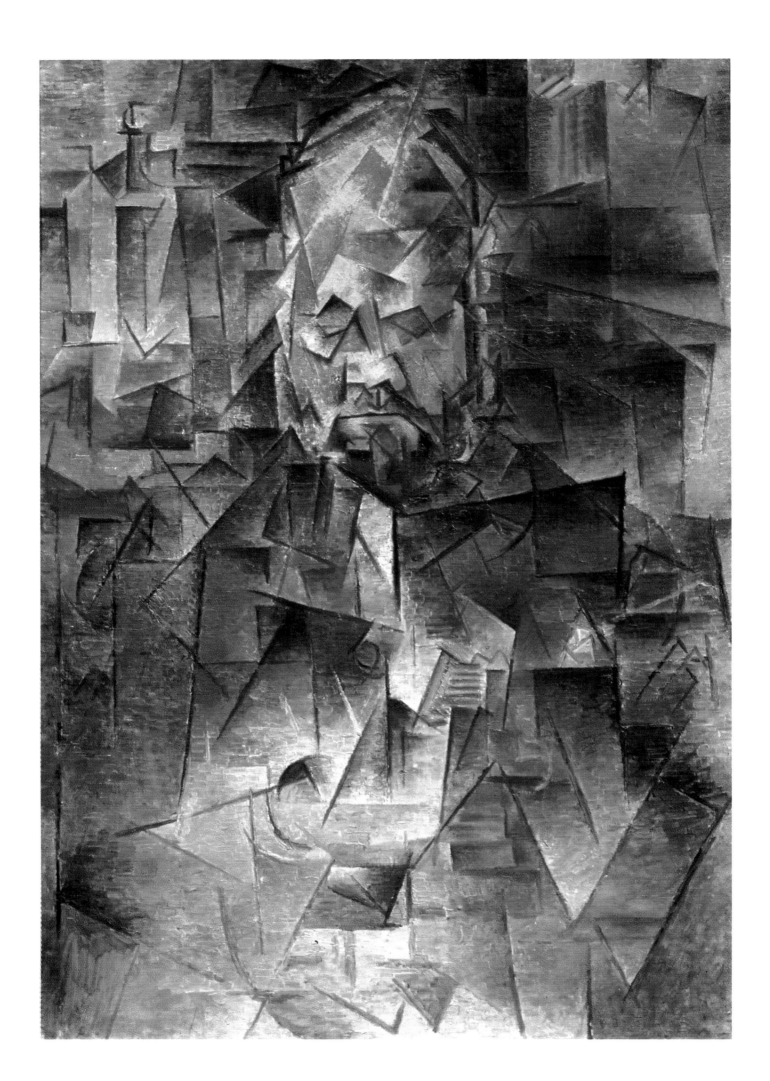

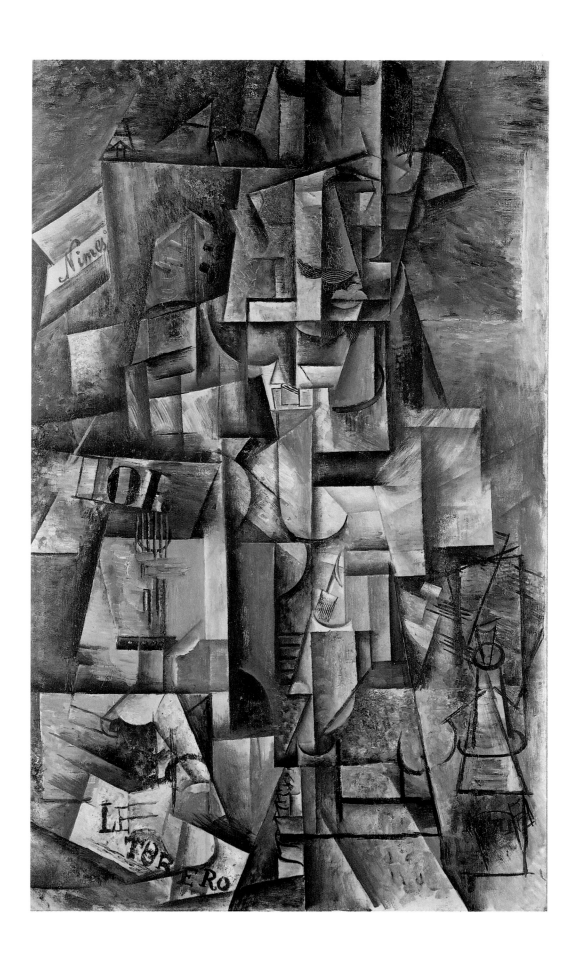

Hermetic Period of 1911-1912, when all cues to the visual reading of the forms and spaces were eliminated.

The process as a whole may be compared to the relation between theatre and film. On the stage, the action takes place in a single, fixed space, as in a traditional painting. In film, however, the viewpoints are constantly changing, and a person or object can be shown successively from afar, from middle distance, or close up, depending on the position of the camera. Unlike a Cubist picture, however, a film is characterized by a temporal dimension and presents the different shots and scenes sequentially; that is, without simultaneously cross-cutting and overlapping.

The progressive dematerialization effected by Cubist cross-cutting can be seen by looking at a chronological series of paintings: the still life Fruits and Glass from 1908 is noteworthy for its concision and massiveness; *Houses on a Hill* (1908) strikes us by its spatial disarticulation; then there is the *Portrait of Ambroise Vollard* (1910), which seems to be comprised of cristalline splinters that score the sitter's features, exploding them across the canvas and leaving only a Socratic figure with heavy-lidded eyes; finally, there is a work like the *Aficionado* (1912), in which there is little of the subject left to be identified: only the block-letter inscription «LE TORERO» at the bottom of the (de)composition gives a clue as to its meaning and orientation in space.

One of the most eloquent texts written about this famous movement came from the pen of Jean Paulhan twenty years ago[1]. He tells of an experience that he had late one night in the studio which he shared with his wife and which served jointly as their office, dining room and bedroom. When he returned at around two in the morning, the bedside lamp was out. To avoid awakening his insomniac wife as soon as he entered the room, he turned the top-light on momentarily before groping his way to the sleeping-alcove at the rear of the studio. Suddenly, the furniture that stood in his way became very hostile: the table jabbing him with its corners, the dresser eluding his grip, and even the typewriter ready to clatter its keys at the slightest touch. He felt himself surrounded by a world of bristling objects, full of unexpected edges, cavities and points.

Paulhan goes on to say that his wardrobe and bookcase stood before him like a barricade of columns and arches. At the end of his laborious crossing of the otherwise familiar room, he suddenly had the

1. Jean Paulhan, *La peinture cubiste*, Tchou, Cercle du livre précieux, Paris, 1970.

strange feeling of having just walked through the space of a modern painting, of having gone into and out of a painting by Picasso or Braque.

There has probably been no better description of the tactile content of a Cubist painting. Although they are related, the senses of sight and touch function independently. There is a well-known test which consists of holding an everyday object – pencil, lighter, bunch of keys – in the hand and trying to identify it with the eyes shut. The gradual discovery of its identity through touch alone is not the same experience as seeing it at a single glance. Moreover, the sense of sight necessarily operates at a certain distance from the objective world: classical perspective, which posited the painting as a window open onto the world, was unable to represent things seen from close up. All the old masters, from Piero della Francsca and Tintoretto down to Ingres and David, represented no more than one among many possible ways of slicing up spatial continuum.

Not realizing this, Cézanne's contemporaries accused him of clumsiness: even admirers such as Huysmans ended up wondering if he didn't suffer from some visual defect. Nevertheless, the French artist persevered in trying to capture perceptions as they arose, representing reality as it was registered not just by the eye, but by the body as a whole.

Too little has been made of the fact that Cézanne devoted a lifetime to depicting his favourite childhood haunts: the Montagne Sainte-Victoire, the Bibemus quarry, the ruins of the Château Noir. Try to prevent a child from climbing trees, clambering up blocks of stone, or scraping its elbows and knees. The striking thing about the photographs of these sites made from the angle adopted by Cézanne for his paintings is their uncompromising regularity. If he distorted classical linear perspective, it was simply because it was unable to express his deep sensibility. The trees, rocks and bathers affected Cézanne. The Provence depicted in his paintings was neither abstract, nor awkward, but apprehended with an unprecedented closeness, from that point where tactile perception takes shape and develops into vision.

Cézanne died in 1906, at the age of seventy-seven, and the Cubists extended what he had begun, probing ever more deeply into the sources of perception. The sense of touch informs us in terms of blocks, planes and edges. Unlike vision, which presents us only with the external facade of objects, touch decomposes and reassembles them. This insight, first explored by Cézanne at the turn of the century, was going to rock the foundations of the art of painting.

MAN WITH A GUITAR

Paris, autumn 1911 and 1913,

oil on canvas,

154 x 77.5 cm. (61 x 31 in.)

Paris, Musée Picasso.

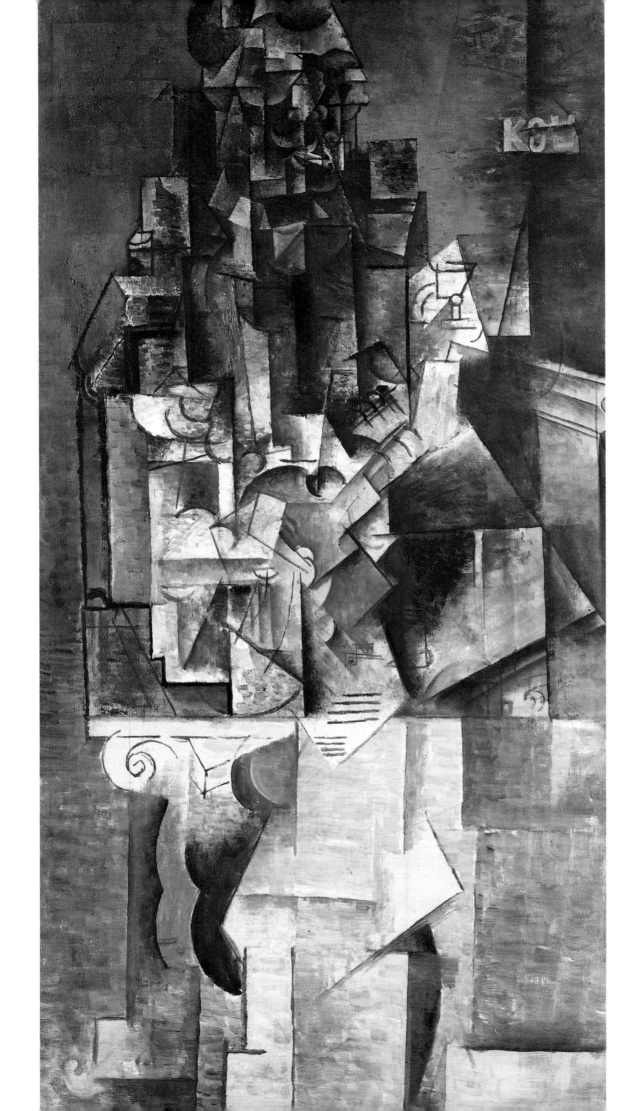

But the scope of the Cubist undertaking and the seriousness with which it was conducted – Braque spoke of working «like two mountain-climbers roped together» – did not prevent the bohemian life from following its merry course. There is, for instance, the story of the famous banquet held in honour of Henri Rousseau, one of whose works Picasso had just purchased for the grand sum of 5 francs. His studio at the Bateau-Lavoir was decorated for the occasion with leaves, garlands and banners, and the whole avant-garde band was present: Leo and Gertrude Stein, Fernande Olivier, Marie Laurencin, André Salmon, Apollinaire, and many others. Rousseau made a solemn entrance escorted by Apollinaire and took his place on a makeshift throne consisting of a chair perched on a crate.

This is not the place to go into the details of the wild proceedings that ensued and which scandalized the entire neighbourhood. Suffice it to say that, after having played a tune of his own composition on the violin and sung his favourite song, «Ouch, ouch, my teeth are killing me,» and after having shed tears of joy, the Douanier collapsed and fell sound asleep oblivious to the hot wax which dripped from a lantern, forming a steadily growing lump on his head. Above him, on a large banner, could be read: «Honneur à Rousseau!»

WHAT IS A THING?

At that time, on a more scientific level, there was much talk of quanta, special relativity and n-dimensional space. Until then, it had been believed that the deterministic laws that governed the visible world also applied to the infinitely large and the infinitesimally small. Planck and Einstein demonstrated, however, that this was not the case on the scale of the atom and the universe. Picasso, of course, was not a scientist, even if, as I have already mentioned, he long harboured the ambition of establishing painting as a science. Kandinsky, for his part, said that the theory of atomic fission made such an impression on him that, while he was painting at Murnau in the Bavarian Alps, he almost expected to see the rocks suddenly rise into the air and dissolve into nothingness. When we consider the random aspect of Cubist paintings of the Analytic Period, there is every reason to suppose that such theories had a similar impact on Picasso.

To be sure, the progress of physics had not yet reached the dizzying heights of Heisenberg, who postulated the Principle of Uncertainty in

1927. But, as the British physicist and astronomer Eddington noted, quantum theory had the immediate effect of overthrowing the traditional concept of the material universe. Using his writing table as an example, he observed that this table, or any other object, was now characterized by a dual nature: on the one hand, table n°1, the everyday, familiar table; on the other, table n°2, a «scientific» table composed, not of wood, but of a void randomly traversed by high-velocity electrical charges.

Heidegger, after quoting Eddington's example, raised the question: «What is a thing?»[1] and then drew the obvious conclusion that the discovery of the atom confronted modern man with an unprecedented situation. For the first time in history, the perception and knowledge that one could have of reality were no longer one and the same thing. Small wonder that the repercussions of this epistemological revolution had such an impact upon the world of the arts.

Taking a closer look now at still lifes such as *Fan, Salt Cellar and Melon* (1909), *Glass and Lemon* (1910), *Pie, Cup and Coffee Pot* (1911), or *Violin and Grapes* (1912), it is easy to understand why each object appears to be opening inside out, disintegrating and spreading across the picture plane in new configurations. The object was no longer in the object, so to speak, but at the antipodes of itself. Each thing was no longer in its place, nor was there indeed any longer a place for each thing, as had been the case in traditional painting, for there were no more things to speak of. As in quantum physics, all that remained were quanta, or «parcels» of forms. The result was a reinforcement of the dissociations proceeding from touch and a further deviation of visual perception.

Apollinaire, who was eventually won over to Cubism despite his initial disapproval of the *Demoiselles d'Avignon*, came unwittingly close to Husserl's phenomenology in his explanations. Indeed, in an article written for the Berlin review *Der Sturm*, he wrote: « Putting it as precisely as possible, Cubism is an art which seeks a new composition based on formal elements derived, not from visual reality, but from conceptual reality.» To further clarify his point, he added: «The legitimacy of such a form of painting is beyond question. Everyone can easily understand that a chair will still have four legs, a seat and a back no matter from which angle it is viewed, and that if one of these elements is eliminated, then an essential element of its reality is omitted.»[2]

1. Martin Heidegger, *Die Frage nach dem Ding. Zu Kants Lehre von den Transzendentalen Grundsätze*, Tübingen 1962.
2. Quoted in Robert Delonnay and Pierre Francastel, *L'art abstrait*, S.E.V.E.P.E.N., Paris 1957, p. 261.

Apollinaire emphasized the importance of the conceptual component over visual or tactile perception, because any particular thing, being composed of a restricted number of «profiles» – in the case of a chair: four legs, a seat and back – is essentially a mental construction. This was nothing less than a frontal attack against the trompe l'oeil tradition, which had strived to render the descriptive illusion of three-dimensional objects on a two-dimensional surface. In the course of the same article, Apollinaire pointed out that when a town was represented in Medieval painting, it was not restricted to what could be seen from a single viewpoint, but included the town gates, towers and even streets, all co-existing in the same pictorial space. And so, centuries before Cubism, painting was a montage, not so much of things seen, as of things known.

This was in 1911-1912 and early 1913. By 1909, Picasso, weary of the bohemian life, no longer lived at the Bateau-Lavoir, but kept on a studio where he could devote himself entirely to painting. Aspiring suddenly to bourgeois respectability, he bought proper tableware and furniture-including a completely superfluous piano – hired a uniformed maid, and settled down to the good life in boulevard de Clichy. In December 1912, he signed an exclusive contract with Kahnweiler, guaranteeing himself a certain degree of material comfort. Was this just his way of confirming his success? Soon after, he left the popular quarters at the foot of Montmartre behind for good and moved across the Seine to Montparnasse.

If anything, Picasso always exercised caution when discussing the ends and means of Cubism. Cubism was not a theoretical movement, unlike Futurism, which exploded onto the artistic scene with the manifesto published by Marinetti in the *Figaro* of 20 February 1909 – before a single Futurist picture had even been painted. And yet, while they left the theorizing mostly up to others, Picasso and his partner definitely had some «thoughts» of their own on the subject. We known this from Braque's recollections of this period of close collaboration. In Cubism, the relationship between subject and object were inverted in the sense that the subject became all important while the object virtually disappeared. Cubism shattered the image of an objective world and put an end to the pictorial reign of the solid, in the sense of entities possessing a closed, measurable volume. Not since the Quattrocento in Florence, had such a radical pictorial revolution taken place.

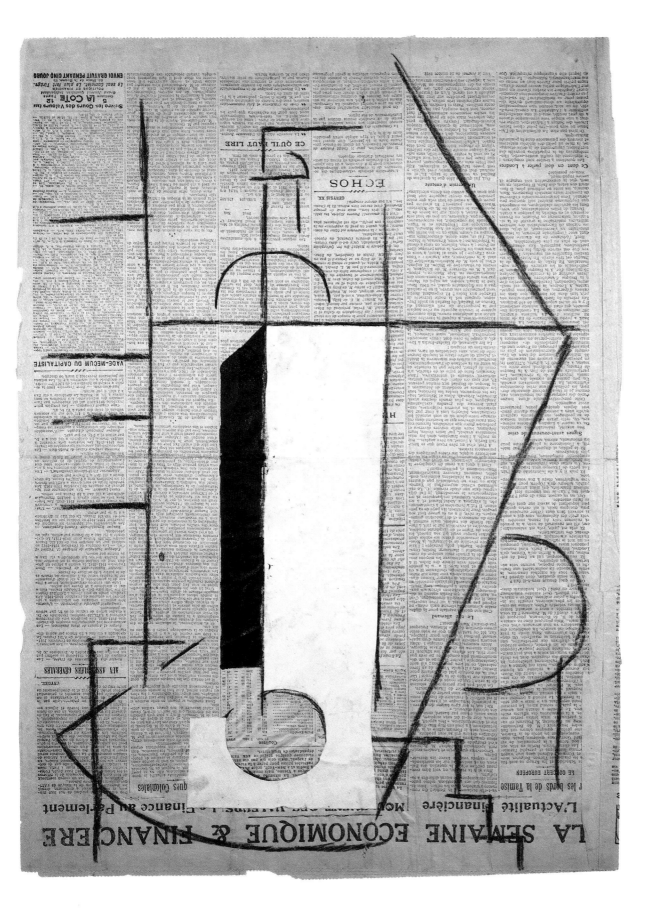

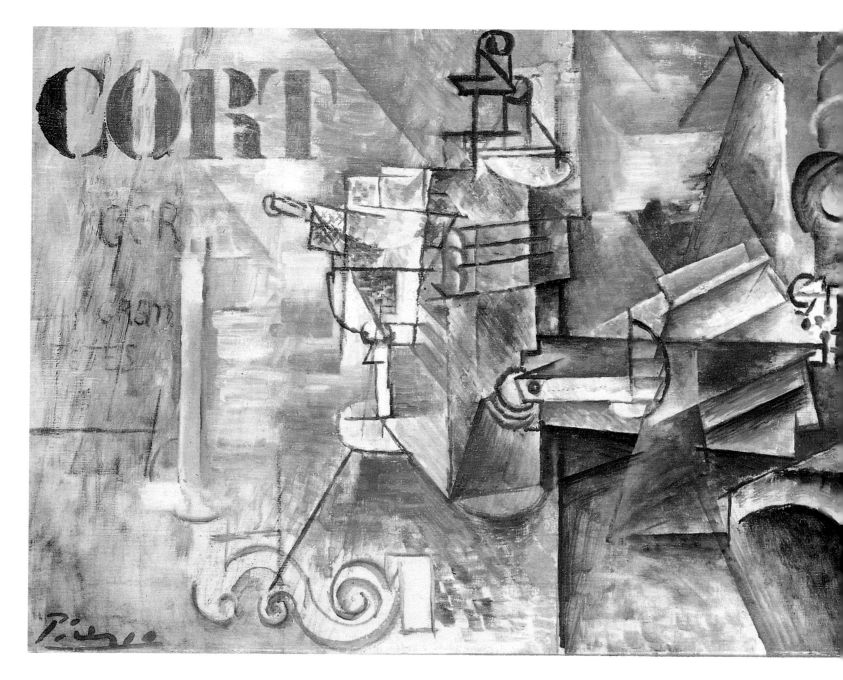

PROVERBS IN PAINTING

In the works of the Hermetic Period, words, or fragments of words, began to play an ever more prominent role: «TORERO,» as mentioned above; the fragment «L'Indep» written in Gothic script imitating the masthead of the daily Indépendant; «Café,» «Vieux marc,» «Cort» (probably short for «Cortot») written in stencilled lettering; and even phrases or parts of phrases: «Les soirées de Paris,» the name of an avant-garde literary review run by Apollinaire; «Not Ave est dans l'A,» an abbreviation of «Notre avenir est dans l'Air» («Our future is in the Air»), the name of an illustrated weekly that devoted much space to aviation.

These verbal elements might have been casual references to such classics as Raphael's *School of Athens*, in which Plato was identified by a copy of the Timaeus tucked under his arm, and Aristotle by a copy of the Ethics – whose title is half hidden by his left arm – except that Picasso's inserts feature no cultural associations.

The words and phrases, or fragments thereof, in the pictures of Picasso and Braque's Hermetic Period could be explained partly by a quest for legibility. But they also reflected their interest in all the visual aspects of modern urban life, characterized by the increasing presence of posters, billboards and printed matter of all kinds. These elements expressed the visual discontinuity of the urban landscape in which more

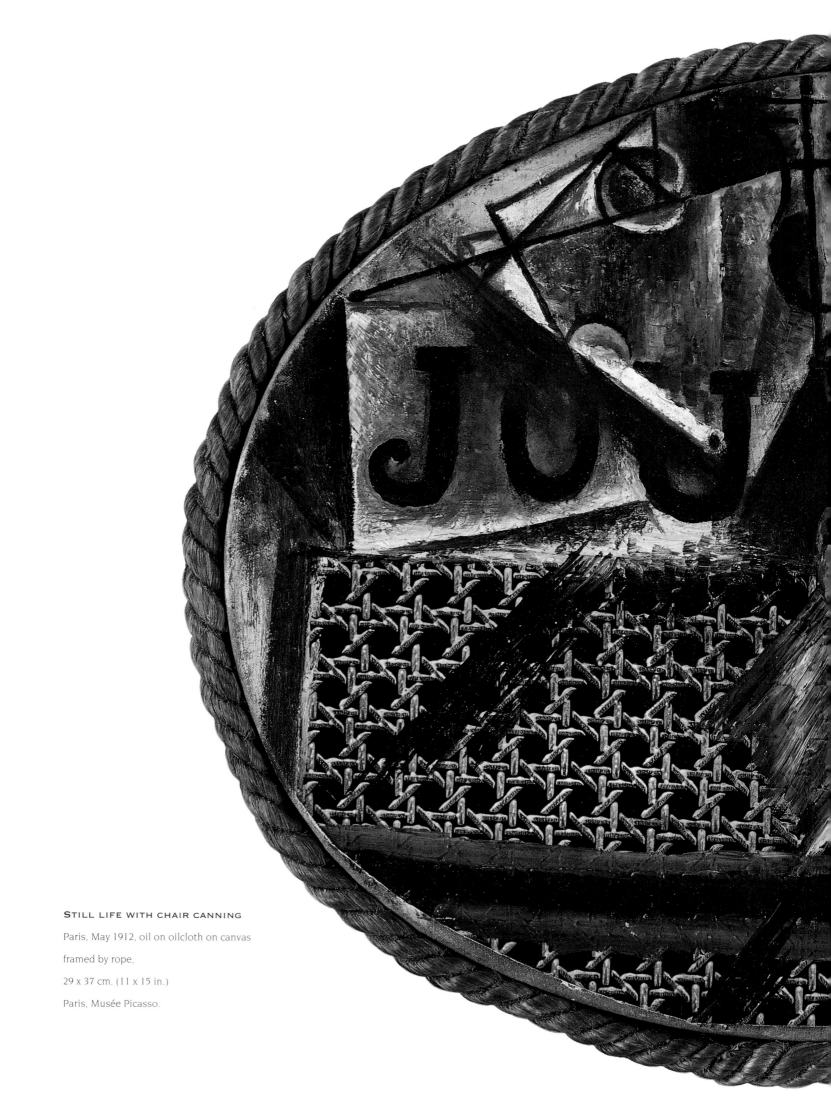

STILL LIFE WITH CHAIR CANNING

Paris, May 1912, oil on oilcloth on canvas

framed by rope,

29 x 37 cm. (11 x 15 in.)

Paris, Musée Picasso.

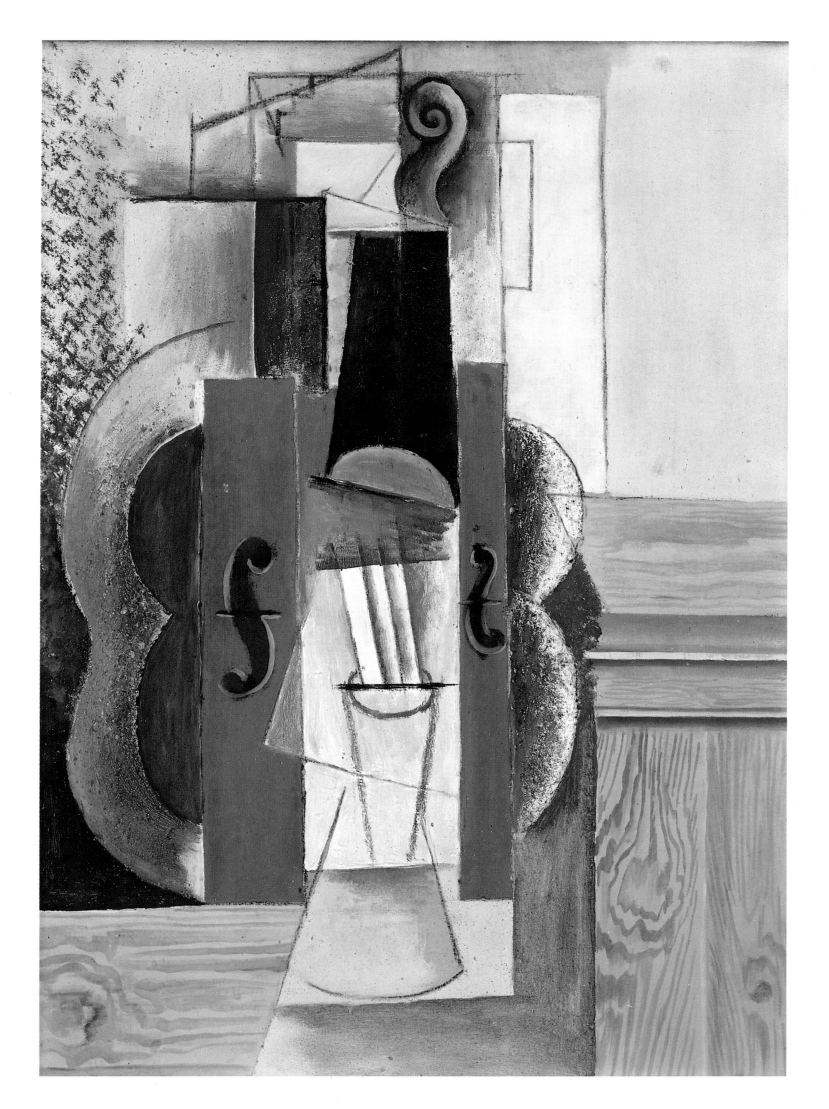

and more people lived, and so brought the Cubists closer to their present-day reality. By the same token, they were a means of introducing a minimum of linguistic coherence by combining two sign systems, one signifying the other, since the crushed, eroded and dispersed objects had been reduced to meaningless pictorial flotsam and jetsam.

Of course, some of these words and phrases may have been purely incidental, as with *Les soirées de Paris*, in which nothing, apart from the presence of a meerschaum pipe similar to those smoked by poets in the literary circles of the day, was related in any direct way to the stated theme. These words and phrases, however, played a no less crucial role, for, unlike Raphael, it was not simply a matter of indicating which figure – the venerable white-bearded man or the man in the prime of his life – was Aristotle and which Plato, but rather of laying the foundations of a new figurative system upon the ruins of an obsolescent one and setting the course for twentieth-century art.

This development became even more evident, during this same period, with the appearance of the papiers collés – the first collages. Tristan Tzara fittingly baptised them «proverbs in painting,» by analogy with the platitudes and puns with which Apollinaire and Cendrars liked to lace their poems. They were simultaneously invented by Braque, who had learned the craft of decorative painting and making imitation wood-grain, and Picasso, who recalled his father's habit of pinning pieces of cut-out and painted paper on his canvases to try out new compositional ideas. The two artists also introduced all sorts of unusual materials in their paintings, including imitation wood and marble, columns of newspaper text, corrugated paper, sheet music and even a packet of tobacco.

One of the first paintings using this procedure was the *Still life with Chair Caning*, a small oval composition executed by Picasso in 1912. At the upper right, we see a glass next to a slice of lemon, and at the upper left, a pipe stem protruding from the letters «JOU» for Journal, a famous daily newspaper of the period, both painted according to the same disjointed spatial disposition developed in Analytic Cubism. But the decisive – and most innovative – element was the piece of oilcloth realistically imitating chair caning, touched up here and there with highlights and shadows, and pasted directly onto the canvas in the lower half of the composition. Apart from the interplay of different spatial planes, there was a confrontation of different degrees of reality; it was more figurative on the whole, but also more ambiguous. The result was a disquieting play between reality and representation.

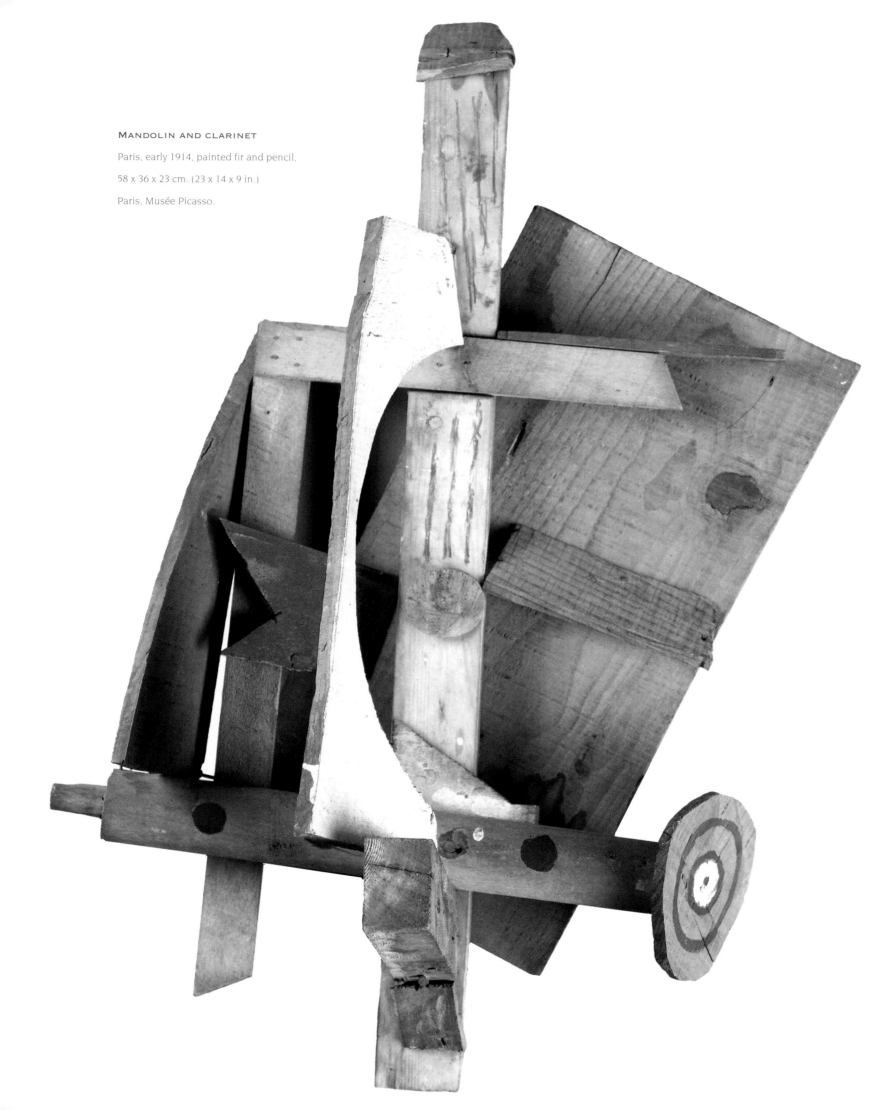

MANDOLIN AND CLARINET

Paris, early 1914, painted fir and pencil,

58 x 36 x 23 cm. (23 x 14 x 9 in.)

Paris, Musée Picasso.

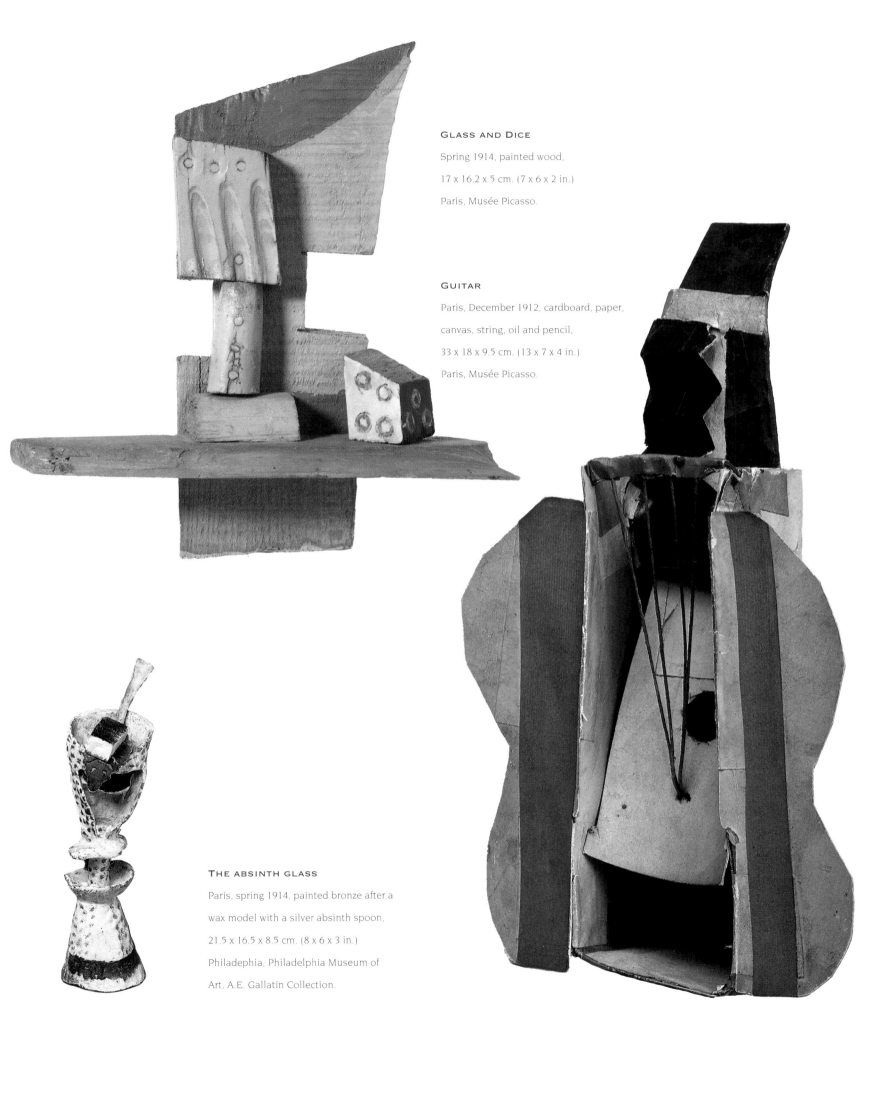

GLASS AND DICE

Spring 1914, painted wood,

17 x 16.2 x 5 cm. (7 x 6 x 2 in.)

Paris, Musée Picasso.

GUITAR

Paris, December 1912, cardboard, paper,

canvas, string, oil and pencil,

33 x 18 x 9.5 cm. (13 x 7 x 4 in.)

Paris, Musée Picasso.

THE ABSINTH GLASS

Paris, spring 1914, painted bronze after a

wax model with a silver absinth spoon,

21.5 x 16.5 x 8.5 cm. (8 x 6 x 3 in.)

Philadephia, Philadelphia Museum of

Art, A.E. Gallatin Collection.

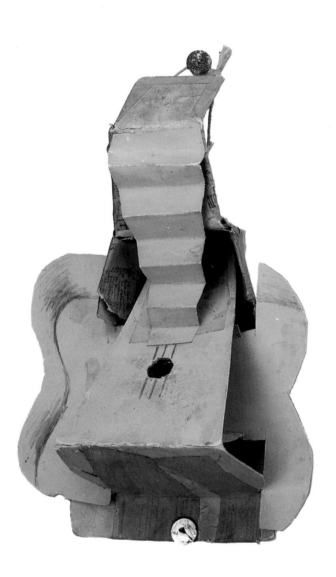

GUITAR

Paris, December 1912, cardboard, paper,

canvas, string and pencil,

22.8 x 14.5 x 7 cm. (9 x 6 x 3 in.)

Paris, Musée Picasso.

While it is true that it takes more than glue to make a collage, the possibilities offered by this new medium seemed inexhaustible. And indeed, countless inventions, innovations and variations were produced during this period – and all with an evident creative jubilation. Picasso not only pasted imitation wood or marble onto his canvases, but also painted fake imitation wood and fake imitation marble, which he deftly combined with pieces of newspaper and wallpaper to keep the viewer's eye constantly guessing. In one picture, *Violin Hanging on a Wall* (1913), he incorporated sand in order to produce textural effects stimulating the sense of touch. In others, he introduced sawn wooden boards to create surface relief. At the same time, he applied pure colours in flat, predominantly rectangular fields.

What was subverted in the general process was not only perspective – which Leonardo da Vinci had called the «bit and bridle» of painting – nor chiaroscuro, which had been linked with the definition of volumes – up to and including their analytical disjunction – but the very homogeneity of what had formerly constituted the art of painting. Even before the birth of Dada, which claimed to destroy art, Picasso demonstrated that it was possible to make works of art out of bits and pieces of paper, cardboard, junk or just about anything!

The *papiers collés* inspired Picasso to create a whole series of musical instruments and objects belonging neither to painting nor to sculpture out of sheet metal, wood or cardboard. This hybrid medium was taken up by Schwitters in his *Merzbilder*, and later by Rauschenberg in his combine paintings, and is still actively practiced as an art form today. Examples of Picasso's creations are the *Guitar with Four Faces* (1912-1913), which has a trapezoidal sound box, and differently oriented sides and neck, like a three-dimensional Cubist canvas, and *Mandolin and Guitar* (1913), which is composed of an assemblage of rough planks and has the savage aspect of a broken toy.

At the same period, Marcel Duchamp was selecting his first ready-mades – for example, an ordinary bottle dryer bought in a Parisian department store – and presenting them as so many sculptures. But his approach was diametrically opposed to Picasso's, for he was raising the fundamental question «What is art?» Picasso, on the other hand, never called art into question. As far as he was concerned, art and life were one, and if he insisted on giving art a shake it was the better to keep it awake. His six painted bronze variations on the Absinth Glass from 1914 were the opposite of a ready-made. Many years later, when he made a

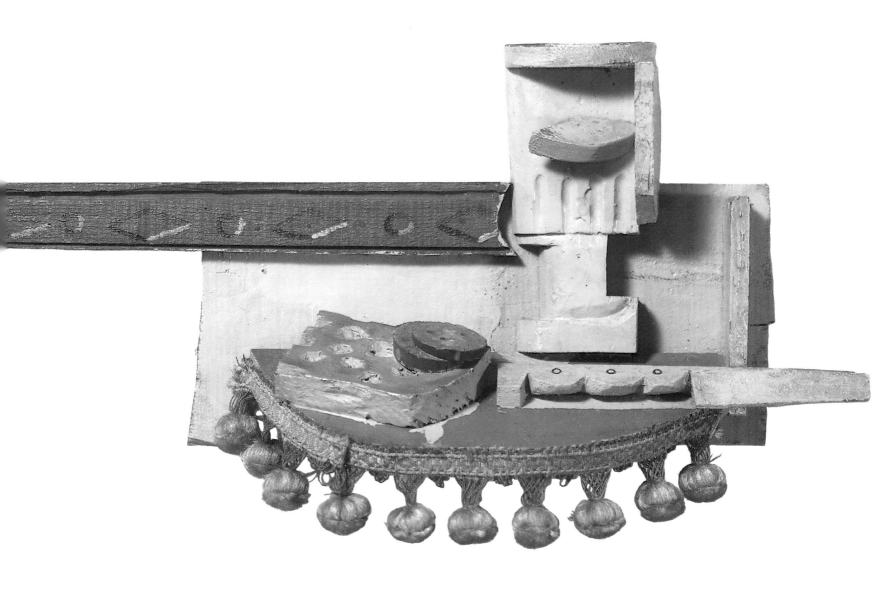

STILL LIFE (THE SNACK)

Paris, 1914, painted wood and trimmings.

25.4 x 45.7 x 9.2 cm. (10 x 18 x 4 in.)

London, Tate Gallery.

bronze cast of his famous *Bull's Head*, consisting simply of a bicycle saddle and handlebars, he confided to Hélène Parmelin that he would have liked to leave it in a gutter so that it could be dismantled by someone in need of these very bicycle parts.

His most accomplished works in this hybrid medium were *Glasses, Bottles and Dice*, also from 1914. A bas-relief from the Still Life series entitled «le casse-croûte» («The Snack»), which shows a slightly tilted, curved surface decorated with trim and on which stood a glass, a knife, a piece of bread and a slice of sausage, all made of painted wood, was not so far removed from Pop Art. Subversion? Not really. Roland Penrose relates how, in the 1960s, he and Sir Kenneth Clark once had to guide Queen Elizabeth II through a Picasso exhibition in the Tate Gallery. They had wanted to avoid the Cubist section, fearing it too provocative for Her Majesty, but she insisted upon seeing it. After having attentively considered the analytic paintings and *papiers collés*, the Queen paused for a long while in front of the still-life relief mentioned above and finally sighed: «How lovely! How I wish I could have done that!»

After the outbreak of hostilities in the first days of August 1914, Picasso, accompanied by a new mistress, Marcelle Humbert, who had replaced Fernande Olivier, spent the summer in Avignon, where they were later joined by Braque, who had been mobilized. Picasso accompanied Braque to the station to see him off to join his regiment, remaining sadly alone on the platform as the train left. He was thirty-three years old, the Cubist adventure had suddenly been interrupted, and a page was being turned.

A GUITAR, A CERTAIN GUITAR

Interrupted, but not over. In the decade between 1920 and 1930, the Abstract painters were fond of pointing out that Cubism logically led to Abstraction, but that Picasso – to his undying disgrace – had never dared to make the necessary leap. It is indeed true that, without Cubism, such painters as Mondrian and Malevich – who immediately felt the impact of the Cubist shockwave – would never have existed, and that Abstraction was one of its possible directions, but these two painters were concerned merely with the formal elements of Cubism. More importantly, both Mondrian and Malevich were motivated by a contemplative notion of painting which led them to transcend the visible, while Picasso was a sort of demiurge who always took a perverse pleasure in playing tricks with reality. In fact, and this is an entirely different

GUITAR

Paris, 1916, oil on canvas,
54 x 65 cm. (21 x 26 in.)
Private collection.

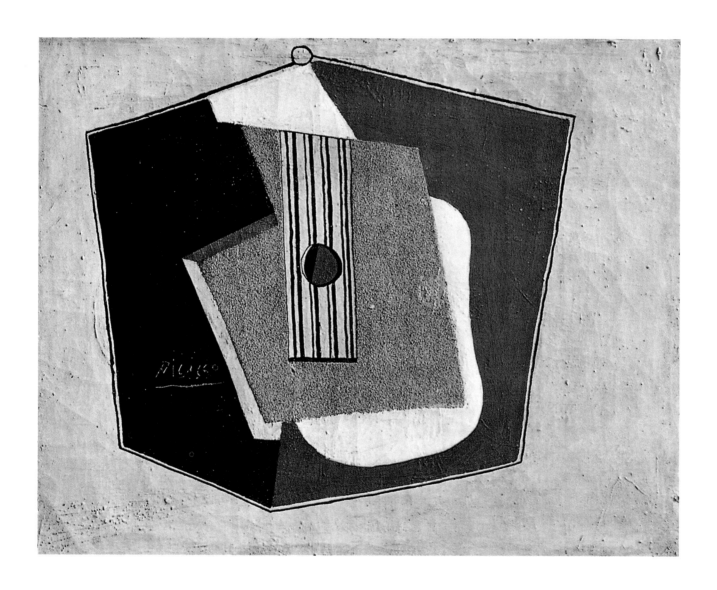

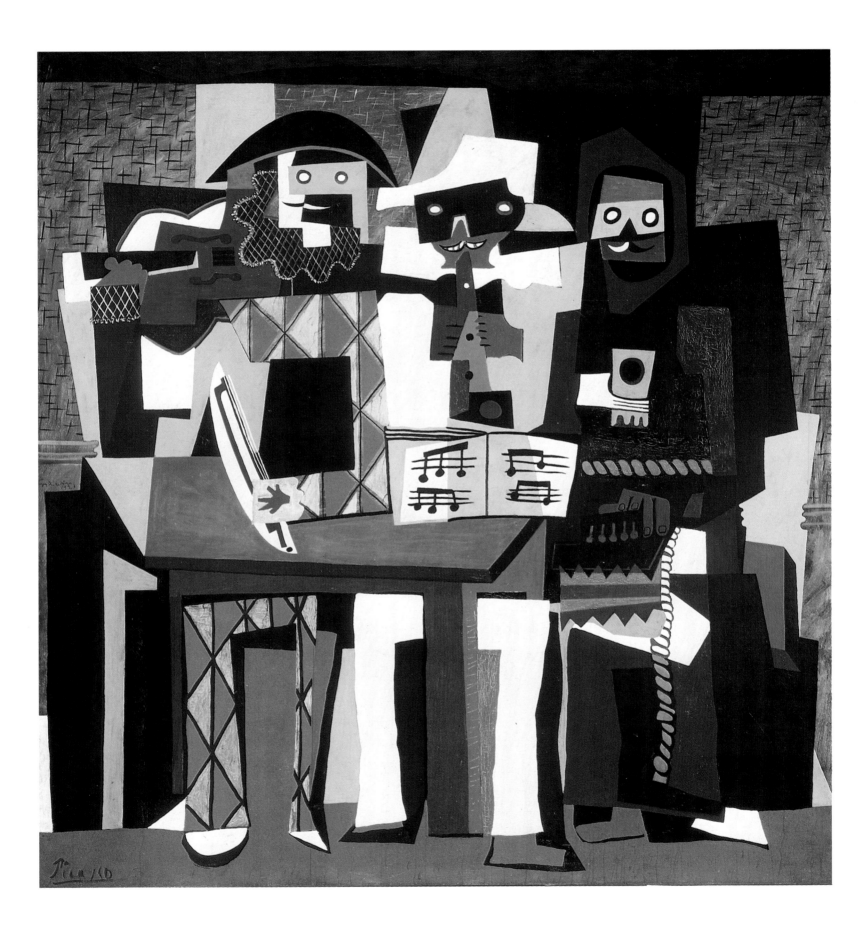

matter, the *papiers collés*, coming hard on the heels of the Analytic and Hermetic Periods, heralded a synthesis which continued to develop and grow in Picasso's work over the next decade.

Maurice Raynal, who was well acquainted with the artist during the Bateau-Lavoir years, pointedly remarked that «up until 1915, Picasso was making guitars into hexagons; starting in 1915, he began turning hexagons into guitars.» The art critic was not simply indulging in facile wordplay, but referring to a specific work from that same year which was composed for the most part of a large, irregular, ochre-coloured hexagon. This work, called *Guitar* and painted in broad fields of flat colour, not only broke away from the decomposition of the objective world, but also from what had remained of chiaroscuro and even vestiges of perspective in the *papiers collés*. As such, it marked the beginning of a new period.

It should be clear that such works were far removed from any attempt to establish a universal geometrical idiom. In any case, the «universal» is almost always invoked when the functioning of an artwork is not readily understood. Juan Gris, a Spanish artist somewhat younger than Picasso who began painting Cubist pictures in 1911-1912, once wrote: «From a bottle, Cézanne would make a cylinder, whereas I start with a cylinder to create an individual of a special type: out of a cylinder, I make a bottle, a certain bottle.»[1] By the same token, in the picture mentioned by Maurice Raynal, Picasso painted a guitar, not just any guitar, but a certain, specific guitar. Far from being an anonymous object, his hexagon, punctuated by a dark-brown hole and four fragments representing strings, existed with a vibrant presence of its own.

But this was still only a prefiguration of the great synthesis that was to come in the years between 1921 and 1926. Excellent examples of this are the two versions of the *Three Musicians*, which are among the artist's unquestionable masterpieces.

Picasso spent the summer of 1921 in a rented villa at Fontainebleau in the company of his wife, Olga, a dancer from the Ballets Russes whom he had married in 1918. They took with them their son Paulo, born in February, in the hopes that the country air would do the frail baby some good. For the last five years, the artist had returned to an approach in which the drawing and traditional technique involved might have led one to believe that, after the bold upheavals and exploits of the first decades of the century, he had calmed down. Thus the rare visitors

1. Daniel-Henri Kahnweiler, Juan Gris, son art, ses écrits, Gallimard, Paris 1968, p. 194.

Opposite

THE THREE MUSICIANS

Fontainebleau, summer 1921, oil on canvas, 203 x 188 cm. (80 x 74 in.) Philadelphia, Philadephia Museum of Art, A.E. Gallatin Collection.

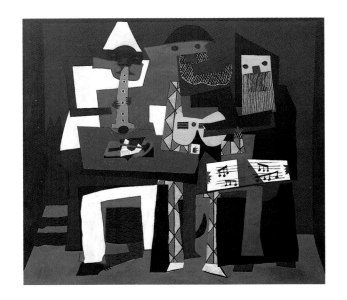

THE THREE MUSICIANS

Fontainebleau, summer 1921, oil on canvas, 200.7 x 222.9 cm. (79 x 88 in.) New York, The Museum of Modern Art, Mrs. Simon Guggenheim Fund.

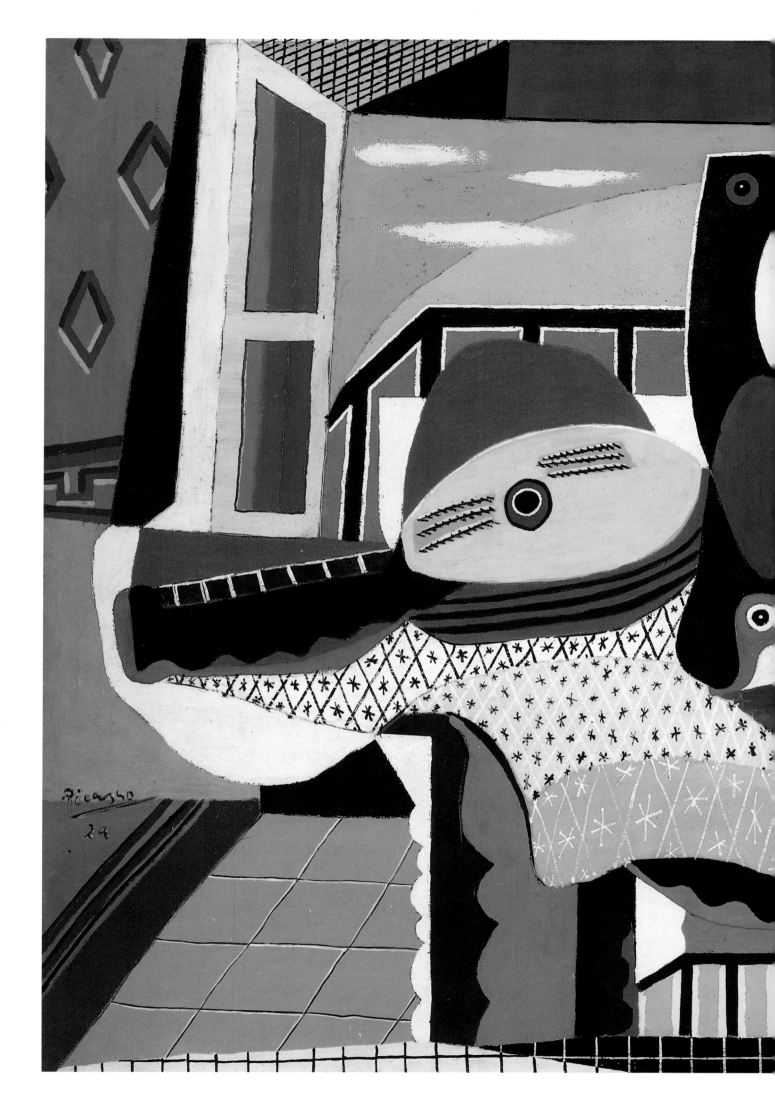

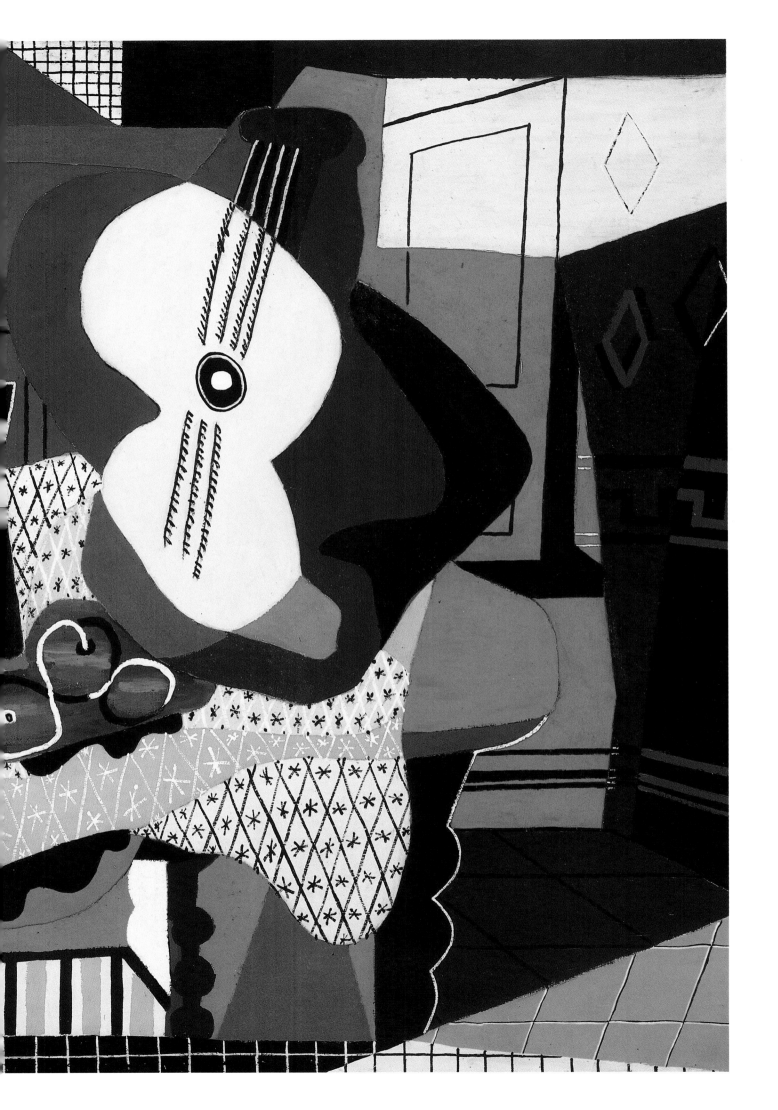

who were admitted into his makeshift studio in Fontainebleau were totally unprepared for what they saw: on the one hand, buxom mother figures and children rendered in a classicizing style, and on the other, two large pictures of almost square format depicting three rather hieratic figures composed of hard-edged contours and flat planes of colour.

These two pictures – today at the MOMA in New York and the Art Museum in Philadelphia – represent figures from the Commedia del' Arte: Pierrot, Harlequin and a monk sitting together at a table. In the first version we see, from left to right: Pierrot playing a clarinet, Harlequin a guitar, while the monk holds a music score on his knees. On the floor behind the table lies a bristling-haired, open-mouthed dog. In the second version, which features no dog, it is Pierrot who plays the clarinet, while Harlequin plays the violin and the monk the accordeon. The important thing, however, lies not in these differences of detail, but in the overlapping and opposition between the two versions, as if each were both the positive and the negative of the other; the one displaying a «classical» severity and the other a «rococo» exuberance.

The richness of Synthetic Cubism is perhaps even more evident in the still lifes painted in the years from 1924 to 1926. The major composition in this vein was the *Still Life with Mandolin* from 1924. In this large-format picture (4 x 6 ft.), the figurative elements – mandolin, guitar, bottle and three apples set on a table in front of an open window – have been depicted with a rare magnificence. Yet the freedom with which Picasso represented them has inspired comments that – even today – verge on outright nonsense: for example, it has been said that the guitar was «swollen» with desire, and that the bottle, whose mouth is deceptively similar to an eye, «steps back to take a better look at it.» Topping that is a statement by an American patroness of the arts whose name I will charitably withhold: according to her, the six variants of the 1914 Absinth Glass were «a celebration of the freedom of choice in alcohol consumption.»

It is useful to quote such foolish remarks from the pens of acknowledged specialists in order to show how difficult it is to grasp the concision and simplicity of Synthetic Cubism in purely theoretical terms. This does not mean, however, that this *Still life with Mandolin* and other pictures of this type, like *Studio with Plaster Head* (1925), cannot be correctly approached.

The poet and writer Michel Leiris, another close friend of Picasso, can help us in this respect. In one of his books[1], he set himself the task of redefining certain words by punning on their assonances.

To mention only a few examples (impossible to render in English here), he recomposed the word «aigle» (eagle) into «angle d'ailes» (angle of wings), the word «abdomen» into «bas domaine» (lower parts), and the word «crépuscule» (dusk) into «quel sépulcre!» (what a sepulcher). This was anything but a gratuitous play on words, but rather an implacable investment – in the original sense of «take-over» – of reality by the imagination. Whoever has watched an eagle winging across the sky must surely have noticed the angular quality of its flight and sensed its menace. And who has not experienced, at one time or another, the vile, viscous and flaccid nature of the lower parts of the body, which are called «low» in more than one sense of the word?

Although there are clear differences between the verbal and the visual, the Synthetic Cubist paintings played on an analogous principle. Now that these normally utilitarian objects – a drinking glass, a guitar for playing music – had been eaten away, so to speak, Picasso could abbreviate, conjugate, and dilate them according to the range of resonances which they aroused in him.

The philosopher Henri Bergson pointedly remarked that we content ourselves in our everyday lives with reading the labels that are stuck on peoples and things, registering and acting on only a few superficial features. But the artists, whether painter or poet, are constantly distracted, and always lifting the labels to see what they conceal. The painters of still lifes had been doing this for centuries before Picasso appeared on the scene. Such masters as Chardin and Zurbarán had long ago revealed the «still life» of objects – an expression which the French render as «nature morte,» which literally means «dead nature.» Cubism, having emancipated itself from the constraints of realism, was thus in a position to carry this art form to its fever pitch. The bottles, pitchers, guitars and mandolins, and the tables which held them, as well as the space all around them, were turned into freely traced signs. The very act of painting now had the upper hand. As Picasso once said: «Painting is stronger than me, it makes me do its bidding.» The façade of things having collapsed, he was able to create a new pictorial poetics from scratch.

Nearly two decades after his *Demoiselles d'Avignon*, having led his titanic campaign against the object to a victorious conclusion, Picasso was ready to embark upon an equally far-reaching contest with the human figure.

1. Michel Leiris, Brisées, Mercure de France, Paris 1966.

3

THE ENCOUNTER
WITH SURREALISM

THE HUMAN FIGURE MAKES A COMEBACK

It has often been said – as I have previously mentioned – that the arrival of a new woman in Picasso's life invariably occasioned a change in his painting style. In this respect, no other relationship seems to have had such a strong impact on the course of his work than his marriage to Olga Khoklova. During the very same period that he was producing large-format still lifes in the late Cubist manner, he was also painting works that displayed an unexpected reversion to personal subjects and academic conventions.

Olga Khoklova was a member of Diaghilev's Ballets Russes. Born in Saint Petersburg in 1881, the daughter of a czarist general, she had begun her dance career too late to qualify for starring roles. Her great beauty and stylish manner, however, quickly conquered Picasso's heart. They first met in February 1917 in Rome, where the artist, accompanied by Jean Cocteau and Erik Satie, was working on the sets and costumes for *Parade*, a ballet which unleashed the fury of Parisian audiences when it premiered at the Théâtre du Châtelet in May. In his memoirs, Cocteau recalled how his friends and the dancers would meet after the rehearsals to take long evening walks through the streets of the eternal city, their

THE CORRIDA

(detail)

Boisgeloup, 22 July 1934, oil on canvas,

97 x 130 cm. (38 x 51 in.)

Private collection.

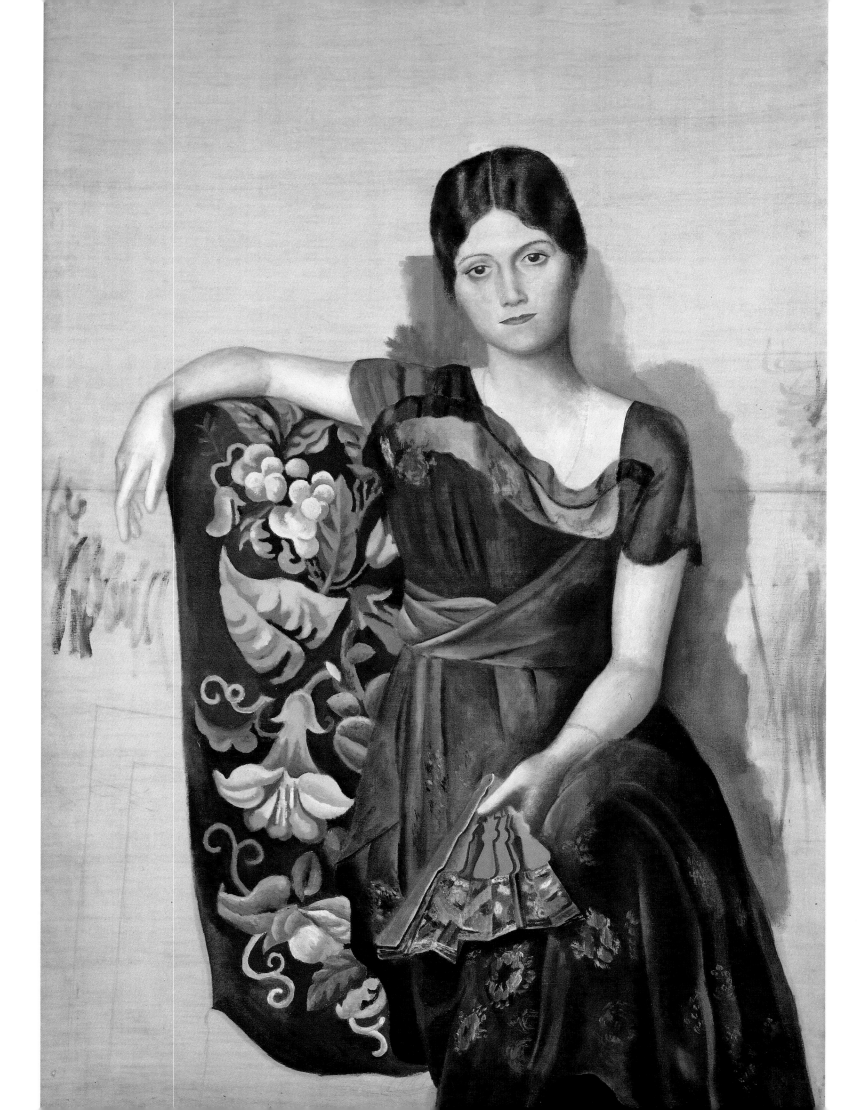

Overleaf

PORTRAIT OF OLGA IN AN ARMCHAIR

Montrouge, late 1917, oil on canvas,
130 x 88.8 cm. (51 x 35 in.)
Paris, Musée Picasso.

SEATED HARLEQUIN (THE PAINTER JACINTO SALVADO)

Paris, 1923, tempera on canvas,
130.5 x 97 cm. (51 x 38 in.)
Basel, Kunstmuseum.

PAULO, THE ARTIST'S SON, AT THE AGE OF TWO

Paris, 14 April 1923, oil on canvas,
100 x 81 cm. (39 x 32 in.)
Paris, Bernard Ruiz-Picasso Collection.

faces eerily bathed in the moonlight, and how this dreamlike atmosphere had a profound effect on Picasso.

It was practically love at first sight and, after having made a trip to Barcelona to present his fiancée to his parents, Olga and Picasso were wed in a civil ceremony and according to the rites of the Orthodox Church in Paris on 12 July 1918.

Picasso's young wife, although a simple ballerina, possessed a willful and authoritarian character: fully aware of her new status as the wife of a famous, wealthy artist, she was determined to take the situation well in hand. To begin with, the newlyweds left Picasso's decrepit studio in Montrouge and moved to rue de La Boëtie, a fashionable street on the Right Bank known for its elegant antique and carpet stores.

They set up house in a «duplex» at 23, rue la Boëtie. The downstairs apartment was luxuriously furnished and decorated according to Olga's taste and ideas of how a successful artist ought to live, while the upstairs apartment became Picasso's studio. He began by removing all the doors and, with his motley assortment of objects and collection of pictures by Henri Rousseau, Matisse, Renoir and Cézanne haphazardly hung or stacked against the walls, and his cigarette butts littering the floor, it presented such a total contrast to Olga's world that it ominously prefigured the antagonism which eventually brought the couple into irreconcilable conflict.

Moreover, on the artistic front, embarking on a quest for perfect resemblance, Picasso made many drawings and paintings after photographs, such as the *Portrait of Igor Stravinsky* (1920) and the *Portrait of Paulo, the Artist's Son*, which shows him at the age of two sitting astride a donkey in the Luxembourg Gardens.

The prototype for these works was the *Portrait of Olga in an Armchair*, painted in 1917 after a photograph taken in the artist's Montrouge studio. Olga's oval face, although regular enough and faintly smiling, betrays an uncompromising temperament, also visible in the hard gaze of her dark eyes, and the resolute chin accentuated by thin, firm lips. Nothing of his future wife's character escaped Picasso's keen eye. The artist always painted the portraits of the women in his life in his current style: the only exception was Agnès Humbert, his mistress during the days of Analytic Cubism, a period when he was too absorbed with his struggle against objects. Here, Olga's likeness was complete in every detail, and, had he finished the background, nothing would have distinguished it from the «dining-room» pictures that later decorated the walls of their apartment

in rue de La Boëtie. All in all, however, there was something claustrophobic about this portrait, both from the human and esthetic points of view.

Picasso's return to classicism resulted nevertheless in some very fine works, in particular several other portraits of Olga, conventional poses notwithstanding, and especially the different versions of the *Seated Harlequin* (1923). Yet his stylistic turnabout was viewed as a debatable move. This was the substance of Juan Gris' criticism in a letter to D.H. Kahnweiler in which he deplored Picasso's defection just when Cubism was beginning to be accepted by the critics and general public. Another way to see it, though, would be as the pirouette of a mischievous and anxious demiurge who, instead of maintaining a steady creative direction, sought to master the widest possible range of styles.

The portraits executed after photographs were paralleled by another important series representing giant female figures. In painting after painting, from *The Siesta* (1919) to the *Three Women at the Spring* (1921), these giantesses with oversized heads on puffy necks and plump bodies, huge hands and fat fingers, disproportionately large legs and feet seemingly modelled out of clay, presented a weighty challenge to the laws of anatomy. Because of the insistent volumetric effects, some authors have interpreted this style as a return to Classical sources. But Matisse, who was as attentive an observer of Picasso's development as anyone, thought otherwise and once quipped: «The origin of his colossal manner is none other than Baby in the Cadum soap adverts.»

Indeed, these obese and barbaric giantesses had little in common with the works of Polykleitos or Phidias. Classical Greek sculpture, with its gently rounded torsos and subtle *contrapposto*, played on the even distribution of light. Everything about these figures was based on harmony, from the musculature of the ephebes to the notion, formulated in a celebrated canon, that human proportions reflected the order of the Cosmos. Picasso probably recalled the plaster casts he had copied as an adolescent, but even then he had tended to dramatize them. If he had Greek art in mind at all, it was only the better to subvert it.

When Roland Penrose asked him where these corpulent female figures really came from, the painter told him how, as a child, he would crawl under the table to observe with mingled feelings of respect and awe the horribly swollen legs of one of his aunts. There is yet another explanation, also of a biographical nature: at the time, Olga was pregnant with Paulo, and so the artist was daily confronted with the sight of her

PORTRAIT OF IGOR STRAVINSKY
Paris, 24 May 1920, pencil and charcoal,
61.5 x 48.2 cm. (24 x 19 in.)
Paris, Musée Picasso.

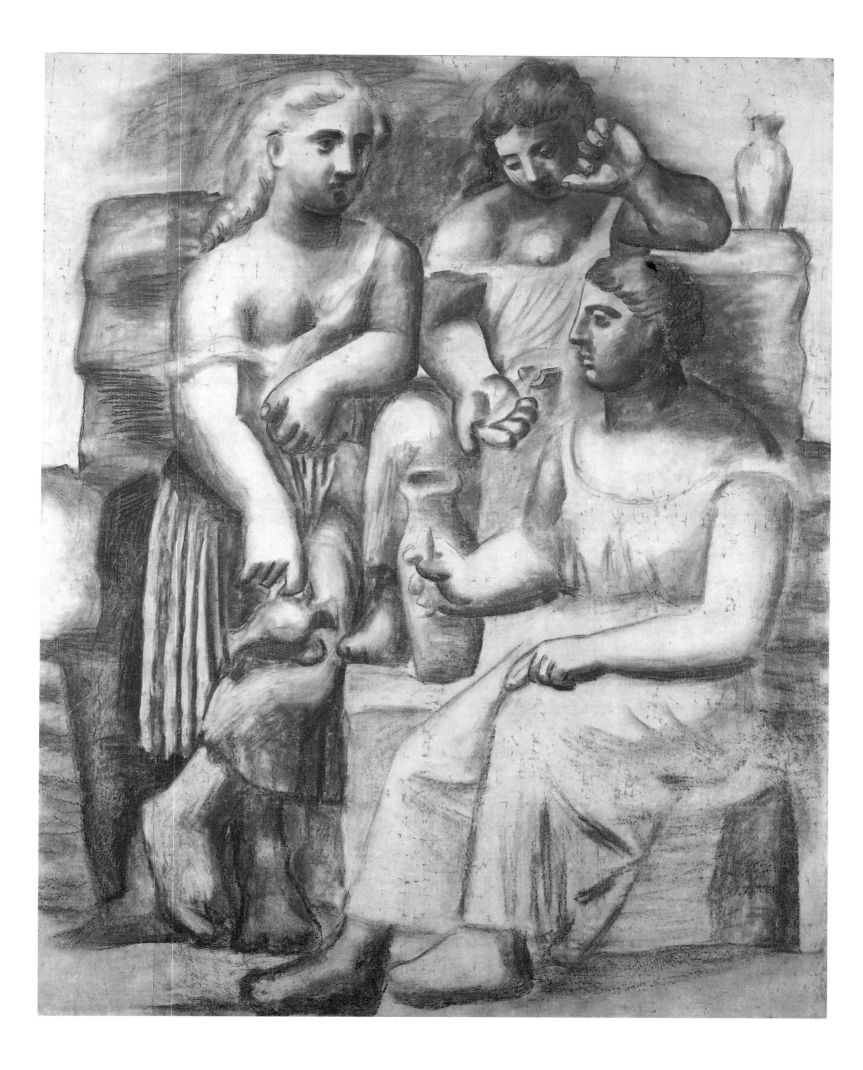

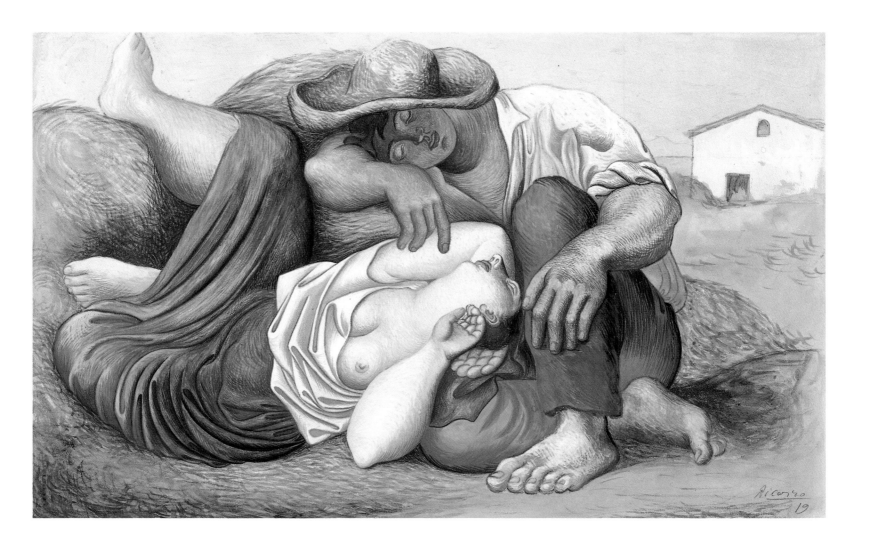

THREE WOMEN AT THE SPRING

Study.

Fontainebleau, summer 1921, red chalk

on canvas, 200 x 161 cm. (79 x 63 in.)

Paris, Musée Picasso.

THE SIESTA

Paris, 1919, tempera, watercolour and

pencil, 31.1 x 48.9 cm. (12 x 19 in.)

New York, The Museum of Modern Art,

Abby Aldrich Rockefeller Fund.

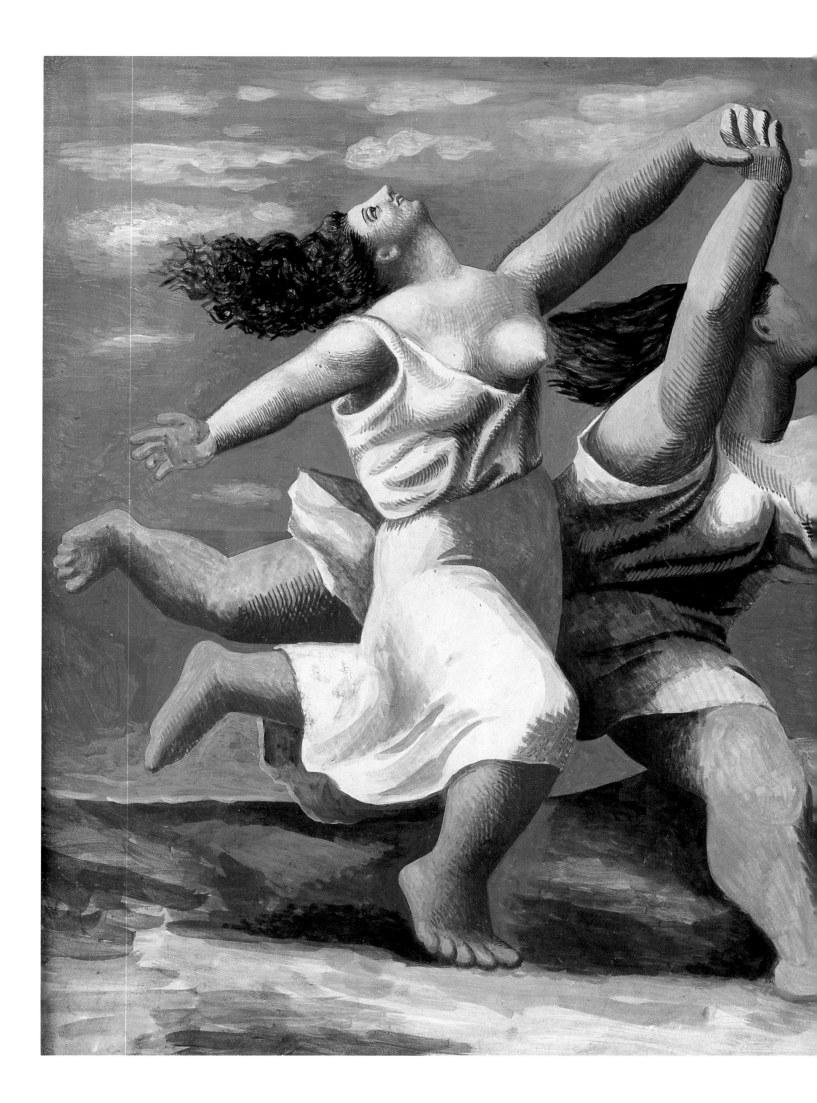

WOMEN RUNNING ON THE BEACH (THE RACE)

Dinard, summer 1922, gouache on plywood, 32.5 x 42.1 cm. (13 x 17 in.) Paris, Musée Picasso.

Overleaf

NUDES

25 August 1932, Indian ink on album sheet, 24.5 x 37 cm. (10 x 15 in.) Private collection.

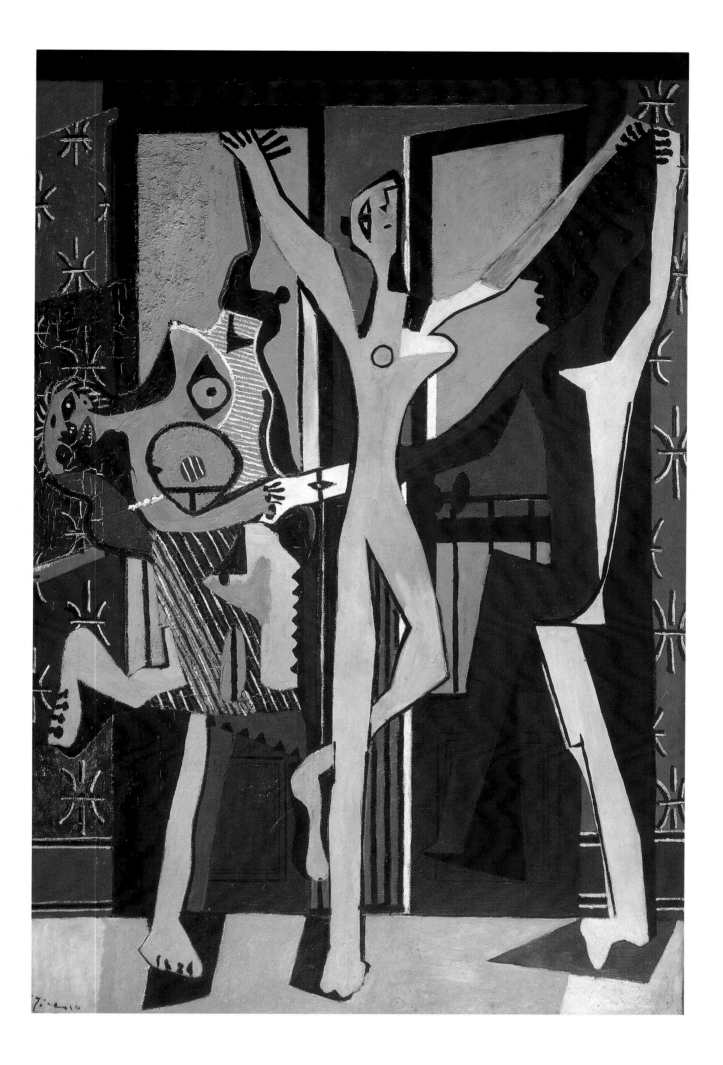

dilated breasts and swollen belly. Many of the giantess pictures have motherhood as their subject. Others, like *Women Running on the Beach* (1922), show giantesses so ponderous that the ground seems to be quaking under their feet. If they had anything to do with Antiquity at all, they referred not to the palestra or stadium, but rather to the Cycladic Mother-Goddess, the hermaphrodite who ruled the world before the advent of Olympian Zeus.

This first phase of Picasso's return to the human figure concluded in 1925 with a major work entitled *The Three Dancers*. The artist had spent the spring of that year in Monte-Carlo, where he again watched the rehearsals of the Ballets Russes, drawing dancing figures in Indian ink with a very pure, flowing line. The dancers he depicted in their tutus were usually very elegant and conventional.

Suddenly, however, upon his return to Paris, the figures exploded. A large-format composition dominated by an oversize profile shows three female figures prancing in front of a window overlooking the sea and sky. These so-called dancers – one, in the middle, with purplish body and long drawn-out limbs, another all brown and white, and a third with a horribly toothy grimace – are reduced to balloon-like figures shaken by violent spasms. They are the *Demoiselles d'Avignon* set in motion. But, while the latter seemed to have been hewn with an axe, the figures here were completely flat, insubstantial phantoms stretched across the two-dimensional surface of the canvas. Their broad, coloured surfaces had more to do with tearing, being torn up and torn apart; something that was often to occur in Picasso's tormented life.

The classical ballet dancer usually has a straight back; it is the arms and legs that do most of the work. The exercises at the bar have less to do with making the body more supple than with forcing it into a fixed mould. The extreme discipline and balance which enable the ballerina to gracefully resolve the most complex series of pirouettes are the hidden spring of her magical presence on the stage. But the forcing of the body which underpins the art of ballet also amounts to a sort of rape, and the intensity of this picture gives us an idea of how deeply the artist responded to its appeal.

BEAUTY SHALL BE CONVULSIVE

While Picasso was painting the giantesses, the major avant-garde event was the irruption of Surrealism, a movement that sought not only

THE THREE DANCERS

Monte-Carlo, June 1925, oil on canvas,
215 x 142 cm. (85 x 56 in.)
London, Tate Gallery.

to revitalize painting and literature, but also to change life in fundamental ways. Here is how André Breton defined it:

«SURREALISM, n. Psychic automatism by which we propose to express either verbally, in writing, or in any other way, the true mechanisms of thought. The dictates of thought itself, independently of any control exercised by rational, moral or esthetic concerns.»

«ENCYCL. *Philos.* Surrealism is based upon a belief in the superior reality of certain forms of heretofore neglected associations, in the omnipotence of dreams, and in the free play of thought. It strives to destroy all other psychic mechanisms once and for all and to replace them in the resolution of the main problems of life.»

Breton wanted to liberate not only art, but went so far as to call for the creation of «sleeping» logicians and philosophers. According to him, logical processes were applicable only to questions of a secondary order, and so he wanted to open the gates of mental asylums and establish the right to hallucination and delirium. To show the true scope of the unconscious, he called for the reinstatement of everything that scientific progress had tried to banish: the irrational, chance, superstition, and so on. Influenced by the theories of Freud and the holocaust of the First World War – with its eight million dead – he rejected cartesian civilization as a patent failure and strove to neutralize it.

Given these premises, an initial trend in Surrealist painting, represented by Magritte and Dali, was based on dreams and incongruous associations: This tendency – inspired by Lautréamont's famous phrase, «Beautiful like the chance encounter of an umbrella and a sewing machine on a dissection table.» – sought expressly to disturb the spectator by combining unrelated elements, as often happens in dreams. However, Surrealism, unlike Picasso's and Braque's Cubism, was mainly the product of writers – and of the younger generation at that – and so Picasso kept his distance from it at first. In a conversation with André Masson on the beach at Golfe-Juan in 1927, he summarily dismissed it, saying: «In other words, you put the dove in the stationmaster's backside, and there you have it.» He later allowed that «backside» was not the exact transcription of the coarser expression that he had used on that occasion.

In his opinion, the dream-imitators were little more than skillful image-makers. They were not true painters, because they deliberately worked in the traditional, even academic style, and so were not concerned with specifically pictorial issues. He himself was tired of the

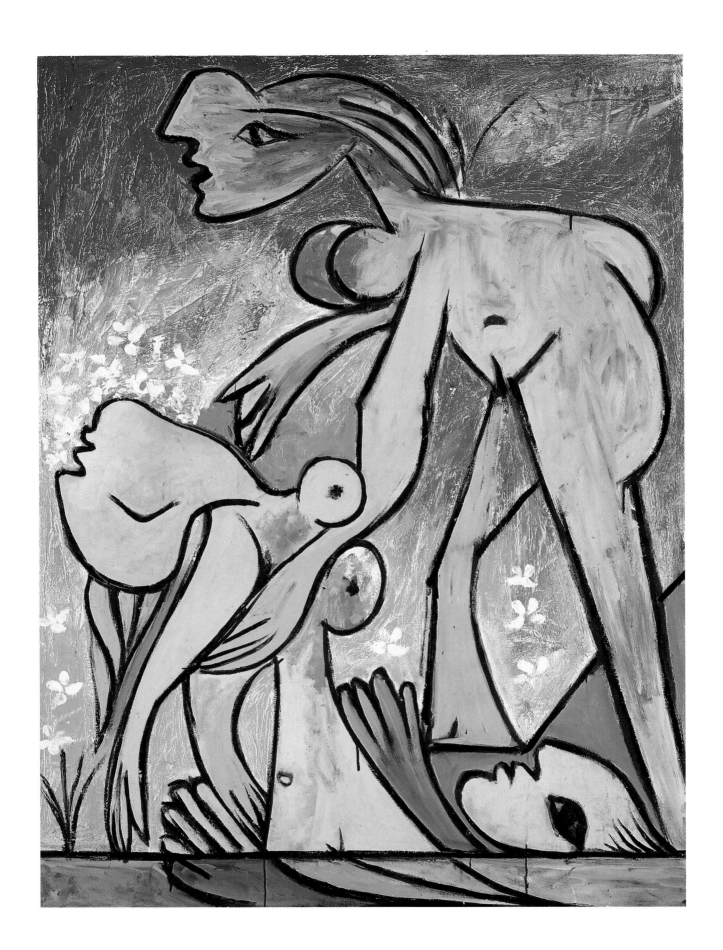

photographic manner by then and wanted to break away from it, but this type of Surrealism did not offer him the hoped-for renewal.

However, there was a second and quite different tendency in Surrealist painting, which was more in line with the definition that Breton, the movement's leader, had given of it, but which had little impact at the time. In 1924, the year in which Breton published the first *Manifesto of Surrealism*, Masson made a drawing on a plain sheet of paper in a matter of seconds; being the product of a pure, unpremeditated nervous impulse, it corresponded perfectly to the notion of psychic automatism.

This drawing, which had no figurative intention, presented a vortex of scattered heads and breasts, spreading legs, genitalia, bulging eyes, free-floating hands and feet in a space with neither top nor bottom. The artist later explained how, in order to free his creative energy, he had had to start by emptying himself, and so the first graphic manifestations began as pure gestures, rhythms, incantations, until a world of fragments and ruins unexpectedly emerged and took shape. The forms recalled Empedocles' famous hybrids composed of disjointed limbs, improperly joined cartilage, and disembodied eyes and foreheads, or the medieval depictions of the *Last Judgment* with the souls of the damned reeling in the hellish depths. Although Cubism had shattered the façade of the objective world along the lines suggested by the new physics, it had retained rationalism and pushed it to the extreme. Masson's automatism now unleashed the irrational among the ruins of the object.

The first type of Surrealism was essentially static: it depicted dreams in the same way that the dreamer recomposes them after the fact, in the waking state. On the other hand, the second type of Surrealism was more dynamic, for it directly tapped the ferment of the unconscious; the swiftness of execution permitting an interplay of reflections, echoes and vectors to emerge at random. This was the union of elementary forces and random imagery. Although Picasso never formally joined the Surrealist movement or applied any of its dictates, it was this second type of Surrealism that later appeared in his art.

And so we come to the period of the Metamorphoses – which neatly coincided with Picasso's illustration of Ovid's masterpice for Albert Skira in 1931 – in which the human figure overflowed its natural shape to become flower, foliage or spider. Summering first in Cannes, then in Dinard, and trying to avoid Olga and the English nanny hired to bring up little Paulo, he would wander along the beach for hours, then return to

SMALL WOODEN SCULPTURES

From left to right: Seated Woman

17.8 x 2.1 x 2.5 cm. (7 x 1 x 1 in.) and

17.2 x 4.5 x 3.5 cm. (7 x 2 x 1 in.)

Centre and opposite: Standing Woman

49.5 x 2.3 x 2.2 cm. (19 x 1 x 1 in.)

and 49 x 5.5 x 2.8 cm. (19 x 2 x 1 in.)

Boisgeloup, autumn 1930, carved fir.

Paris, Musée Picasso.

their rented villa and paint such bizarre scenes as *Ball Players* (1928) and *Women and Children at the Seaside* (1932), ruthlessly tearing the human anatomy apart and recombining it according to his whim. As he explained: «Nature and art are two separate things. In art, we express our concept of what nature is not.» In the same way that he had shown objects simultaneously from different angles during the period of Analytic Cubism, he now dislocated the anatomy of the bathers, depicting their faces both from the front and in profile, dilating, deflating and petrifying their bodies with a vengeance – and seemingly with great relish.

Whereas in the Blue Period the artist had been content to elongate a hand or emaciate a silhouette in order to evoke emotion, here he pulled the limbs, heads, breasts and bellies in all directions, like so much putty. As Breton wrote in the review *Minotaur*: «Beauty shall be convulsive, fixed exploding, veiled erotic, or not at all.»

Convulsive, to be sure, but veiled erotic too. On 8 January 1927, walking past the Galeries Lafayette on Boulevard Haussmann, Picasso encountered a devastatingly sensual young blonde woman with striking blue-grey eyes. He followed her a while before approaching her and introducing himself with these words: «Mademoiselle, you have an interesting face. I would like to paint your portrait. I am Picasso.» Although quite famous by then, this name meant nothing to the young woman, who had little interest in modern painting. Two days later, he saw her again at the Saint-Lazare metro station, where they had arranged to meet, and declared: «We will do great things together.»

Her name was Marie-Thérèse Walter and she was not yet eighteen, while Picasso was in his forty-sixth year. The pleasure of attending theatre premières at Olga's side and going to evening parties and balls – in which he sometimes appeared dressed as a matador – had begun to pall. His new mistress was to influence his art as much as Surrealism.

Strangely enough, the first paintings in which Marie-Thérèse's sensuality appeared in all its ripeness – *Reclining Nude*, *The Dream* – were slightly out of phase in time, for they dated from 1931 and 1932. She was evidently the kind of woman who loved to curl up in her femininity. Picasso liked to depict her voluptuous face against a background of bright colours – greens, purples, bright yellows – while contracting or retracting the shapes of her body. The works in which she featured had the stillness of plant life, with consistently gentle and flowing lines. This was a marked contrast to the intensity of the desire which she –

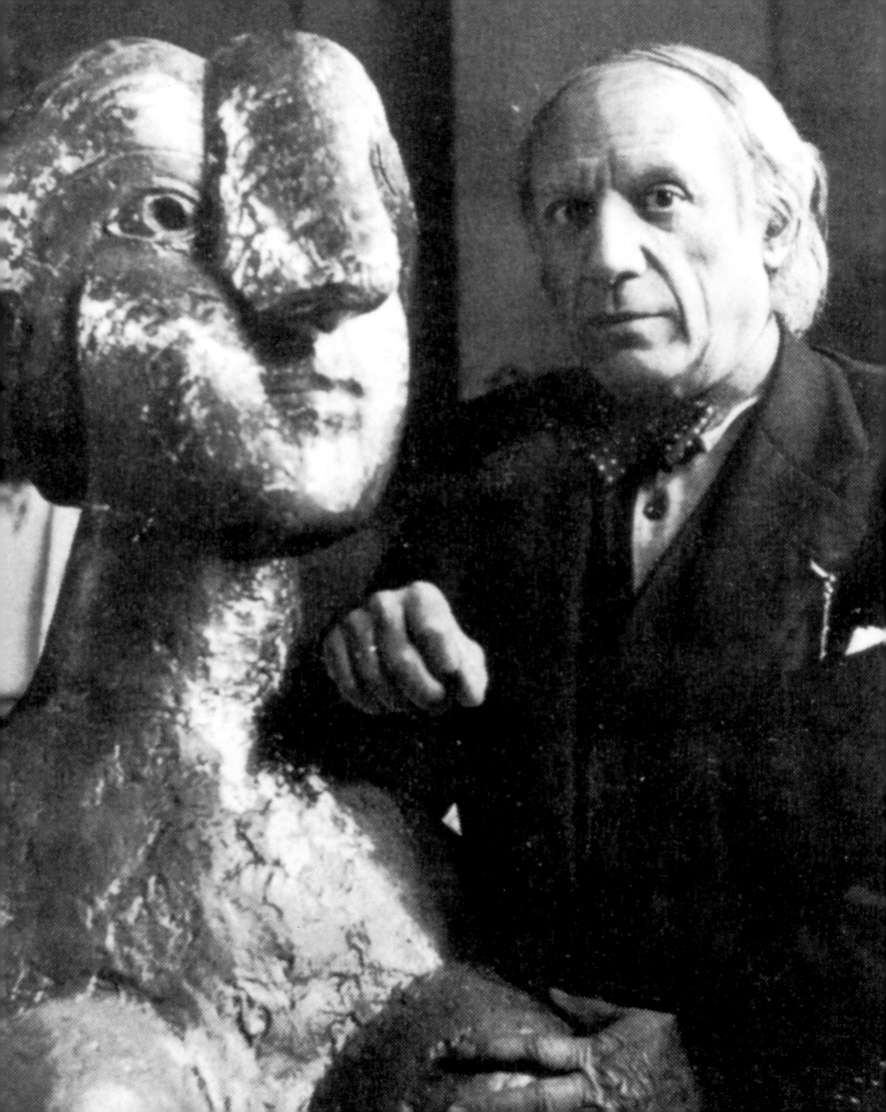

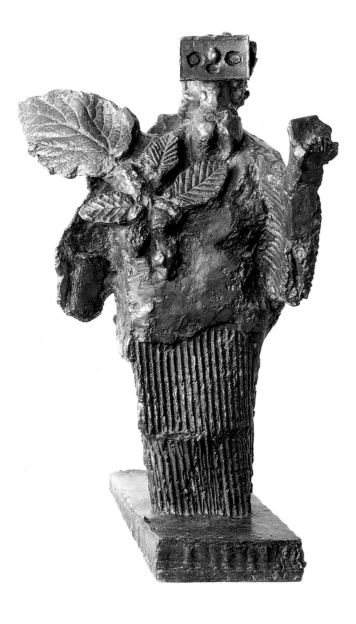

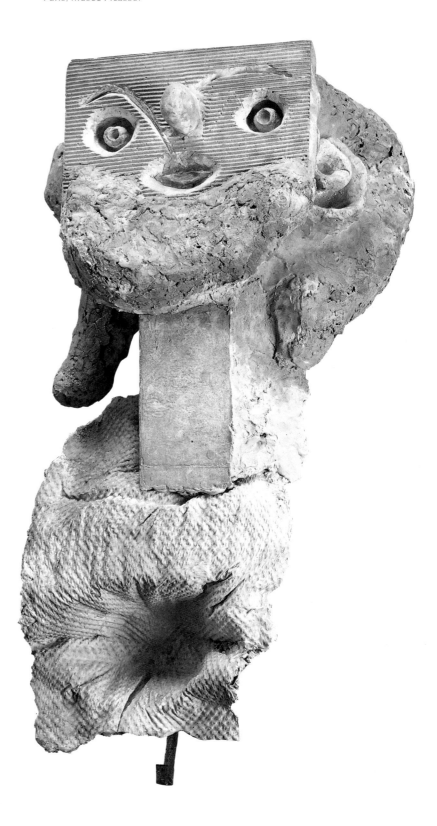

WOMAN WITH LEAVES

Boisgeloup, 1934, bronze,

37.9 x 20 x 25.9 cm. (15 x 8 x 10 in.)

Paris, Musée Picasso.

BUST OF A BEARDED MAN

Boisgeloup, 1933, plaster,

85.5 x 47 x 31cm. (34 x 18 x 12 in.)

Paris, Musée Picasso.

Opposite

Picasso next to a sculpture,

Female Head.

1944.

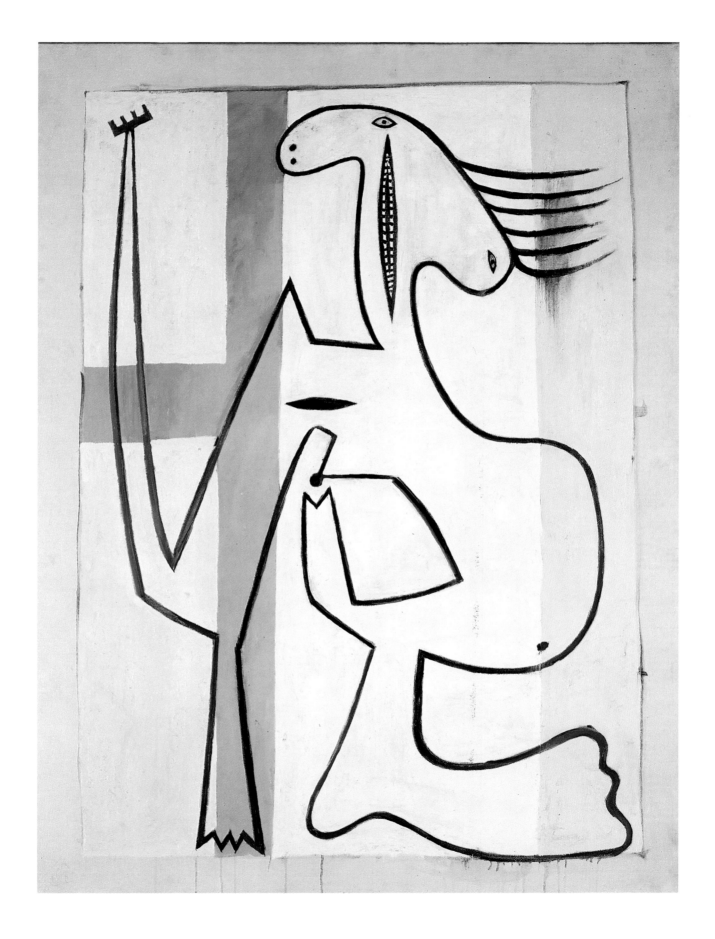

indifferently – provoked. Clearly under the spell of her charm, the artist maintained such an intimate dialogue with his model that his brushstrokes seem indistinguishable from caresses.

Marie-Thérèse Walter also inspired some of Picasso's most sensitive works in the medium of sculpture. In 1930, the artist purchased the Château de Boisgeloup, a seventeenth-century manor near Gisors which he used as a studio and where his young mistress sometimes stayed. The magnificently archaic heads which he modelled out of plaster, although referring to ancient Mediterranean civilization, all displayed her characteristic features: a prominent nose (which he further enlarged), bulging eyes, and even her hair style.

This double life involving two women could not last forever. Out of recklessness or provocation, he had rented an apartment for Marie-Thérèse at 44, rue de La Boëtie, practically next door to the building in which he lived with his family. Olga naturally became furiously jealous and eventually moved out, taking their son Paulo with her. On 5 October 1935, his young mistress gave birth to a daughter, Maya. But Picasso's affective chaos was not to end there: a new woman, Dora Maar, was about to enter his life.

FROM SEX TO EXCESS

However, we have not finished discussing the works from this period. Let us go back a few years. Shortly before exploring Marie-Thérèse's voluptuous body in paint, Picasso produced such erogenous monsters as the *Figure* from 1927 and the *Female Bust with Self-portrait* from 1929, which were some of his most explicit depictions of sexual desire. The first picture showed a female nude that was barely recognizable as such: with its hideous head, sole breast and vaginal slit, it displayed the obtuse primitivism of an insect. The second, with a gaping, tooth-ridden mouth standing out against the painter's own profile, was as trenchant as an emasculation. Once asked when his sexual activity had begun, Picasso had answered by making a gesture toward the ground with the palm of his hand and saying: «Very, very little!» These two pictures were by far the most extreme that had ever been executed in the erotic genre.

A large-format composition in the Musée Picasso in Paris, *Woman in an Armchair* (1929), sprang from the same unbridled impulse. This was evident in the general disorganization of the woman's bodily form, with its flailing octopus-like arms and legs, castrating mouth, tumbling

111

breasts, notch-like genitalia and smear-like anus. Together, it made for an anatomy that was quite unrealistic yet perfectly appropriate from the standpoint of the libido.

According to psychoanalytic theory, the erogenous zones work like so many force-fields directing our bodily consciousness. From our earliest childhood explorations on, we create a veritable topology of orifices: mouth, nose, anus, breasts, genitalia and urethra, which are the various poles of tension for the circulation of libidinal energy. To these openings should also be added the eyes, which are symbolic holes. It is through these orifices that our most intimate contact with ourselves and others takes place. And it was precisely on this topology and its resulting tensions that Picasso's paintings were based.

Thus we can understand why his figures were not so much deformations of human anatomy, as its complete denial. Being divested of the structures of bone, muscle, organs and skin, they were reduced to the state of an erotic patchwork composed solely of erogenous zones. The bodies were left to expand like wild growths or were forcefully squeezed into bottlenecks; they were nothing more than wanton ulcers, obscene bedsores. The notorious *Demoiselles d'Avignon*, while already presenting an all-out break with the naturalistic and idealizing Renaissance tradition, still adhered to a solid architectonic structure borrowed from African sculpture. In this series of nudes, however, the human forms were liquidated, left to spill willy-nilly: exactly the same movement which makes us relapse to the very core of desire.

The Surrealist writers considered eroticism as a subversive force. In his efforts to free sexuality from the constraints of bourgeois morality, Breton converted to Marxism, believing that love would be liberated through the emancipation of the proletariat. Benjamin Péret defected instead to pornography. The Surrealist painters, for their part, sublimated the cherished female into a marvellous and ambiguous being, while Picasso raised the question: «What is sex?» Judging from the outrageous creatures in his paintings, the answer would seem to be: «An excess!»

This was the definition of sex given at the time by Jean-Pierre Brisset, a railroad employee and linguist of a very peculiar sort who maintained, among other things, that the analysis of words indicated that Man descended from the frog. A darling of the Surrealists, who discovered him, he explained the genealogy of sex in a long homophonic and delirious digression. The following is a short – but mostly untranslatable – excerpt: «*Sais que c'est? ce sexe est, sexe est, ce sexe*. This

LARGE NUDE IN A RED ARMCHAIR
Paris, 5 May 1929, oil on canvas,
195 x 129 cm. (77 x 51 in.)
Paris, Musée Picasso.

Opposite

CORRIDA
Boisgeloup, 22 July 1934, oil on canvas,
97 x 130 cm. (38 x 51 in.)
Private collection.

112

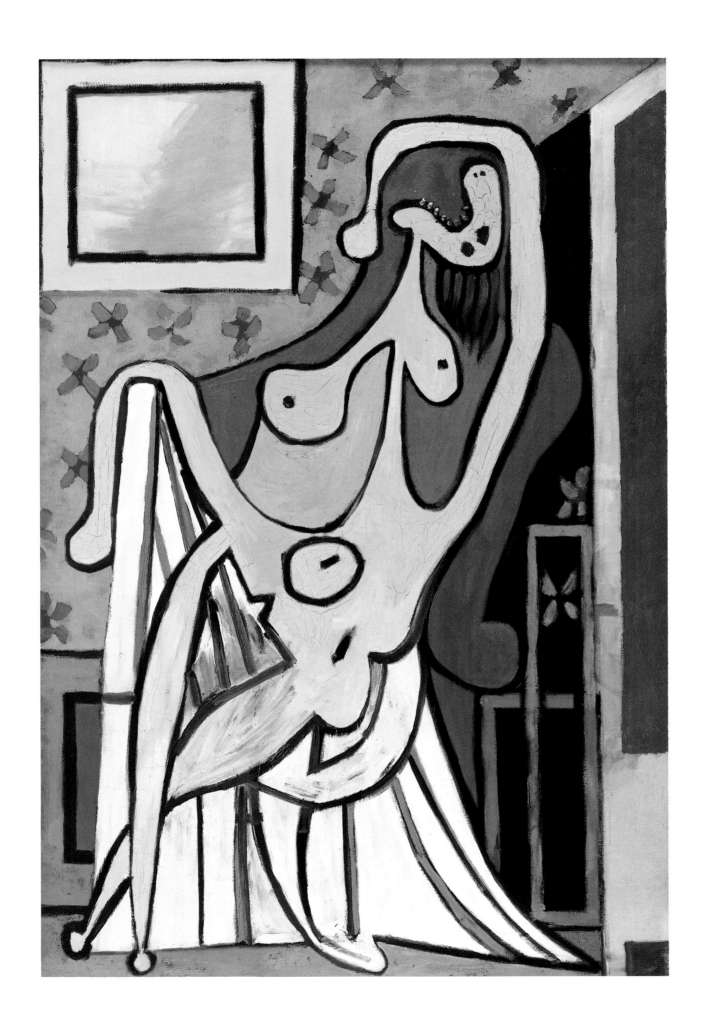

excess, is sex. We see that sex was the first *excess*. We have no excess to fear from those who have no sex...» I have quoted Brisset for the fun of it, of course, but also because he is a perfect complement to Picasso.

And yet, the death urge was sometimes stronger than the life urge in the painter's work. It is not surprising therefore to see in these same years the reappearance of a major subject he had long neglected: the bullfight. During his childhood and youth, Picasso had been strongly impressed by the sight of horses gored by bulls in the arena, with their entrails grotesquely spilling out onto the sand. This barbaric spectacle has become a thing of the past, now that the picadors' horses are well protected by thick caparisons. A picture like *The Bullfight* (*Corrida*) from 1901, which shows an agonizing horse in the foreground while a matador and his peons try to lure the bull away in the middle ground, is an example of this type of scene in his early style.

It was a superb picture, but his subsequent artistic development now made it possible for him to express his revolt at the carnage with greater force and outrage. In certain paintings, a woman, also mortally wounded, rides the disembowelled horse, and in another the bull is replaced by a gorgon-like figure who sticks out her tongue as she stabs her victim in the belly. To depict the agony of the dying bull, the matador's sword thrust to the hilt between its shoulders, the artist resorted to the traditional manner or to the device of dilating the forms. The masterpiece of this series was undoubtedly the medium-format *Bullfight* (*Corrida*) that he painted in July 1934 at Boisgeloup.

In this masterly handled work, Picasso resorted to the weird association of images that were so dear to the Surrealists and that he had mocked several years earlier on the beach at Golfe-Juan. The horse strains its head and neck in a cry of pain, while the bull's horns project like steel blades, its tongue pointing dagger-like, its muffle a tensed clamp, its limbs armoured as with steel plates, its hide a broad field of dark-brown outlined by a double contour of red and grey which brings out its metallic hardness. The bull depicted here was less of an animal – wild or not – than a cold killing machine.

After the Second World War, during his most glorious years, Picasso was often shown by the press attending bullfights held in the summer at Nîmes, Vallauris and Arles (his opposition to Franco's regime prevented him from returning to Spain). The photographs showing him officiating from his ringside box in the company of his family and friends, opening the corrida, greeting the matadors, setting the length of the

tertios, have created the image of a fervent aficionado, which he had indeed always been, but this did not blind him to the cruelty of this most mythic of spectacles.

MY GOD, MY GOD, WHY HAVE YOU FORESAKEN ME?

Concerning the subject of suffering and death, Picasso created a number of works inspired by its ultimate symbol, the crucifixion of Christ. Crucifixion, which was abolished by the emperor Constantine in 313 – or later, in 330, the exact date is uncertain – was a much crueller form of execution than even the most graphic images of the Christian tradition have been able to show. We know this thanks to research conducted in the early 1930s by a pious surgeon, Dr. Pierre Barbet, who undertook to investigate Jesus' torments scientifically and published his findings in a book that is almost too unbearable to read[1].

The author spares us none of the grisly details of his experiments: from the manner in which he nailed freshly-amputated hands to test their resistance, to the actual crucifixion of a corpse just off the operating table to measure the tension exerted on a body in this position. He discovered that the fact of being hung by the hands created a contraction in the victim's limbs and trunk that resulted in a complete tetanus which rendered the muscles of the arms as hard as stone. Furthermore, the muscles necessary for breathing contracted to such an extent that the victims could no longer empty their lungs, and so died of asphyxiation after having vainly tried to relieve the constriction by pushing themselves up with their feet. In fact, the executioners broke the legs of the crucified with iron bars to prevent them from raising themselves and easing their agony, which, in some cases, could last for days.

Picasso's origins, his Catholic upbringing, the popular religious holidays fervently celebrated in Spain, and the Spanish painting of the past – El Greco, Zurbaràn – had made him sensitive to the image of Christ since his childhood. Christian imagery appeared in a number of his earliest works, as for example his depiction of Jesus' arrest by Roman soldiers – *Religious Subject* (1896) – or his drawings of sickbed scenes with praying women and crucifixes. It reappeared in 1915 in an academic drawing with manneristic elongations, then in another drawing in 1926 which played on distorsions and metamorphoses. Much later avatars

1. Pierre Barbet, *La Passion de N.S. Jésus Christ selon le chirurgien*, Paris 1930.

MATHIS GOTHART NITHART,

CALLED GRÜNEWALD

THE CRUCIFIXION

c. 1516, central panel of the Issenheim

Altarpiece.

Colmar, Musée d'Unterlinden.

were the bullfight scenes in which the matador was replaced by Christ on the Cross, in keeping with the 12th Psalm which prophesied that the dying Jesus would be surrounded by many calves and bulls, their jaws wide open like roaring lions.

But Picasso's most important works in this vein were the *Crucifixion* from 1930 and the series of ten Indian ink drawings done after Grünewald in 1932, in which the body of the crucified Christ was simplified to a heap of gigantic bones.

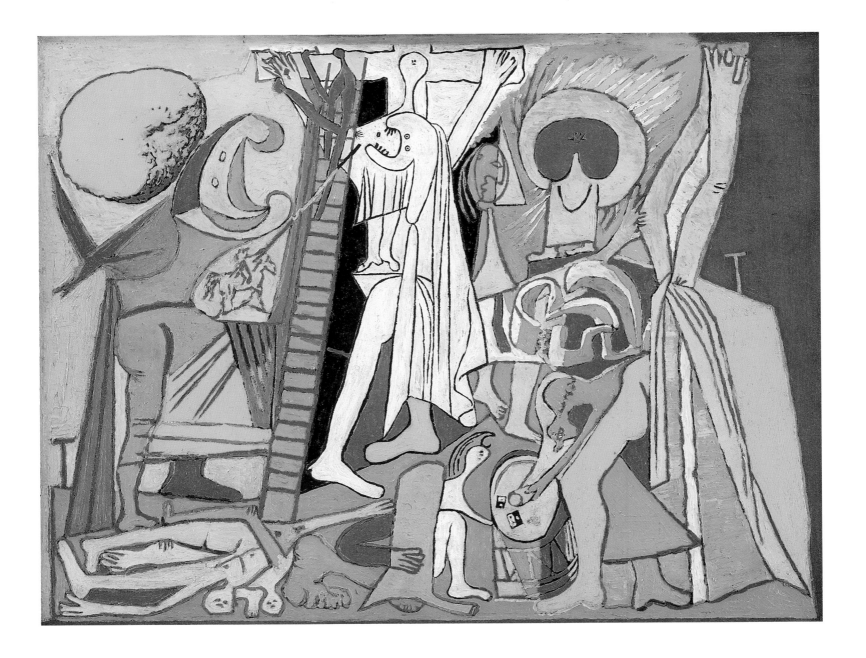

Despite its small size – 24 x 20 in. – *Crucifixion* was a landmark composition in Picasso's oeuvre. The scene was shown in keeping with the traditional iconography – the emaciated Christ wearing a loincloth, Longinus piercing his side with a spear, the soldiers throwing dice for his mantle on a drum, Mary-Magdalene praying and weeping, the vinegar-soaked sponge to wipe his face, and even the crosses of the two thieves just visible in the distance – but there was such a chaos of forms and colours that the painting became quite hallucinatory.

THE CRUCIFIXION
Paris, 7 July 1930, oil on plywood,
51.5 x 66.5 cm. (20 x 26 in.)
Paris, Musée Picasso.

119

Among the old masters, Grünewald had already ventured quite far along the pathways of horror, unlike Cimabue, who had set his perfectly serene Christ against a heavenly gold ground – as the fashion of the times required – and Tintoretto, who, working in the theatrical city of the Doges, had turned the Crucifixion into a spectacle of high drama. In an evocation of physical and moral suffering of rare intensity, Grünewald's Crucifixion, the central panel of the Issenheim Altarpiece, showed Christ's mortified body covered with wounds. The straining fingers of the hands pierced with long, spiky nails, the crown of thorns dug into the flesh, the half-open mouth frozen in a last gasp, the grotesquely twisted feet, every detail of this figure was designed to impress on the faithful the cruelty of the martyrdom endured by the Lord Jesus Christ to redeem their sins. This work is so powerful that, even today, no one can fail to grasp its message.

And yet, however tragic a figure he may be, the wounds and sores that cover Grünewald's Christ show instead the effects of flagellation: Roman law called for the victims to be whipped before being crucified, and for centuries this was considered as the most inhuman aspect of the punishment inflicted on the Saviour. Picasso's Christ, however, was clearly tetanized: the artist depicted him as he died, with his muscles totally cramped, finally succumbing to asphyxiation. Everything in this painting, its pitiless colours and stiff lines, contributed to this ghastly impression.

Did Picasso know about the experiments conducted by Dr. Barbet? This possibility is not to be excluded, for the dates happen to coincide. In any case, the ill-treatment to which he had subjected his Woman in an Armchair and other such female monsters found its culmination in this Crucifixion. If the effects of eroticism, as we have seen, distort the normal bodily image, what disjointed the anatomy in this picture was not the libido, but the most horrendous suffering that a human being can endure. Whereas Analytical Cubism attacked the outer world through successive fragmentation, corrosion and erosion, as if the eye were orbiting around the objects, Picasso now worked from the inside out: his painting, influenced by automatism, became a spasm that disrupted life with every stroke of the brush.

Picasso's drawings after Grünewald were among the darkest works he ever produced. In Dante's Divine Comedy, which exerted a major influence on Medieval painting, we can read the following: «On this Cross, the splendour of Christ shone so greatly that words fail me.»

Another passage reads: «from one arm to the other, and from head to foot, coursed a light that sparkled more intensely where it converged and crossed.» This was already a foretaste of the Resurrection, which, in Picasso's *Crucifixion*, was perhaps hinted at by the spectral quality of the light. But in Picasso's drawings, all such hopes were absent, all that remained was the despairing cry: «My God, my God, why have you foresaken me?» (Matt. 27: 46). Reduced to a gigantic boneheap, Christ was doubly and definitively dead – both physically and spiritually.

During the years that followed, weary of portraying the torments of his personal life, Picasso painted less and less. Only eighty paintings and drawings are catalogued for the year 1935, and forty in 1936, a vastly inferior number in comparison to his average annual production. In those two years, there was a long period in which he did not even take up his brushes, but wrote texts with words clashing together in the Surrealist manner. Considering the fact that painting had always been his life, this was most surprising.

Be that as it may, the theme of the Crucifixion, like that of the bullfight, referred to more than the mere details of his personal life. The scene in which the soldiers mock Jesus – «Hail, king of the Jews» – which precedes the Crucifixion in the scriptures, was a hagiographic ploy to show how Jesus' divine majesty was ignored and sullied by the blindness of mortals. The spear thrust into his side by Longinus was less a merciful coup de grâce owed to the victim, than the blow that brought forth the wine of the Eucharist and the water of Baptism. The sudden darkening between the sixth and ninth hours was nature's way of expressing its grief at the death of an exceptional being.

With this *Crucifixion* and the series of drawings after Grünewald, and in spite of the creative impasse that ensued, Picasso had taken decisive steps in the direction of the archetypal and the collective. This was to be even more evident in the spring of 1937, after he had taken up his brushes again and begun to paint what became one of the most famous pictures of this century: *Guernica*.

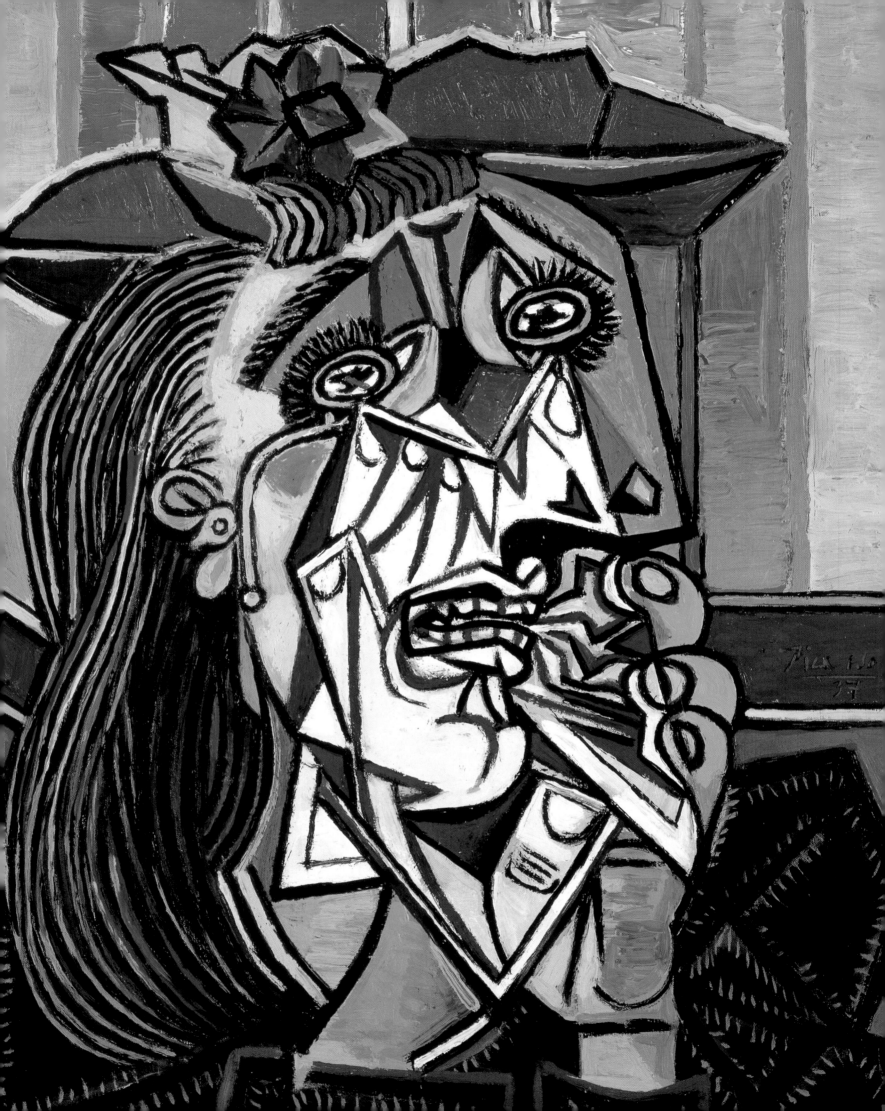

4

THE VICTOIRY OF GUERNICA

In February 1936, at the «Deux Magots» café in Saint-Germain-des-Prés in Paris, Paul Eluard, who had become one of Picasso's close friends, introduced the painter to a young woman. She had black hair and dark, striking eyes; the artist had noticed her at a nearby table and had called over to her in Spanish. She recognized him and smiled. Yugoslavian by birth, she had been raised in France and her father lived in Argentina. Her real name was Dora Markovitch, but she preferred to be called Dora Maar. On18 July, civil war broke out in Spain. Picasso was then in his fifty-fifth year. Dora Maar, bright, anxious, and an excellent photographer who had given up painting because she felt she was not talented enough, was to be his constant companion throughout this period which, once again, was to give birth to work of genius.

The 1937 Paris World's Fair was soon to open. Sprawling on both banks of the Seine around the Eiffel Tower and the Palais de Chaillot – which was rebuilt for the occasion – it became a major event, featuring such technological breakthoughs as cinemascope and television. Dominated by the two colossal pavilions of Nazi Germany and Soviet Russia, which stood opposite each other, the Fair also included many

WOMAN CRYING

Paris, 26 October 1937, oil on canvas,

60 x 49 cm. (24 x 19 in.)

London, Tate Gallery.

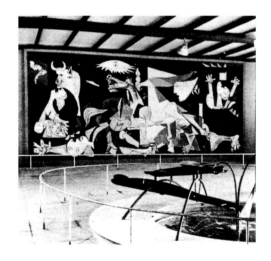

Guernica *in the Spanish pavilion at the World's Fair.*

other smaller participants such as Spain. The Republicans were still legally in power, and, as Picasso had openly voiced his opposition to Franco's insurrection, the government in Madrid commissioned him to paint a mural for the Spanish pavilion without specifying a subject, hoping only for a monumental and powerful work.

In early January of that year, the artist had written and illustrated a pamphlet titled *The Dream and Lie of Franco*, which was composed like a comic strip and consisted of fourteen etchings depicting the grotesque exploits of a polyp-like creature caricaturing the "Caudillo". The World's Fair was to open in May, and, although work should already have been underway, inspiration was lacking. Picasso spent his time pacing about like a caged animal in the studio Dora Maar had found for him at 7, rue des Grands-Augustins, which was spacious enough to paint a monumental canvas.

This was the state of affairs in the last week of April, when the world learned with shock of the aerial bombardment of the small Basque town of Guernica. The raid carried out by German aircraft of the Condor Legion under the command of Lieutenant-Colonel von Richthofen – the future marshal – lasted no less than four hours, between mid-afternoon and nightfall. The Junker 52s and Heinkel 51s based at Vittoria attacked in successive waves, dropping fifty tons of high explosives on the little town, including thousand-pound bombs and incendiaries to set the demolished houses on fire. Monday was market day in Guernica, which accounts for the scale of the tragedy: in addition to the local population and refugees, there were many peasants who had not been dissuaded from selling their products in town by the proximity of the front. In all, the attack left some 1,664 dead and 889 wounded.

More decisive than the bombing, however, was the «Guernica Affair,» which made a profound impact on public opinion. At the time, France was governed by the left-wing coalition known as the Front Populaire. It opposed war against Hitler believing that France could only lose. At the same time, however, it feared that a popular insurrection might force it to go to war, and therefore sought to conceal the truth, giving credence to the Nazi version of the facts, according to which the Basques themselves had destroyed the town for propaganda purposes. Nevertheless, public opinion was split into two opposing camps, not only because people who had actually witnessed the air raid were arriving from Spain, but also because the American and British press – still free to cross the borders – published reports from its war

Ce soir

6e édition — 6e édition

GRAND QUOTIDIEN D'INFORMATION INDÉPENDANT

Ope. 99.34 - 15.60 (8 lig. groupées) — 30 cent. — Samedi 1er Mai 1937 — 30 cent. — 31, rue du 4-Septembre, Paris-2e

AU PONT BINEAU
deux voitures se sont rencontrées

L'avant d'une des voitures, témoigne de la violence du choc. **LIRE PAGE 3**

L'accident
d'une grande violence a fait deux morts et deux blessés graves

Le dépeceur COLLINI
était-il l'adepte d'une secte ?...

Les Assises du Rhône jugent aujourd'hui ce personnage étrange

De notre envoyée spéciale Edith THOMAS

Lyon, 30 avril. — (Par téléphone.) — Lyon, ville sombre, enfumée, vous murmure, fleuve léoland à fleuve de la grandeur démocrate de Londres avec la cathédrale plus parsemée encore.

Le pied noue aux pierres contre à la peau, et c'est par ces passages l'hôte tente de s'enduir pour qu'aucun de ses pratiques les plus mystérieuses et les plus folles celles d'un autre temps où la terre hostile à l'imprenomable se prestait être dominée que par le sonderage.

(LIRE LA SUITE DANS LA 7e PAGE)

LE CUIRASSE INSURGE "ESPANA"
coulé devant Bilbao

D'UN DES ENVOYES SPECIAUX DE L'AGENCE HAVAS

Bilbao, 30 avril. — Le cuirassé insurgé « Espana » a été coulé par l'aviation loyale.

CE QUE SERA LA FÊTE DU TRAVAIL

Deux grands cortèges défileront demain
A TRAVERS PARIS
pour se disloquer à la porte de Vincennes

Avant la dislocation MM. Léon Jouhaux et Henri Raynaud prononceront des discours qui seront radiodiffusés par les postes d'État

Qui n'a pas son brin de muguet porte-bonheur ?

Les organisations ouvrières assureront le transport des manifestants et les besoins normaux de la population

M. RACAMOND secrétaire général adjoint de la C. G. T. dit à "Ce soir" le sens de cette journée

M. Racamond nous a reçu dans son bureau du nouvel immeuble de la C. G. T., un building blanc et ensoleillé, digne d'une organisation forte de cinq millions d'adhérents.

« Nous nous préparons, nous a-t-il dit, à célébrer, en ce Premier Mai 1937, les victoires salariées par des luttes longues et rudes. Cette année, le 1er Mai sera la fête des quarante heures, des congés payés, la fête célébrant une vie un peu plus saine et un peu plus joyeuse pour les travailleurs.

« Toutefois, beaucoup reste encore à faire [...]

« Trop souvent, les réformes décidées, souçonneusement sabotées, restent lettre morte. C'est pourquoi nous nous préparons également à rendre sensible à l'opinion, le 1er Mai, notre légitime impatience de voir enfin les lois socialectivement et également appliquées, avant d'être étendues à des catégories toujours plus larges de travailleurs...

« En même temps, le 1er Mai 1937 manifestera puissamment la solidité de notre C. G. T., qui résiste à toutes les attaques dont elle est l'objet.

« Malgré la pression patronale et la concurrence des syndicats fondés par le grand patronat, nous enregistrons tous les jours de nouvelles adhésions.

« Les effectifs de presque toutes nos fédérations vont constamment en progrès.

« Notre plus cher désir est de voir l'unité syndicale, qui a donné de si brillants résultats sur le plan national, se réaliser enfin sur le plan international...

« Disons que notre 1er Mai sera l'expression de cette volonté qui s'affermit tous les jours.

« Enfin, le bilan, satisfaisant bien qu'incomplet, de notre action, ne nous fait pas oublier que nous n'avons pas cessé de nous préoccuper de l'Espagne républicaine aux prises avec le fascisme international. Dans cet ordre d'idées, nous signifierons notre...

...solidarité de ne pas tolérer l'invasion du sol espagnol par les armées étrangères... c'est l'intérêt de la France elle-même.

« Il faut que cesse enfin la carence des démocraties, que les mesures soient prises contre les actes de guerre internationale que constitue l'intervention fasciste en Espagne.

« Voilà le sens que nous allons donner à la fête du Travail du 1er Mai.

LES DEUX CORTÈGES

Cette grande journée formera deux cortèges, qui se rejoindront, à la place de la Porte pour aller, sur double largeur, jusqu'à la Porte de Vincennes.

Les textes, avec front groupés, cette fois, par profession, avec leur syndicat.

La tête du cortège, place Voltaire, sera composée par le Bureau et la Commission administrative de la C. G. T. et de l'Union des Syndicats de la Région parisienne. Les membres du Comité national et régional du Front Populaire seront aussi.

Puis, par le boulevard Voltaire, la place de la République, le boulevard Magenta, le faubourg Saint-Martin, jusqu'au rond-point de la Villette, se formera le premier cortège.

Le second cortège partira de la place de la Bastille, par la rue de Lyon, l'avenue Daumesnil et le boulevard Diderot. La concentration sera occupée: vos boulevards, entre la Bastille et la République, le boulevard du Temple, la rue Réaumur et le boulevard Sébastopol, jusque vers le Châtelet.

Le premier groupe du premier cortège sera formé par les syndicats du Bâtiment; le premier groupe du deuxième cortège par les métallurgistes, et les deux grandes Fédérations de la région parisienne marcheront côte à côte sur les Cours de Vincennes. **LIRE EN PAGE 3**

VISIONS DE GUERNICA EN FLAMMES
A Galdacano 22 trimoteurs allemands ont mitraillé la population

Un de nos photographes vient de rentrer de Guernica avec ces photographies qui montrent la ville historique en flammes et un vieillard de 81 ans que les bombes ont blessé. On lira dans la page 3 le récit de notre reporter photographe, les informations et les dépêches de notre envoyé spécial Mathieu Corman

300 millions d'œuvres d'art arrivent à Paris

« La Vierge », de Jean Fouquet, du musée d'Anvers.

...Pour l'exposition des chefs-d'œuvre de l'art français : 18 nations ont contribué à son succès

par Georges-Henri RIVIERE

Lire l'article dans la neuvième page

A 950 MÈTRES SOUS TERRE UNE EXPLOSION...
Dix-sept victimes dont deux ont succombé sont ramenées à la surface

Charleroi, 30 avril. — (De notre correspondant particulier.) — A six heures ce matin, l'aube était à peine levée qu'une nouvelle sinistre se répandait dans un trois des quartiers populeux de Marcinelle.

Le coup de grisou au Grand Mambourg ! se répétaient avec effroi les femmes dont les époux étaient déjà descendus à leur travail.

Hélas ! cette veille du 1er mai, qui est toujours celebrée avec une particulière ferveur par les mineurs de Charleroi, se transformait en une journée de deuil.

(De notre correspondant particulier) Lire la suite dans la 7e page

L'agent de Franco à Toulouse
interviewé malgré lui

Lire l'article de Charles REBER dans la neuvième page

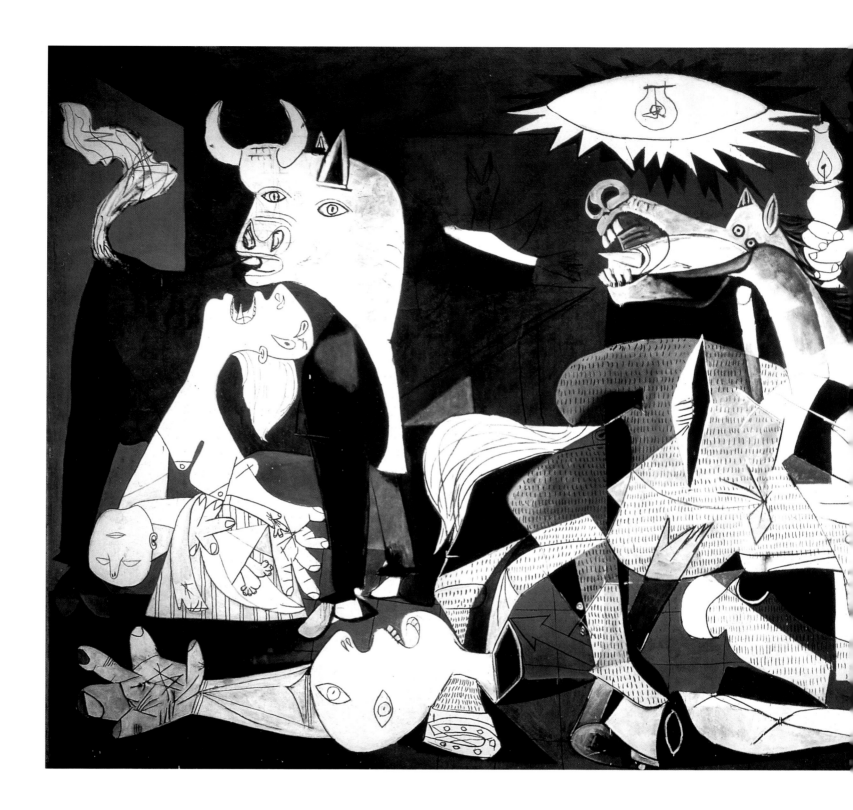

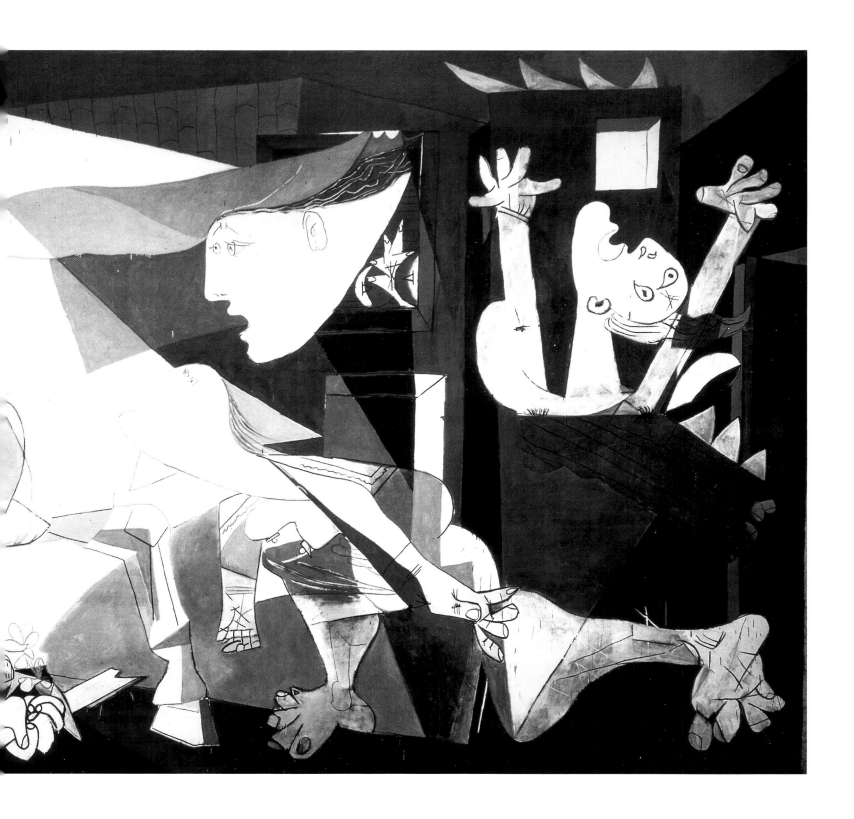

Studies for *Guernica*.

HORSE

Paris, 1 May 1937, pencil on paper,
21 x 26.9 cm. (8 x 11 in.)
Madrid, Museo nacional del Prado.

HORSE

Paris, 1 May 1937, pencil on blue paper,
21 x 26.8 cm. (8 x 11 in.)
Madrid, Museo nacional del Prado.

correspondents that left no doubt as to the identity of the perpetrators of the massacre.

It was in the midst of this feverish atmosphere of contradictory press releases and radio broadcasts that *Guernica* was born.

Picasso's decision to paint this subject was sparked by the headlines in the Friday 30 April issue of *Ce Soir*, a daily directed by Aragon which broke the news of the Nazi air-raid in a four-column spread, publishing three photographs of the ruined town. Picasso was shattered by the news and executed his preliminary studies for the picture the following day. He began with a series of sketches on blue stationery paper: one horse drawn in a childlike awkward hand, another slumped on its knees, the impassive figure of a bull, a grieving mother carrying her dead child in her arms, and large close-ups of victims of the bombing. According to Malraux, who visited the painter in his studio at the time, there were about a hundred preparatory drawings and gouaches, fifty-five of which have been preserved.

In a recent publication, one young historian has insinuated that Picasso was no more than a lukewarm supporter of the Republican cause. As proof, she claims that it was only after seeing photographs of his wounded compatriots that he belatedly rallied to their cause[1]. But this is beside the point; the important thing is to realize the role played by the increasing spread of mass communication in the form of newspaper headlines and photos, for they created a new, totally-present vision of reality to which Picasso readily responded. Breton, a more discerning commentator, who initially did not like *Guernica*, considering it too political for a work of art, changed his mind in 1939, on the eve of the Second World War, remarking with great lucidity: «The problem is no longer to know if a painting *bears up* in a wheatfield, for example, but rather if it can *bear up* alongside a daily newspaper, which is a veritable jungle.»

The painting of *Guernica* was like the sounding of an alarm. Asked why there was no colour in his picture, Picasso would exasperatedly reply that he had been pressed for time and had not been able to finish the picture. But *Guernica* was black, grey and white just like the contemporary newspapers which delivered the terrible truth to the man in the street. Ink black like the photos that were cabled from the front at Biscayne and that featured so much contrast that they created a shock effect on the viewer

1. Laurence Bertrand-Dorléac, *L'art de la défaite*, Le Seuil, Paris, 1993, pp. 190-194.

even before he could identify the image. *Guernica* was an indictment plainly written in black and white accusing the democratic governments of procrastination and blindness in the face of the Nazi threat.

«NO, IT WAS YOU!»

At the beginning of June, after the Fair had already been opened to the public, *Guernica* was transferred from the studio and installed in the entrance hall of the Spanish pavilion. Inscribed in block letters at the bottom of the large frame surrounding the two hundred and eighty square-foot canvas – the picture measured eleven and a half feet by twenty four and a half feet – there was a poem by Paul Eluard, *The Victory of Guernica*:

> «…May the men for whom this treasure was sung,
> May the men for whom this treasure was spoiled,
> May the true men for whom despair
> Feeds the fires of hope,
> Together, may we open the last bud of
> The future…»

The tone was set. Unlike such famous history paintings as *The Entry of the Crusaders in Constantinople* or *Napoleon in the Pest-house at Jaffa*, and despite the fact that it was commissioned and would not otherwise have come into existence, *Guernica* was neither an occasional, nor a hagiographic work. The figures of women, their bodies turned inside out like gloves of charred flesh, the mutilated warrior clutching his broken sword, the horse in its death throes, everything in this painting reached well beyond the event which had inspired it. *Guernica* was about revolt, suffering and murder, concerns which had always preoccupied the artist. In a special issue of the *Cahiers d'Art* which came out soon afterwards, Michel Leiris wrote: «In a black and white rectangle like an ancient tragedy, Picasso sends us our funeral letter: everything that we have loved is due to perish.»

I devoted an entire book to *Guernica* several years ago[2], and it is no easy task to analyze this work in a few pages. I will, however, briefly demonstrate how this famous picture combined Surrealism and Cubism, and how they contributed to creating a graphic indictment of the spiritual bankruptcy of our society.

Page 126 and 127

GUERNICA

Paris, 1 May - 4 June 1937, oil on canvas, 349.3 x 776.6 cm. (138 x 306 in.) Madrid, Museo nacional del Prado.

1. Jean-Louis Ferrier, *De Picasso à Guernica, généalogie d'un tableau*, Denoël, Paris, 1985.

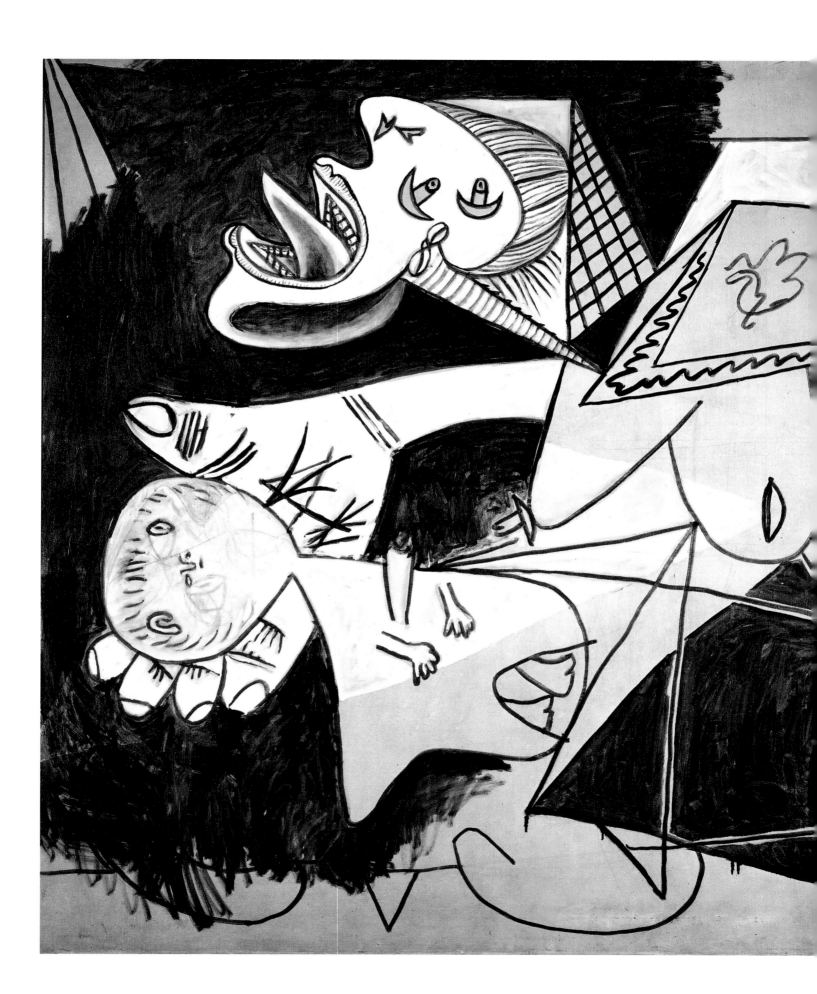

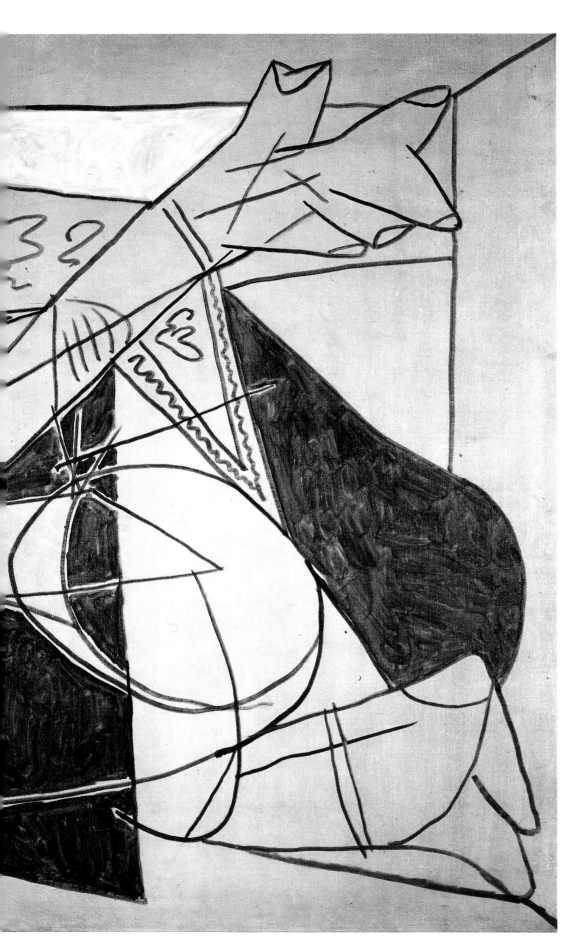

MOTHER WITH DEAD CHILD

Study for *Guernica*.

Paris, 22 October 1937, pencil, coloured

chalk and gouache on paper,

23.2 x 29.2 cm. (9 x 11 in.)

Madrid, Museo Nacional del Prado.

For example, the eye-sun which dominates the composition at the top is simultaneously pupil, lampshade and light bulb, in other words a typically Surrealist assemblage of random elements. The photographs of the work in progress taken by Dora Maar show that it originally took the form of a sunflower with a ring of spiky petals and a fist clenching an ear of wheat (a contrived borrowing from Soviet iconography which he soon dropped). A similar combination in the lower right section of the painting turns the flames of a burning house into the teeth of a hellish maw, which are further transposed into the dagger-like tongues of the horse, and the grief-stricken mother carrying her dead child, wailing to the heavens.

Furthermore, the few close friends who were permitted to enter Picasso's studio during the five or six weeks he worked on the picture all reported that the painter was almost constantly in a sort of trance. Although we cannot speak of automatism in Masson's sense here, it is evident that *Guernica* was created in a fever of gestural activity – the many paint drippings still visible are proof of this. The artist's figures have been reduced to bundles of reflexes, as if charged with electrodes, convulsing under the cold stare of an electric sun which symbolized the war of nerves as much as it did the slaughter of a civilian population.

Except for its dagger-tongue, the horse owes much to Cubism. Along with the grieving mother, this is the figure to which Picasso devoted the most studies before and during the elaboration of the painting. Its massive jaws, the eyes pinned to the same side of the head, and its archaism present obvious analogies with the *Demoiselles d'Avignon*. Its structure, which ranges from a flattening of the body and legs to their re-arrangement in separate facets, looks as if it had been cut out of a newspaper, and its mane precisely aligned like lines of type recall the papiers collés and montages of Synthetic Cubism. Heeling and staggering, its side pierced by a spearhead in a distant echo of the bullfight, it was Picasso's perennial symbol of the victim.

The oblique, lop-sided, spatial construction in *Guernica* also derived from Cubism. It is an emotional and immaterial space with neither inside nor outside. An impossible street lined with demolished buildings leads without transition to the interior of an equally impossible house, in total defiance of Euclidian perspective which traditionally organized and articulated the visible world. It is a labyrinth with no exit, peopled by spectral, insubstantial phantoms fleeting across the two-dimensional surface of the canvas. An insoluble logical stalemate.

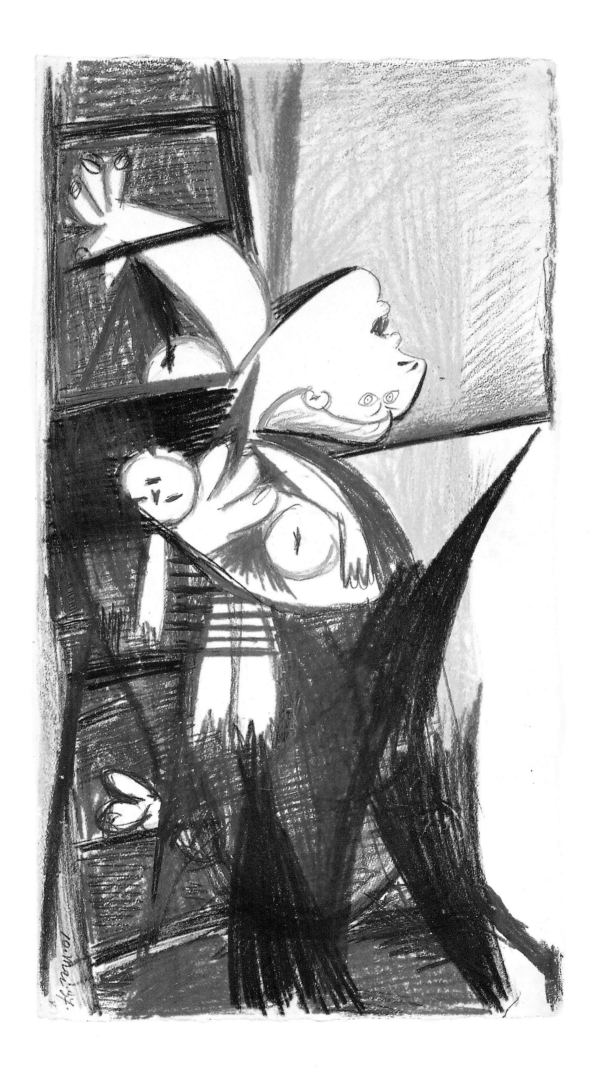

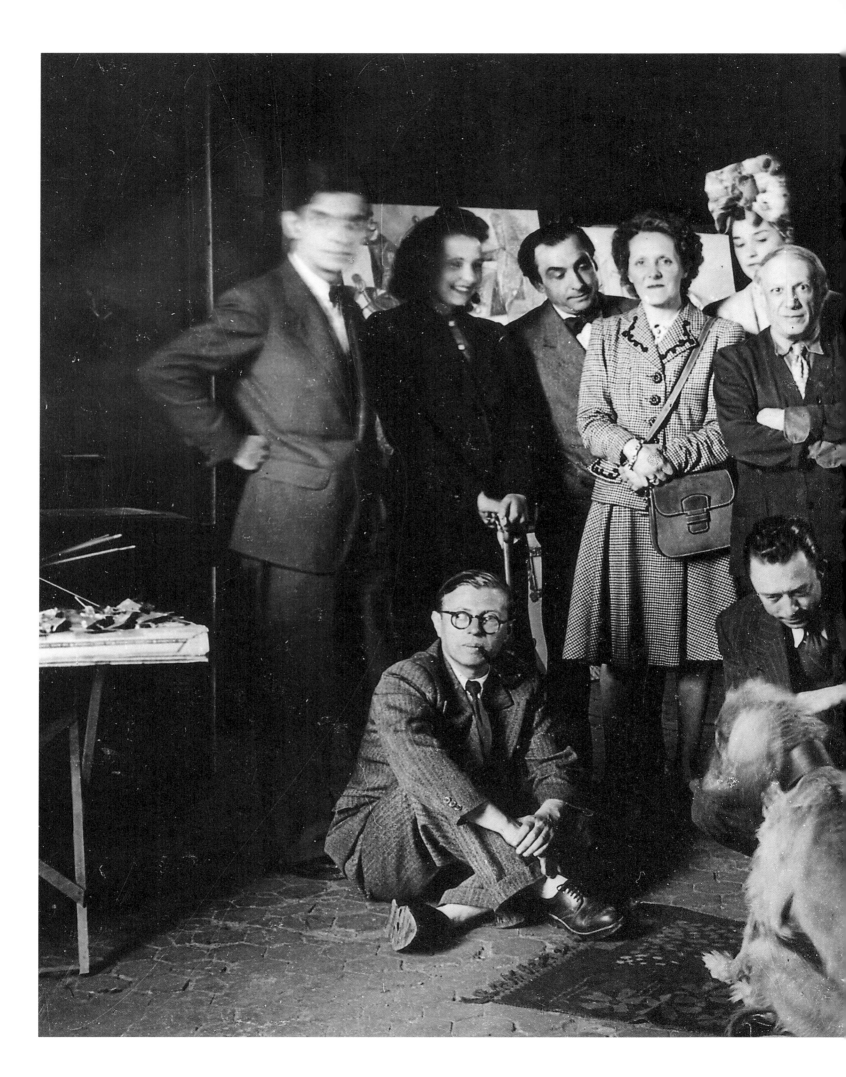

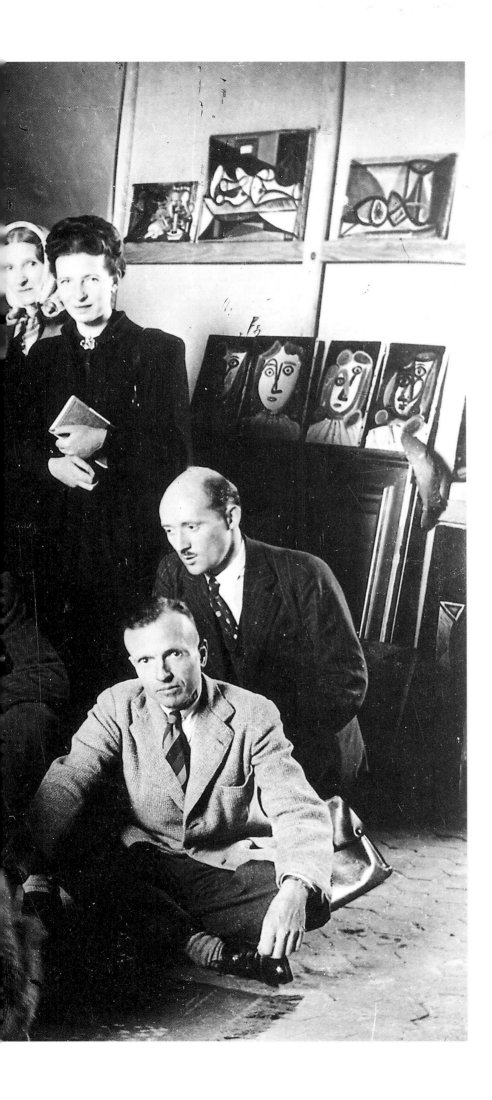

LE DÉSIR ATTRAPÉ PAR LA QUEUE

Photograph taken by Brassaï on 16 June 1944 in Picasso's studio in rue des Grands-Augustins. The artist invited the actors who had participated in the first reading of Le désir attrapé par la queue («Desire Caught by the Tail»), a farce in the surrealist style which he had written in two days early in 1940. The reading of his play was held on 19 March in the apartment of Louise and Michel Leiris. Stage direction was by Albert Camus, and the main parts were played by Michel Leiris (the large foot), Raymond Queneau (the onion), Simone de Beauvoir (his cousin) and Jean-Paul Sartre (the round end). Seldom has a play had such a distinguished cast. Standing, from left to right: Jacques Lacan, Cécile Eluard, Pierre Reverdy, Louise Leiris, Zanie Aubier, Pablo Picasso, Valentine Hugo, Simone de Beauvoir. Seated: Jean-Paul Sartre, Albert Camus, Michel Leiris, Jean Aubier and Kazbek, the artist's Afghan hound. Among those not present: Raymond Queneau and Dora Maar (the lean anguish).

Paris, 1943, bronze, 222.5 x 78 x 78 cm.

(88 x 31 x 31 in.)

Paris, Musée Picasso.

Written in 1923, in the aftermath of a world war that had left eight million dead, Freud's *The Ego and the Id* revolves around a notion that the author had long intuited and rejected: that of a death urge lurking in the human soul. Traditional morality maintained that man was good, wise and caring, and that if he acted brutally, the reason lay in personality disorders or the vicissitudes of history. Instead, the constant manifestation of aggressive drives now seemed to be our sad and dramatic lot. In his earlier work, Freud had been content to base human behaviour on the libido, arguing that any disorders that arose could be attributed to the caprices of Eros, and claiming that psychoanalysis would be able to restore order. But his discovery of the Id showed that a realm of subconscious activity that remained mostly inaccessible to our understanding constituted the true basis of our psychological existence.

Appearing on the eve of another worldwide conflagration, and with already thousands of victims in Spain, *Guernica* could well be considered as a representation of the Id.

Picasso's cruelly distorted bodies were to our modern times what the angels in Medieval painting were to the Age of Faith. His disarticulation of anatomy began within the context of his erratic love life shortly before the 1930s, was then given a technical basis by automatism, and finally became reality with the aerial bombing of a small Basque town. Yet although this atrocity provided a decisive impulse, it was only an incidental cause: *Guernica* was a collective crucifixion, a latter-day massacre of the innocents, and the child of the *mater dolorosa*, a stillborn Christ. This irruption of monsters expressed the dead end that confronts man when heaven is emptied, leaving him to be buffeted about by fate and bringing civilization to a standstill.

Not surprisingly, despite the clearsightedness of a few and the emotion it elicited in many, *Guernica*'s message was not so readily perceived by his contemporaries. Some of the Spanish Republican officials, who would have preferred a social-realistic picture, found the monumental work to be «antisocial, ludicrous and completely at odds with the sound spirit of the proletariat.» Critics went so far as to demand its removal from the Spanish pavilion, but, in view of Picasso's international reputation, it remained. Today is another matter, however, and it is dismaying to see how often this picture is misunderstood. We can even still find traces of the argument advanced at the time by the Marxist theorist Max Raphael, who held that *Guernica* was nothing more

than an allegory of the artist's personal obsessions and finally – the supreme insult – no better than a petty bourgeois artwork[1].

When the Second World War broke out on 1 September 1939, *Guernica* was on exhibit at the Museum of Modern Art in New York, where it was to remain for another forty years. Its artistic and psychological impact in the United States was to be considerable. Picasso decided that it would stay there until democracy was restored in Spain. When Juan Carlos came to power, his heirs judged that the conditions had been fulfilled, and it was transferred to Madrid in late September 1981. It was initially installed in the Buen Retiro Wing, an annex of the Prado, but later moved to the recently-opened Museo de la Reina Sofia. Protected against terrorist attack by a bulletproof window, it is one of the most visited paintings in the world, coming second only to the *Mona Lisa*.

A latent theme running through Picasso's work during this period was the Minotaur, a hybrid monster born of the adulterous union of Pasiphae, the wife of King Minos, and a white bull. The artist had first treated it in 1928 in a collage composed of a bull's head combined with a pair of human legs. He returned to the theme in his design for the cover of the first issue of *Minotaur*, a literary review founded in 1933 by Albert Skira. This figure re-appeared in many different works, both paintings and etchings, until 1938. The figure of the bull standing on the left in *Guernica*[2] could well be a minotaur. This interpretation is suggested by its human eyes and the labyrinthine space of the picture: the legendary Minotaur was kept prisoner in the labyrinth at Knossos. A symbol of perverse domination, unbridled chaos and blind violence, it was a perfect prefiguration of what humanity was to suffer during the six years in which the world was to be subjected to Nazi aggression.

When France capitulated in June 1940, Picasso was staying in Royan, where he had fled with Dora Maar upon the outbreak of hostilities. After the armistice was signed by Pétain and Hitler, he had no reason to remain in his self-imposed exile, and returned to Paris in August, staying first at rue de La Boëtie, then in his studio in the rue des Grands-Augustins. He could very well have fled to the United States, where he was awaited with open arms, but he preferred to stay in France, no matter how dangerous the situation might be. Oddly enough, although he was the most outstanding representative of the «decadent art» which Hitler had proscribed throughout Europe, he was not harassed

1. Laurence Bertrand-Dorléac, *op. cit.*, pp. 190-194.
2. Jean-Louis Ferrier, *op. cit.*, pp. 19 et 20.

Picasso photographed by Brassaï in front of his
stove in his studio in rue des Grands-Augustins,
September 1939.

during the Occupation. Many German army officers who did not share the Führer's esthetic taste even came to visit him in his studio. But when the Kommandantur offered him coal in the hopes of earning his good graces, the artist flatly refused, saying: «A Spaniard is never cold!»

In another famous anecdote, to a German officer who had seen a photograph of *Guernica* at the rue des Grands-Augustins and asked if he had done it, the artist retorted: «No, it was you!» Retelling this anecdote many years later, Picasso presented a slightly different version: «Sometimes the *Boches* would come to me under the pretext of admiring my paintings. I would offer them postcards reproducing *Guernica* and say: 'Here, take them. Souvenirs! Souvenirs!'»

In addition to portrayals of women which still gave the human figure no respite, the painter returned to the theme of the still life in works such as the *Still life with a Bull's Skull* (1942), but, as we can see both from the handling and mood, clearly with a tragic edge. It was during this period, too, that he sculpted the *Man with a Sheep*, which today stands in the church square at Vallauris, and a *Deaths' Head* of amazing density. At the Salon d'Automne of 1944 – dubbed the Salon of the Liberation – the artist's courageous stand during the Occupation was commemorated with an exhibition of seventy-four paintings and two sculptures. It was assumed that the Parisian public would be eager to applaud his work, but the response was so violent that a team of guards including painters and students had to be formed to protect the pictures. The incidents inspired a protest by the Comité National des Ecrivains, with such signatories as Louis Aragon, Paul Eluard and Jean-Paul Sartre. On the opening day, 6 October, Picasso announced that he had joined the French Communist Party.

The discovery of the Nazi concentration camps inspired another large-format work titled *The Charnel House* (1945). Painted solely in shades of black, grey and white, it had the quality of the unbearable newspaper photographs showing the piled-up bodies of men, women and children who had been put to death in the gas chambers. Although Malraux praised this work highly, it had neither the power, nor the universality of *Guernica*.

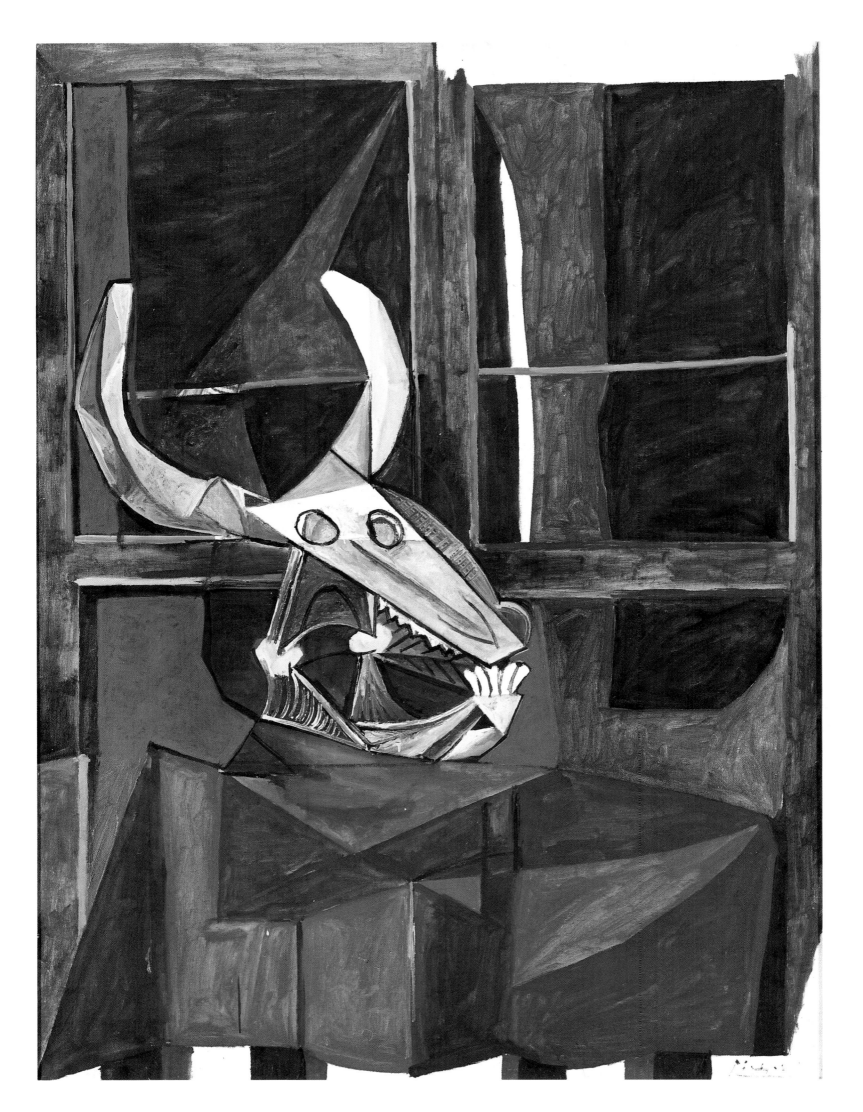

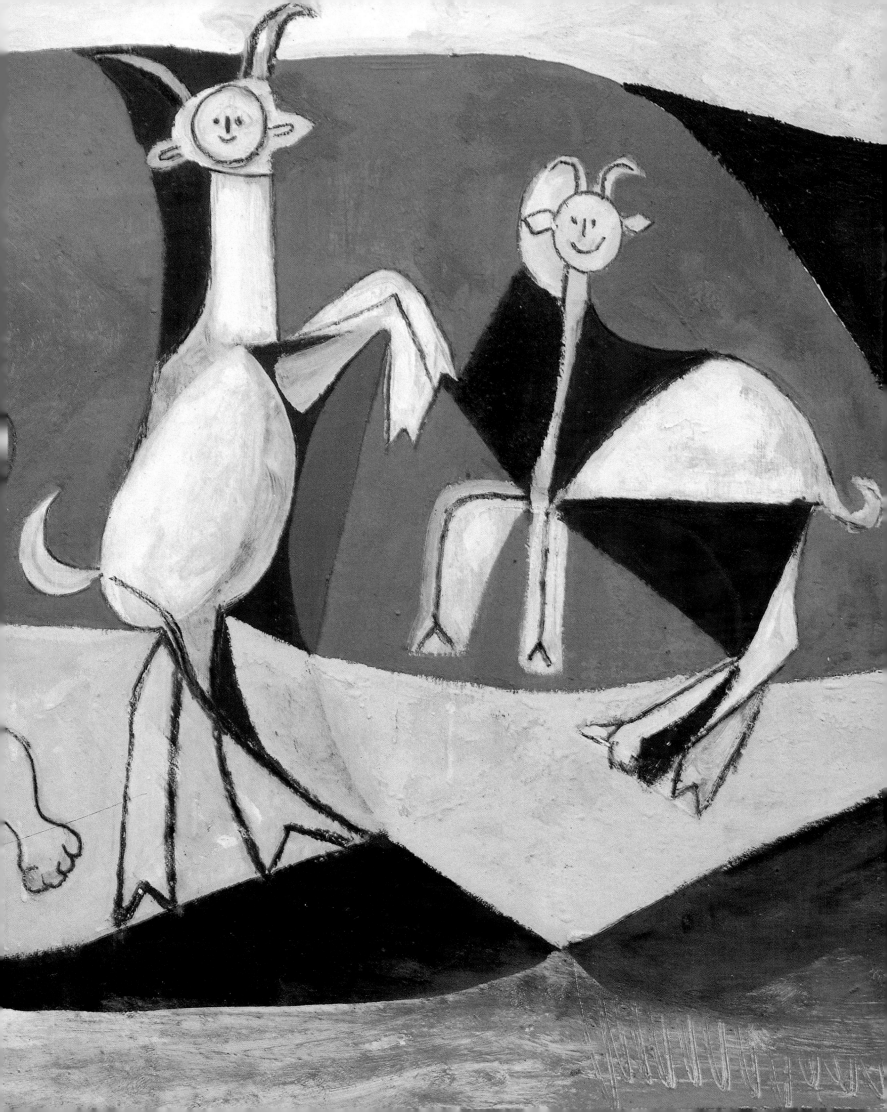

5

THE HALCYON YEARS

THE JOY OF LIFE

In the autumn of 1937, Picasso painted one of his most wrenching portraits, *The Weeping Woman*, generally considered as a dedication to *Guernica*. His model was Dora Maar, who had often been subject to fits of tears during the weeks he worked on the famous composition; not that she was more sensitive to the atrocities committed in Spain than the artist himself, but her beloved father was suffering from an incurable disease. With her red hat, clenched teeth tearing at a handkerchief, green, yellow and white nose, and cheeks spiked with sharp angles digging into the skin, *The Weeping Woman* was both an image of extreme suffering and the portrait of a person often prey to anxiety and metaphysical anguish.

No starker contrast could be found to the regular oval of Françoise Gilot's face in the many likenesses that Picasso left of her. They had first met in May 1943, in a Left Bank restaurant where she was dining with a friend and the actor Alain Cuny. She was the daughter of an industrialist, open-minded and unprejudiced, and had taken up painting after having abandoned philosophy studies. Picasso was attracted both by her beauty and by her unreserved admiration for him. The arrival of a twenty-year old

Opposite (detail) and overleaf

JOIE DE VIVRE (PASTORAL)
Antibes, fall 1946, oil on chipboard,
120 x 250 cm. (47 x 98 in.)
Antibes, Musée Picasso.

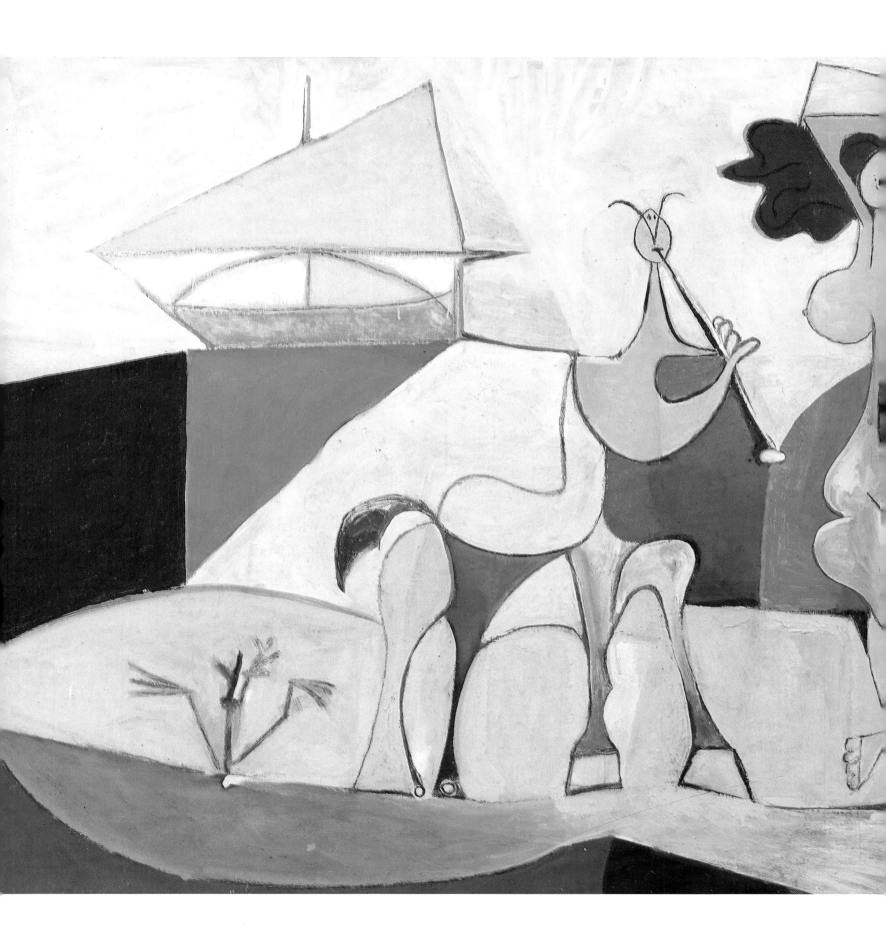

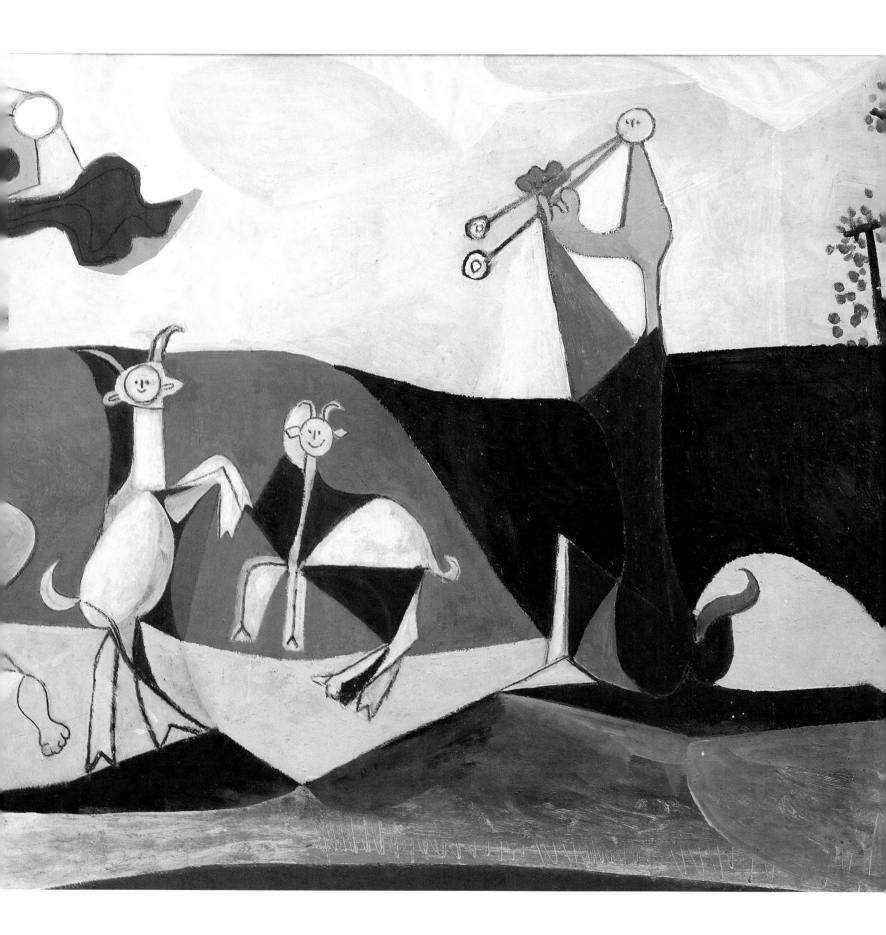

woman in the life of a man already in his sixties, on the brink of old age, was something of a miracle. Beaming with joy, he expressed this in his own way later, after the births of Claude in 1947 and Paloma in 1949: «Still making babies my age, how ridiculous!»

Picasso and Françoise Gilot, who had been intermittent lovers for three years, began living together in the summer of 1949. They were vacationing on the Riviera and the artist was looking for a studio, when Romuald Dor de la Souchère, teacher of classics in a Cannes high school and curator of the new archaeological museum that had been installed in the former Grimaldi castle in Antibes, offered him space to paint in vacant rooms on the second floor. This imposing fortress had a tower and terrace overlooking the Mediterranean and foundations dating back to Roman times. It was just the kind of old dwelling in which, paradoxically enough, the most innovative artist of the century always felt at home. He prepared himself by buying ordinary boat paint, large house-painters' brushes, installing spotlights in order to be able to work at night, and then, between August and mid-January, using the panels of fibrocement that were lying around for future building work, he created an imaginary world peopled with nymphs, centaurs, wanton fauns and music-playing tritons.

These cavorting figures appeared in over thirty compositions, usually of large format, like the *Triptych* which shows three enormous bucolic figures with laughing faces, or *Ulysses*, a free interpretation of Homer's epic, in which we see the hero's ship surrounded by sirens, seemingly enthralled by the savage splendour of the sea. Picasso was inspired not just by mythology but also by the market near the old town, and the subject matter of his paintings included melons, sea urchins – the smell of which he loved – sailors, a statuesque vegetable vendor, and an owl who visited him during his nights at the easel.

But the major work from this period was the medium-format *Joy of Life*. It gives the impression of a great wave of harmoniously combined blues and yellows framed by black planes of rock, and punctuated in the middle by a slender, full-breasted dancing girl with windswept hair. This latter-day Venus is flanked by a large-hoofed centaur playing the flute, two frolicking goats, and a faun playing reed-pipes, while a motionless boat under full sail appears peacefully on the horizon. The simplicity of the curves parallels the economy of the colour scheme, which is as unreal as the scene itself. The dancer's body is suffused with the blue of the sky as if it were transparent. Some mauve accents verge on purple. And while eroticism is omnipresent, there is nothing left of the sexual nightmares

of former times. In the words of one biographer: «It is a dream in broad daylight, a fairytale for grown-up children.[1]»

Picasso left the entire production of those four magnificent months behind, and in 1948, the Grimaldi castle became the first museum – before Barcelona and Paris – to be devoted entirely to the painter's work. In Antibes, the artist had rediscovered his fondness for metamorphoses, recreating a mythical Greece with its imaginary figures and an amazingly free pictorial handling. The clear light of Hellenic civilization had replaced the black sun of Spain. And by then he had become immensely famous. Ever since the Liberation of France, he had become the darling not only of art magazines, but was stalked by journalists, chroniclers and photographers of all stripes who eagerly recorded his every gesture and opinion.

This glory was never to fade. After his stay in Antibes, Picasso settled in Vallauris from 1948 to 1955, living in a graceless house that seemed oddly unsuited to his stature. Vallauris, a formerly prosperous centre of ceramic production, now turned out only old-fashioned ware and cheap souvenirs. One after the other, the kilns whose smoke had once darkened the surrounding hills were closing down. Almost by chance, Picasso was present at the annual ceramics, perfume and flower fair in the summer of 1946 and visited the Madoura pottery works, which were still in operation. Attracted by the potter's art, he decided to try his hand at it and soon became an passionate ceramicist.

The quantity of ceramic works that he produced within a few short years – several thousand pieces – is simply astounding. On a normal day, a potter would throw the pieces in the morning, in the afternoon Picasso would come and, pressing his fingers into the moist clay, transform a vase into a reclining ibex, then, with a pinch of the thumb and forefinger, turn a pitcher into a bird with an open beak, and with a caress of the palm change a jug into a woman's body. He also created dish and plate designs which his virtuoso brush decorated with bullfights, owls, fish, and pigeons with tufted heads, while he experimented with all the materials that were put at his disposal: metallic oxydes, slips, opaque and transparent enamels, silicate and lead sulfate glazes, and so on. Here again he overturned the traditional rules and explored techniques to their limits. Had an ordinary apprentice worked in such a way, he would surely have been dismissed on the spot. The purpose of his unorthodox

1. Antonina Vallentin, *Picasso*, Albin Michel, Paris, 1957, p. 383.

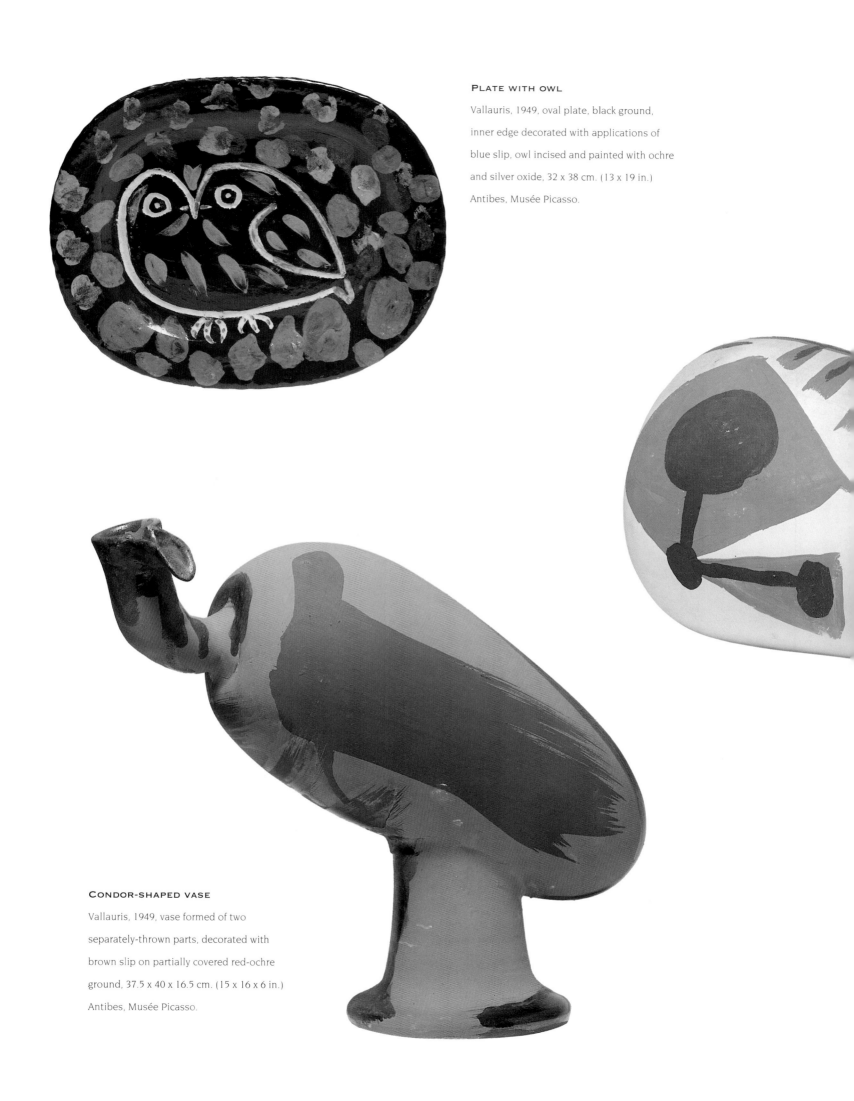

PLATE WITH OWL

Vallauris, 1949, oval plate, black ground,
inner edge decorated with applications of
blue slip, owl incised and painted with ochre
and silver oxide, 32 x 38 cm. (13 x 19 in.)
Antibes, Musée Picasso.

CONDOR-SHAPED VASE

Vallauris, 1949, vase formed of two
separately-thrown parts, decorated with
brown slip on partially covered red-ochre
ground, 37.5 x 40 x 16.5 cm. (15 x 16 x 6 in.)
Antibes, Musée Picasso.

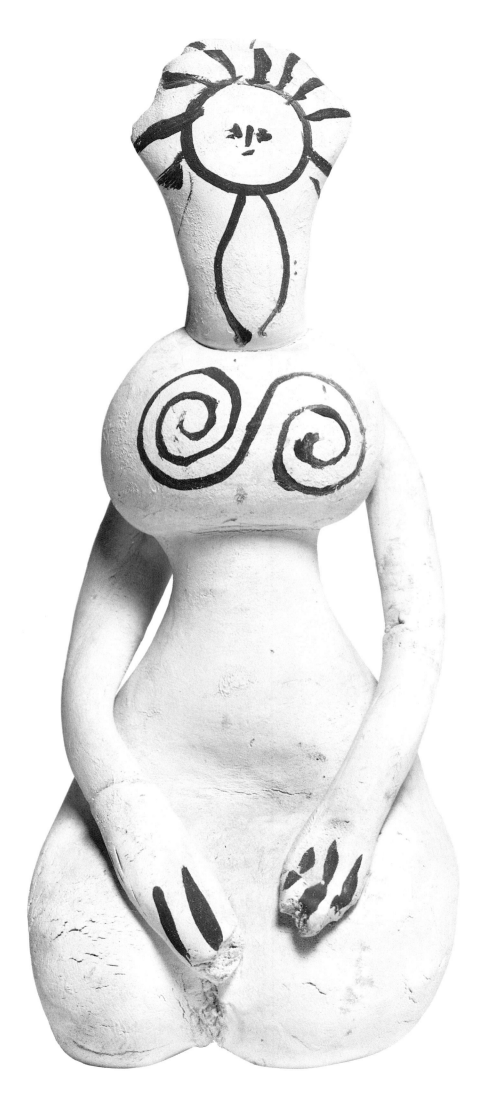

VASE IN THE SHAPE OF A RESTING KID

Vallauris, 1949, vase formed of two
separately-thrown parts, decorated with
brown and ochre slips,
32 x 19 x 32 cm. (13 x 7 x 13 in.)
Antibes, Musée Picasso.

TANAGRA WITH SPIRALS

Vallauris, 1947, thrown and modelled
figurine, decorated with slip on matt
ground, arms and hair added,
29 x 12 x 10 cm. (11 x 5 x 4 in.)
Antibes, Musée Picasso.

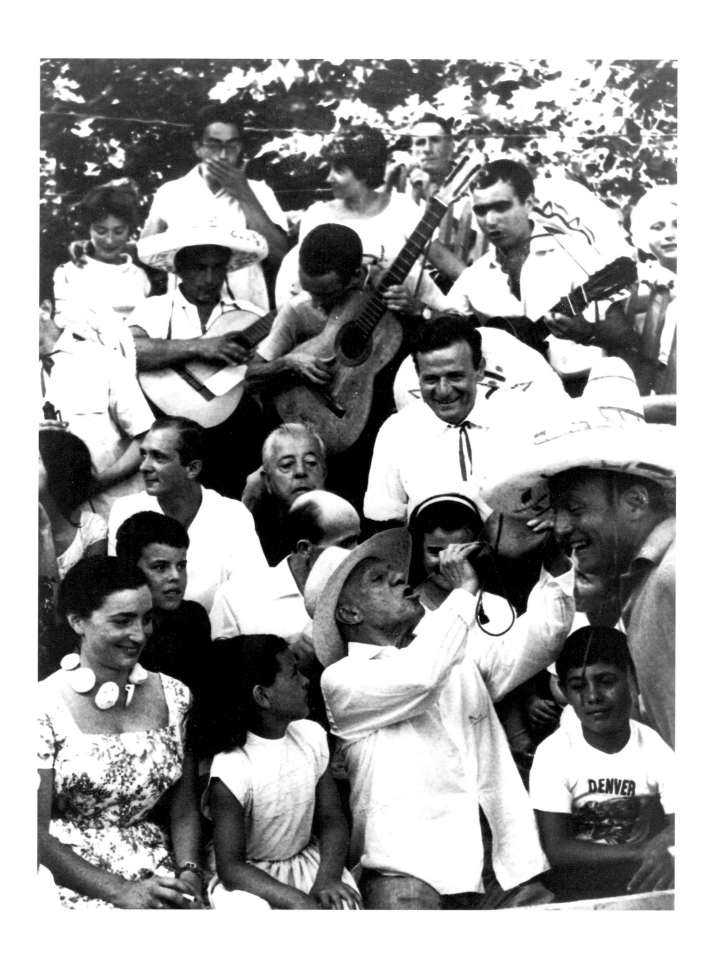

manipulations this time, however, was to create enchantment.

Picasso's ceramic works contained echoes from the Neolithic Age, when the Cycladic potters still fashioned their wares from coils of clay and Greek civilization was still at its unsuspected beginnings. Like the pyxids of Syros and Amorgos, they had asymmetrical bellies; like the oenochoi with upturned spouts from Phylakopi, they were zoomorphic. Although designed to contain liquids and food, they seem worthy of ritual ceremonies. Today, the wares from Vallauris, handcrafted after original designs by Picasso, are famous throughout the world.

Rarely – if ever – has an artist had the opportunity to rescue a dying community. During these same years, Picasso devoted himself not only to ceramics, but continued his quest for an ephemeral happiness in paintings of spellbinding tenderness.

Shortly before their move to Vallauris, Picasso and Françoise had had a son, Claude, and a daughter, Paloma, was born in 1949. They were the subject of such works as the *Portrait of Claude and Paloma* and *Woman Drawing next to Her Children*, both from 1950. The first of these pictures shows a red and black-cheeked Claude at the wheel of a red toy automobile, seemingly about to run Paloma over as she lies on a rug. The broken lines and strident colours perfectly express the turbulence of children's games. In the second picture, the little girl is seated in a high-chair while her brother crouches at her feet playing with a toy train and Françoise, drawing, watches over them. Paloma's rattan chair, dress, bib, laced-up shoes, her mother's serenity and the simplicity of the colour scheme create an impression of great peace and intimacy.

Mother and children were a recurring theme in Picasso's work, beginning with the portraits of Paulo during his childhood in the 1920s. But when the artist had represented his eldest son, he not only used an academic manner, but also showed him in flattering poses, disguised as Harlequin or riding a pony in the Luxembourg Gardens, fresh from the lap of his English nanny. Nothing more of the kind was to be seen here. In the late 1940s, he was living in the most modest of villas and professing to all and sundry: «Only those who can afford luxury can scorn it!» The children, after another day of romping about, were surely not very clean, and there was a sickly smell of milk in the air. Few painters have explored the bitter-sweet mysteries of childhood to such a degree.

For Cocteau, Picasso was a gypsy who liked to keep his luxuries simple, like sleeping under a golden bridge. But during the Vallauris years, the artist was more of a ragpicker or scrap collector. He would

Pablo Picasso with his children and Jacqueline watching a bullfight in Vallauris, 1958.

scrounge around the junk heaps and return to his studio with his arms full of such priceless treasures as odd bits of wood or sheet-metal, rusty wires, broken baby carriages, crushed boxes, tattered baskets, etc. The *She-Goat* from 1950, his second most famous sculpture after *The Man with a Sheep*, was created from an assemblage of many different elements – a broken basket for the belly, two small jugs for the teats, the rib of a palm frond for the backbone – the whole being coated with plaster. Another sculpture, *The Crane* (1951), was made from an old faucet with bent forks for the feet. The two sculptures were later cast in bronze, and *The Crane* touched up with paint.

July 1954 saw the inauguration of the Temple of Peace in Vallauris, Picasso's gift to the town which had just made him an honorary citizen. There was a two-day-long celebration with parades of Arlésiennes, gypsy girls and toreros perched on a sky-blue automobile decorated by Picasso with bull's horns, and the artist himself playing the trumpet in the bandwagon that followed. Many of the painter's close friends and admirers were also on hand, including Jacques Prévert, Edouard Pignon and Hélène Parmelin. One of the highlights was a burlesque bullfight attended by three thousand spectators packed into a makeshift arena. Françoise Gilot made a much-applauded appearance on horseback. An all-too brief taste of the joy of life.

STALIN'S MOUSTACHE

These happy years were also a time of political militancy for Picasso. In April 1949, seeking to give maximum publicity to the coming World Peace Congress in Paris, Aragon asked him to design a poster. Pressed for time however, Aragon picked out the existing lithograph of a pigeon from the artist's studio, re-christened it *The Dove*, had it printed by the thousands and posted in the streets of the French capital. It became a popular favourite and soon appeared in workers' homes alongside the traditional post-office calendar and reproductions of Millet's *Angelus*. This image eventually found its way around the world and became known to people of all creeds and races. Who said that Picasso's work was restricted to a small circle of connoisseurs? Seldom has an artist appealed to such large segments of the population in his own lifetime.

In 1950, North Korean troops crossed the 38th parallel and captured Seoul. Protesting against the atrocities committed by Americans after their entry in the conflict, Picasso painted the large *Massacre in Korea*

SHE-GOAT

Vallauris, 1950, bronze,

120.5 x 72 x 144 cm. (47 x 28 x 57 in.)

Paris, Musée Picasso.

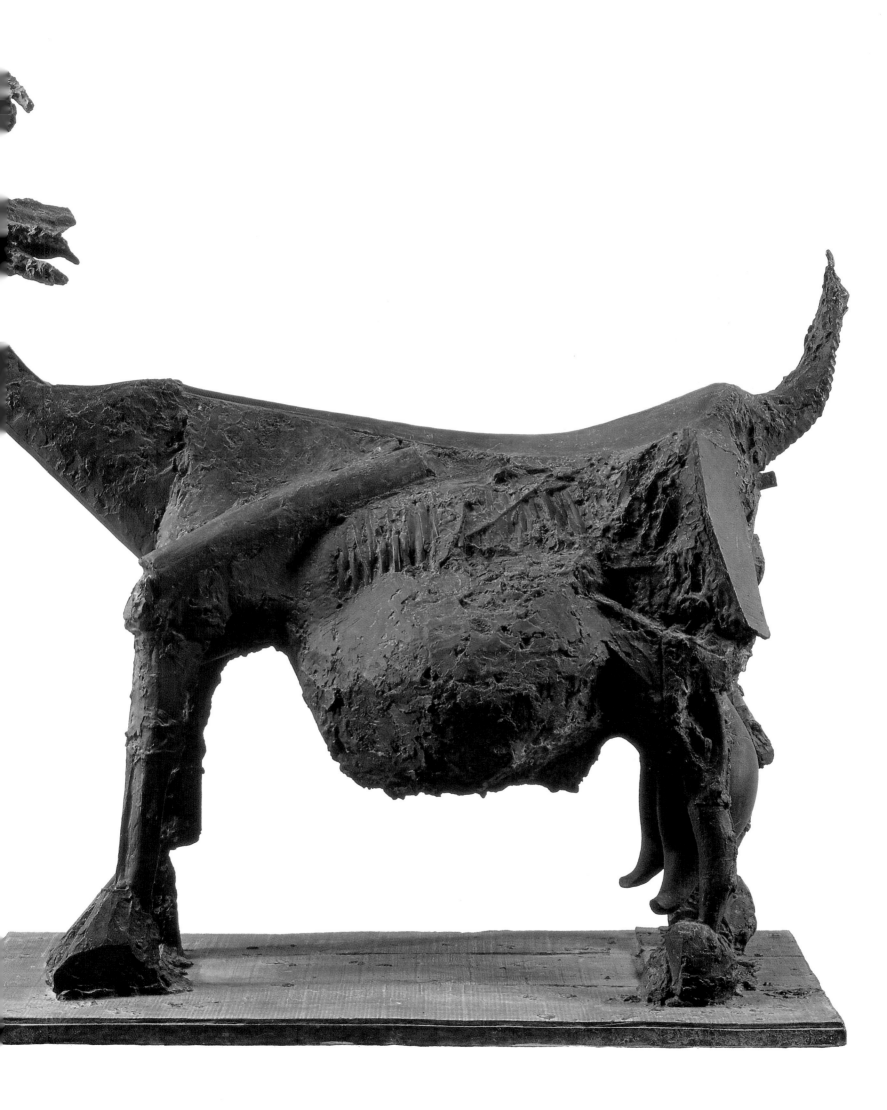

(1951). Ever since he had been forced to take Jean-Paul Sartre's defense at the Congress of Intellectuals in Wroclaw in 1948, his enthusiasm for the Communist Party had cooled somewhat, yet he remained sincerely concerned by the plight of all innocent victims of oppression.

The picture shows a row of nude women facing an execution squad. One horror-stricken woman clutches a baby to her breast, two others are pregnant and, arms dangling in a gesture of dispair, fail to grasp what is happening. In the middle, a child tries to flee, while a baby unconcernedly picks flowers at his feet. By its subject-matter, this work recalls Goya's *May Three* 1808, in which partisans who had fought the French invaders with pitchforks died a hero's death. However, the soldiers training their machine guns and rifles point-blank on the women in Picasso's picture are timeless: armour-clad, their faces concealed by medieval-looking helmets, they could just as well be robots, the anonymous gears of a killing machine. The colour scheme is sparing: grey figures set against a grey sky, the landscape green with traces of yellow. Like *Guernica*, this is an emblematic composition, and, again like *Guernica*, it displeased some of those who had commissioned it, a point to which we will return later.

The major work of this militant period, however, was *War and Peace*,

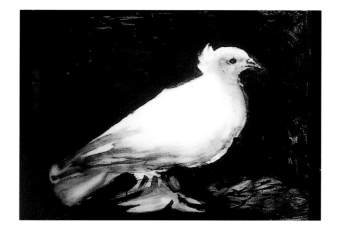

THE DOVE OF PEACE

1949, lithograph.

MASSACRE IN KOREA

Vallauris, 18 January 1951. oil on
plywood, 109.5 x 209.5 cm. (43 x 82 in.)
Paris, Musée Picasso.

which was painted on two monumental panels, 15 ft. high and 32 ft.long. They occupy the entire wall space inside the Temple of Peace, which, as we have already mentioned, was inaugurated in July 1954 with two days of festivities.

The idea for the project came to Picasso during a banquet held on his seventieth birthday in the former priory chapel. The encounter between modern and sacred art was a striking phenomenon of the years immediately following the Second World War. Léger had executed a monumental mosaic for the church at Assy; in Savoy, Le Corbusier was building Notre-Dame-du-Haut at Ronchamp, and Matisse had just finished decorating the chapel at the Dominican convent in Vence. Picasso was also to associate his name with a religious edifice – albeit a deconsecrated one – but on his own terms. The priory chapel was composed of a massive, windowless stone vault leading up to a choir that had been converted into an oil press: the project called for decorating the vault with two large murals, one representing *War* and the other *Peace*, which combined at the top to form a single, bipartite composition.

After having made many sketches on ordinary notebook paper, he began painting *War*, symbolized by a ramshackle hearse drawn by four black horses. Riding the hearse is an ominous faun carrying a basketful of

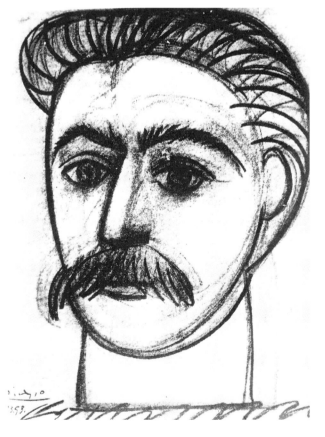

PORTRAIT OF STALIN

1953, drawing.

153

skulls and scattering hordes of repugnant, poisonous insects, while on the ground a book burns and a pair of hands emerges, seemingly imploring mercy. In the background stalks a group of demonic figures brandishing knives, spears and axes. Opposing this macabre cortège is a monumental figure bearing the sword of Justice and a shield decorated with a dove. In the panel symbolizing *Peace*, we see a boy playing the flute, figures of women dancing, nursing, writing and cooking, a winged horse pulling a plow, fish in a birdcage and birds in an aquarium. The whole scene basks in the light of a radiant, diamond-like sun. A third, smaller panel at the rear of the chapel shows four male figures representing the four races – black, white, red and yellow – together vowing to live in perpetual harmony.

The chapel being fairly dark, Picasso originally wanted visitors to discover the three panels by torchlight, like our ancestors from twenty thousand years ago viewing the cave paintings at Lascaux. This proved unfeasible, but because of the curved shape of the vault, the sun coincides with the zenith and shines above our heads: Peace wins out over War. The overall effect is very striking.

Before the temple at Vallauris was even inaugurated, however, a serious incident arose involving the painter and the French Communist

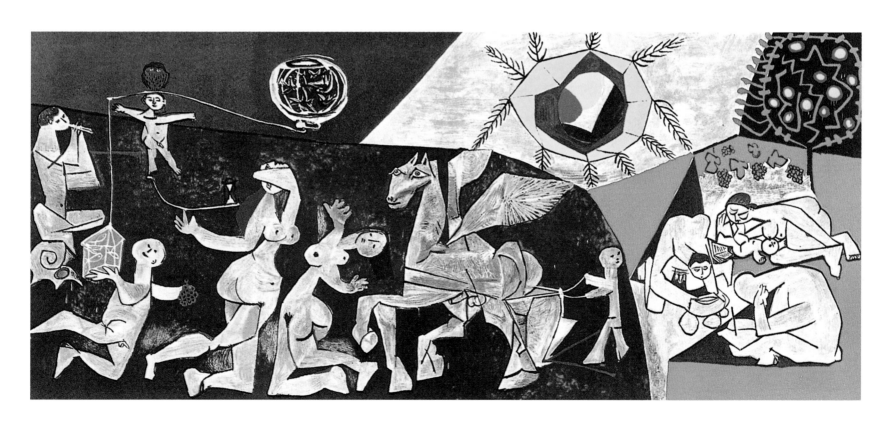

Party. On the occasion of Stalin's death on 5 March 1953, Aragon, then director of the weekly *Les Lettres Françaises*, asked Picasso to illustrate the front-page obituary panegyric to their immortal comrade. Inspired by a photograph of Stalin in his youth, the artist made a rough drawing showing a hearty-looking fellow whose only resemblance to the dictator was a broad moustache. This was far removed from the calm, sober portrait that the party faithful had expected, and the newspaper was flooded by a «spontaneous» wave of protesting letters from readers throughout France. The Soviet embassy in Paris also reacted with disapproval, while the Party issued an official condemnation. Aragon, called to account for himself, disavowed the controversial portrait. Picasso's response? «I brought my bouquet of flowers to a funeral. It was not appreciated. That can happen. But usually people are not reprimanded because their flowers fail to please.»

This incident shed a sudden and uncompromising light on the unnatural union contracted between Picasso and the Marxist-Leninist esthetic. This esthetic, monitored by remote-control from Moscow under the name of Socialist-Realism and championed in France by mediocre artists, advocated a revival of the illustrative Academicism of the nineteenth century. Under the pretext of educating the masses, Picasso

WAR

Vallauris, 1952, oil on chipboard,
4.5 x 10.5 m. (13 x 33 ft.)
Vallauris, Temple de la Paix.

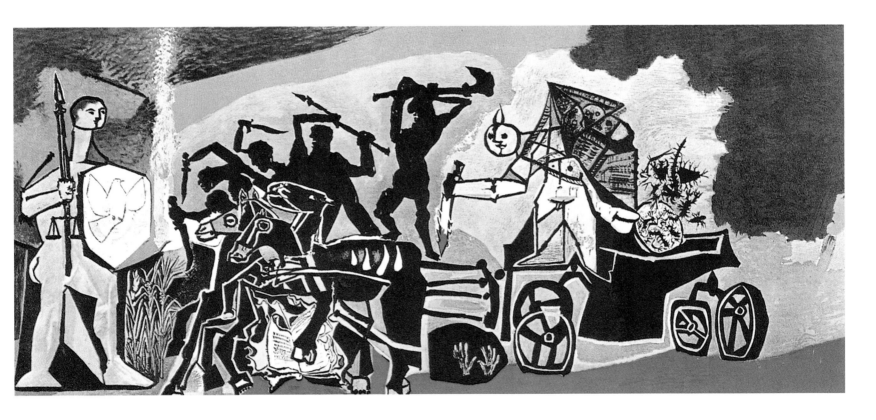

was expected to revert to the large conventional compositions of his adolescence, painted under his father's direction and which he had never really liked, and, moreover, to deny not only his own achievements, but also their influence on the course of modern painting ever since his epoch-making *Demoiselles d'Avignon*.

If his encounter with Surrealism during the 1930s had sparked a profound renewal, his membership of the Communist Party turned out to be an illusion. In fact, the French Communist Party, which would have preferred a *Massacre in Korea* done in the manner of Meissonnier and secretly balked at *War and Peace*, had had no other aim than to exploit the artist's great celebrity for political purposes. But was this a reason to quit? For Picasso, remaining in the Party meant maintaining a link with ordinary people, something that was evidently very important for him. However, this did not prevent him from signing a letter of protest in November 1956 against the invasion of Hungary by Soviet troops.

At the same time, a new figure, a woman with classical profile and large, dark eyes, began to appear in his paintings. After his separation from Françoise Gilot, who left with their two children, another woman, Jacqueline Roque, whom he had met at the Madoura ceramic works, entered his life. Olga died on 11 February 1955. In June of that year, he bought «La Californie,» a spacious, turn-of the century villa overlooking the Bay of Cannes and moved in with Jacqueline. Six years later she became his second wife.

«IT WASN'T SO TERRIBLY BAD»

One of Picasso's enduring sources of inspiration had always been art itself. The light-bearing figure with outstretched arm which swoops above the disaster of *Guernica*, for example, was derived from Prud'hon's *Vengeance Pursuing Crime*, a famous allegorical painting that anticipated Romanticism. His artistic borrowings, however, never involved purely descriptive elements. If he borrowed Prud'hon's hovering figure, it was because it perfectly expressed his own dismay at the havoc wreaked by the Nazis on the small Basque town.

A book published thirty years ago accused Picasso of outright plagiarism, a notion to which he lent credence himself when he claimed: «If there is something to steal, I steal it!»[1] The author of the book, which

1. Pierre de Chambris, *Picasso, ombre et soleil*, Gallimard, Paris, 1960.

seemed thoroughly iconoclastic at the time, put forward documentary evidence to prove that pictures like the ones from Dinard showing bathers playing ball on the beach had two distinct sources: the swaying figure of Botticelli's *Venus* being wafted shorewards on her seashell, and the striped jerseys of Henri Rousseau's *Football Players*. He further demonstrated that rock motifs lifted straight out of Carpaccio could be found in seascapes from Juan-les-Pins, and the majestic stiffness of the Princess of Cleves portrayed by Holbein re-emerged in the figures of Harlequin! In the introduction, we have also seen the role that a photograph of Cézanne seated in front of his *Large Bathers* played in the genesis of the *Demoiselles d'Avignon*.

The accusation of plagiarism, however, missed the point of Picasso's borrowings; if anything, they were his way of measuring himself against the great masters of the past. Hélène Parmelin tells the story of how, after the war, Georges Salles, the director of the French National Museums, invited Picasso to go to the Louvre one night with his own paintings to see if they could bear comparison with recognized masterpieces[1]. We can imagine them climbing the main staircase to the first floor and confronting a Picasso with *The Death of St. Bonaventura*, a second Picasso with the *Portrait of Mademoiselle Rivières*, or a third with *The Massacres at Scio*, comparing, discussing and pausing in silent contemplation. After this momentous nocturnal showdown, Picasso is reported to have said: «It wasn't so terribly bad.»

Picasso's frequent references to the art of the past were, to a large extent, a by-product of his incredible virtuosity at a time when everything was being called into question. Past and present cancelled each other out in his work, for he was not afraid of putting them to the test, and may even have thought that he was the last real painter. Similarly, Heidegger believed that metaphysics no longer had any place in the Age of Science and that the only creative possibility lay in the perpetual re-formulation of its history.

These pictorial sources, which had always been more or less disguised by the artist, finally came to the fore in 1950 in a stunning composition, *Women on the Banks of the Seine (after Courbet)*, then, between 1955 and 1963, in several series of compositions inspired by Delacroix's *Women of Algiers*, Velázquez's *Las meninas*, Manet's *Déjeuner sur l'herbe*, and David's *Rape of the Sabine Women*.

1. Hélène Parmelin, *Voyage en Picasso*, Paris, Laffont, 1980.

Overleaf

YOUNG WOMEN ON THE BANKS OF THE SEINE
(after Courbet)
Vallauris, February 1950, oil on plywood,
100.5 x 201 cm. (40 x 79 in.)
Basel, Kunstmuseum.

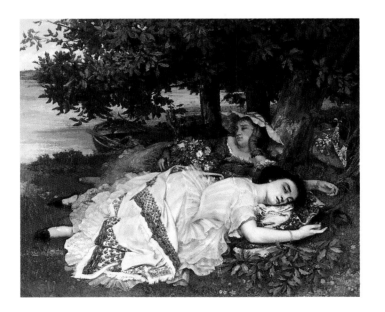

Gustave Courbet
YOUNG WOMEN ON THE BANKS OF THE SEINE
1856, oil on canvas, 174 x 198 cm. (68 x 78 in.)
Paris, Musée du Petit Palais.

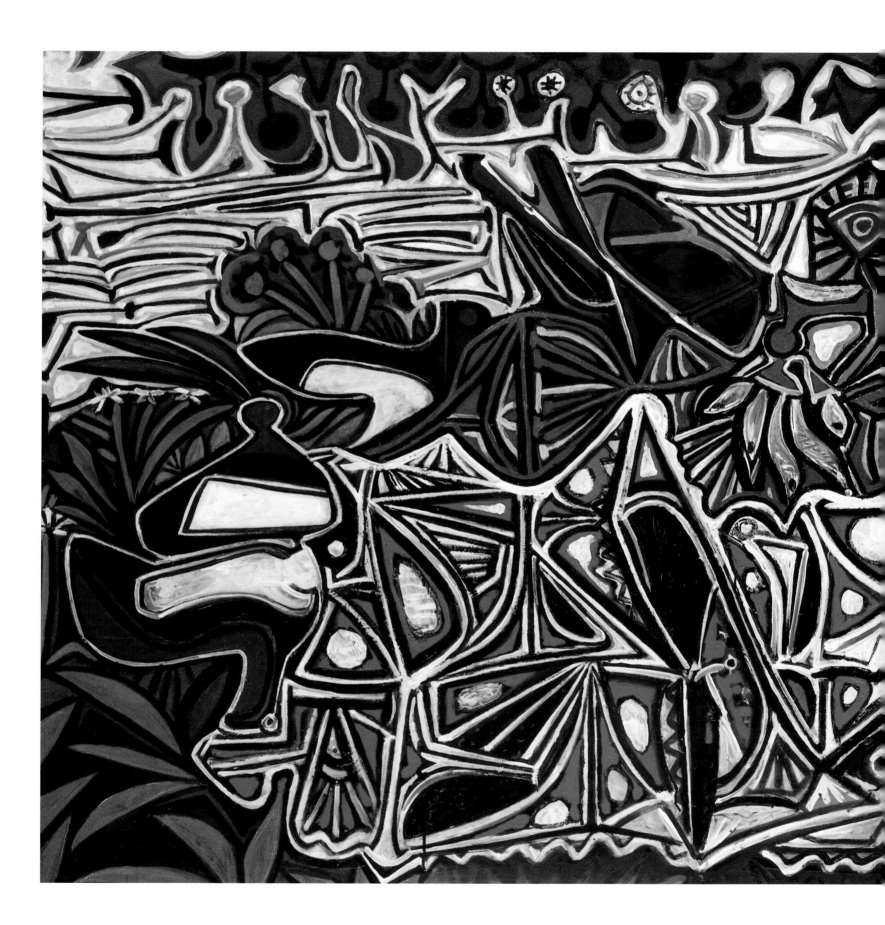

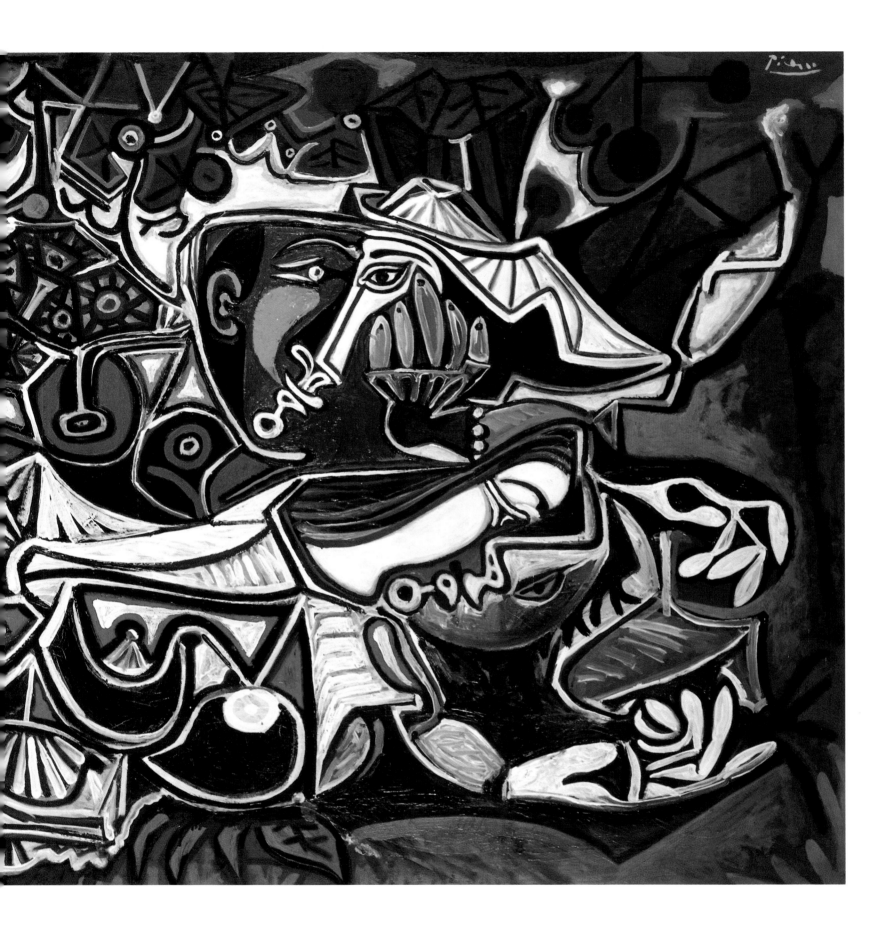

Courbet's painting had created a scandal when it was shown at the Salon of 1857. The subject was a country outing featuring two healthy-looking young women of doubtful virtue, lounging by the river bank; this at a time when the merest reference to a river in an Academic painting would have called for nymphs and other mythologically inspired nudes. In Courbet's day, viewers were blind to the superb treatment of the dresses worn by two women, or to the splendour of the bouquet that one of them holds and the lushness of the trees sheltering them with their shade – exactly the elements which Picasso noticed and stressed in his rendition of the scene. The wonderfully free handling of the figures and costumes, the faces shown both frontally and in profile, the boldly cut fringe of foliage, and even the diminutive rowing boat in the background, made this «re-make» one of the artist's great pictorial achievements.

More than that: what Picasso was formulating here was the very issue of painting itself. Courbet's *Women on the Banks of the Seine* was a realistic picture, which could be taken to mean that he had limited himself to representing what was – or once had been – before his eyes. Yet such was not the case. When Champfleury advanced the first definition of Realism in 1850, he opposed the idealism of the Renaissance tradition to such values as earthiness, temperament and the volubility of the common man: in his eyes, a stone-breaker was as good as a prince. Yet Realism remained a style, with its own rules and values. Like Idealism, Romanticism and Cubism, Realism was a mental construction. Consequently, if even Realism had its source in the imagination, then the painter had the right to paint reality in other ways as well.

The same applies to his *Women of Algiers* – a painting which is said to have especially fascinated Picasso because the figure in the middle bore a striking resemblance to Jacqueline – and even more so to his interpretation of *Las meninas* by Velázquez, in which he radically revised the art of the Spanish Golden Age.

The series after the *Meninas* includes fifty-eight small and large-format paintings produced between mid-August and late December 1955 in Cannes, during a period of total isolation in his second-floor studio at «La Californie.» Picasso had been familiar with this masterpiece ever since his first visit to the Prado with his father, at the age of fourteen. He had admired its line, light, and sharp harmony of colours, but was even more struck by the enigmatic nature of the composition. The relationship between the various figures in the picture is extremely difficult to grasp.

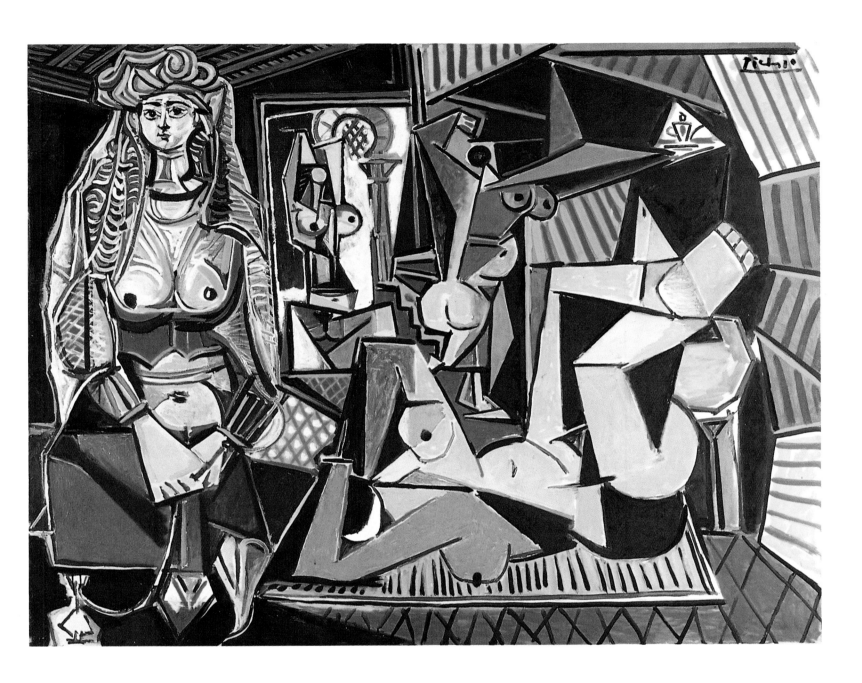

THE WOMEN OF ALGIERS

(after Delacroix)

Paris, 14 February 1955, oil on canvas,

114 x 146 cm. (45 x 57 in.)

New York, collection of Mrs. Victor W. Ganz.

Opposite

Three studies for *The Women of Algiers*

after Delacroix.

1955, lead pencil and Indian ink.

Private collection.

Studies for *Las meninas*
General view Cannes, 2 October 1957,
oil on canvas, 162 x 130 cm. (64 x 51 in.)
Barcelona, Museo Picasso.

LAS MENINAS

(after Velázquez)
Cannes, 17 August 1957, oil on canvas,
194 x 260 cm. (76 x 10 in.)
Barcelona, Museo Picasso.

Velázquez represented himself in the foreground of the painting, where, logically, he should not appear, with his back turned to the Infanta, whom, at first glance, one might have taken for his model. He is standing in front of a large canvas shown from the rear and on which he seems to be working. It could be that he is painting a portrait of the king and queen – visible as reflections in the mirror hanging on the wall in the background – in which case they would be standing between us, the viewers, and the painter.

While retaining the original arrangement of the figures – from left to right: Velázquez holding his palette, the infanta Margarita Maria flanked by her maids-in-waiting, the dwarf Mari-Barbola, and, in the background, José Nieto, the queen's chamberlain – Picasso completely overhauled the construction in his eight variations on the general composition. In the first of these, a grisaille made up of contrasting planes of white and grey, Velázquez stands with the authority of an inquisitor. In other versions, all based on contrasts of pure colours, the lighting no longer came from a single direction, as in the original, but was diffused throughout the picture, while the scene was built up from angular facets of Cubist inspiration which seal off and amplify the spatial effect.

The fifty subsequent versions were studies of details: the centrepiece of Velazquez's composition, Margarita Maria, whose light-coloured dress is the strongest accent, her maids-in-waiting, Maria Augustina Sermiento and Isabel de Valesco, and the groups composed of the male and female dwarves Nicolasico Pertusato and Mari-Barbola, and the dog. Picasso explored the forms and facial expressions, turning them in all directions, sharply outlining or flattening them. This was not just a free interpretation, but a veritable autopsy of a masterpiece, to which he added a touch of humour and metamorphosis: Velázquez's splendid German shepherd was transformed into the artist's basset, Lump, who managed to sneak into the artist's studio in the heat of the action.

The most impressive series, however, was the one after Manet's *Déjeuner sur l'herbe*, for Picasso not only deconstructed the tradition, but forced a confrontation between modern art and itself. Manet's picture, an update of Titian's *Country Concert*, introduced an entirely new handling of paint that was radically at odds with the finicky style of the period. When it was first shown at the Salon des Refusés in 1863, it was received scornfully by critics and public alike. It was considered indecent because it depicted a nude woman seated opposite two fully-dressed men. And

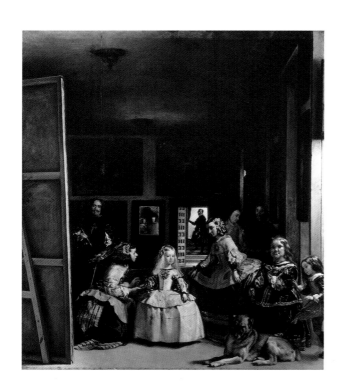

Diego Rodriguez de Silva y Velázquez

LAS MENINAS

1656, oil on canvas, 318 x 276 cm. (10 x 9 in.)

Madrid, Museo Nacional del Prado.

because the artist dared to curtail the forms, he was considered unskilled. In Picasso's series after the *Déjeuner sur l'herbe*, we see a face to face confrontation between two giants of modernity standing a century apart, seemingly drawn by a mutual fascination, now eyeing each other, now suddenly lunging to attack.

The modifications to which Picasso subjected Manet's composition speak for themselves. Some contemporary authors have seen this exercise as nothing more than the empty soliloquy of an artist at a loss for ideas and lacking a «guiding intellectual concept»[1]. Yet these critics are ultimately no less blind than their precursors of 1863 who could not grasp that Manet's picture was opening new perspectives. Picasso's paraphrases were an unrelenting deconstruction in which the protagonists – nude and clothed – were shuffled in all directions, while the figure of the draped bather, barely visible in the background of Manet's picture, advanced into the foreground. One critic complained of the green colour of the grass in the painting, saying that it grated on the eye like a saw. Picasso must have known of this remark and wanted to put it to the test, for the colour green, alternately shrill, flat, nuanced, and even playful, was at the crux of his variations.

Picasso's work on the old masters has been studied often enough, but what has not been sufficiently stressed is the reciprocity of this undertaking. To be sure, the artist investigated Courbet, Velázquez, Manet and the others, but above all he was putting himself to the test. His variations were another way of raising the question which he had ceaselessly asked himself throughout his career: how far can painting be pushed? As in the nocturnal confrontation in the Louvre mentioned above, his interpretations reflected mainly the image of his own painting. A fascinating play of shattered mirrors.

1. Carsten Peter Warncke, *Pablo Picasso*, vol. II, Taschen, Munich, 1992, p. 611.

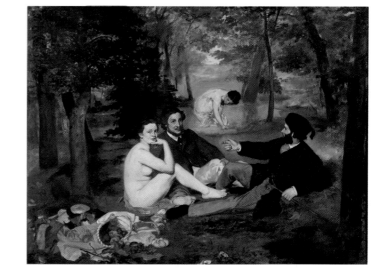

Edouard Manet

LE DÉJEUNER SUR L'HERBE

1863, oil on canvas,

208 x 264.5 cm. (82 x 104 in.)

Paris, Musée d'Orsay.

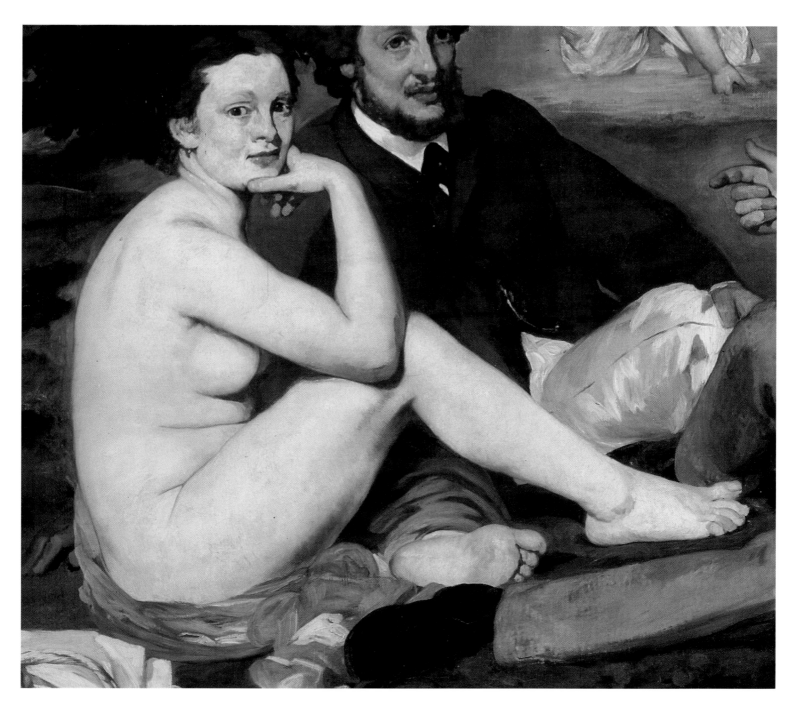

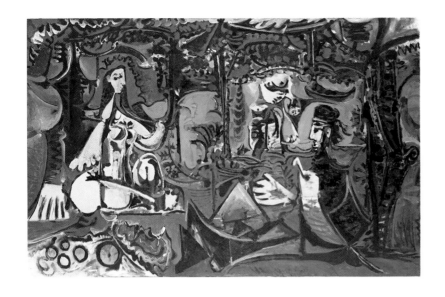

LE DÉJEUNER SUR L'HERBE

(after Manet)

Vauvenargues, 3 March - 20 August 1960,

oil on canvas, 129 x 195 cm. (51 x 77 in.)

Paris, Musée Picasso.

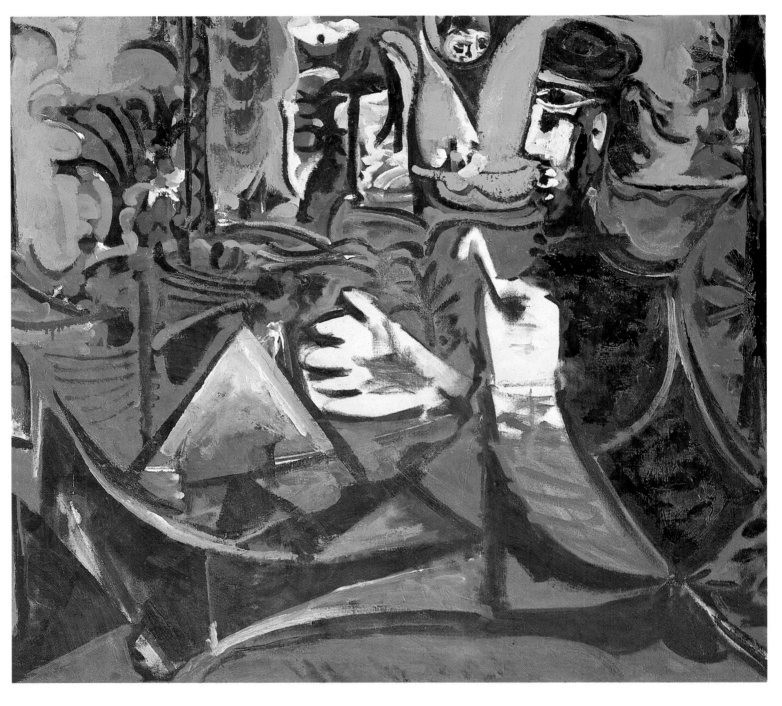

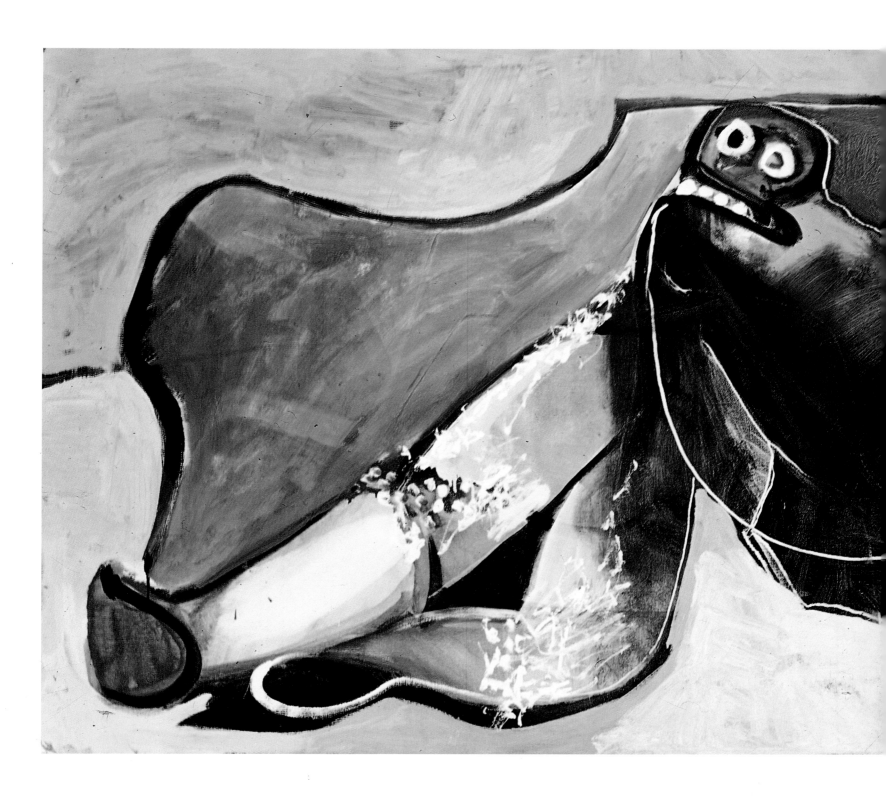

BULLFIGHT SCENE

(THE UPTURNED TORERO)

Nice, 1955, oil on canvas,

79.5 x 190.4 cm. (31 x 75 in.)

Private collection.

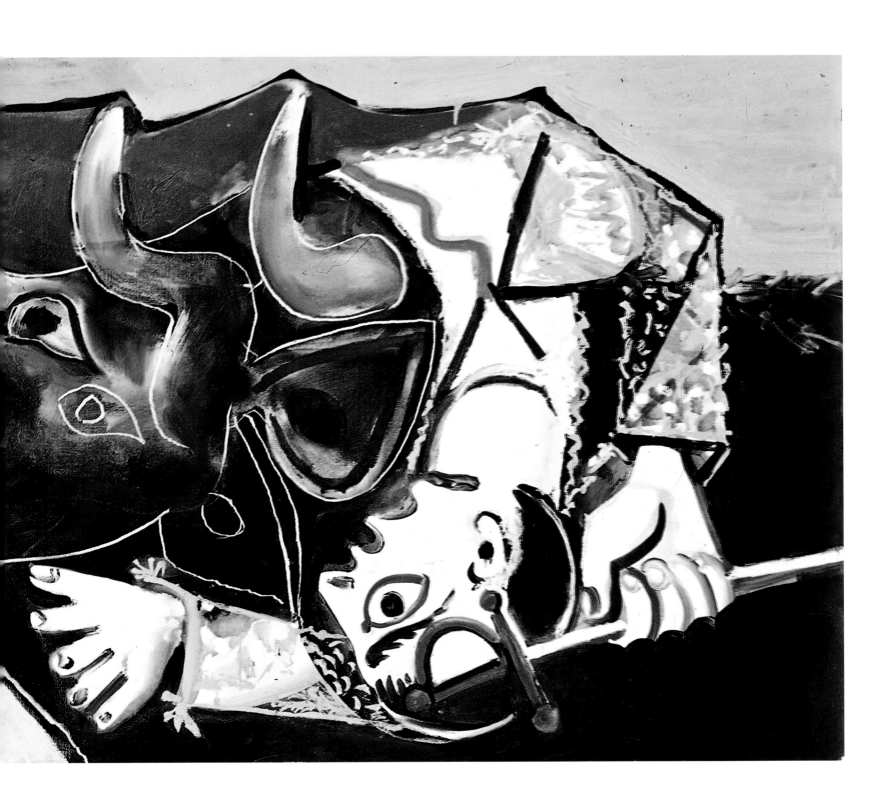

CORRIDA-CRUCIFIXION

1959, ink drawings.

second sketchbook of «Toros y Toreros.»

THE DRUMS OF BASEL

During these same years Picasso returned to some of his favourite themes, the nude and the bullfight, handled this time in an apparently syncretic manner combining Cubist stylization and the feverish recombinations of Surrealism, yet completely brought up to date. With unprecedented mastery, he painted his memorable *Bullfight Scene* (*The Uplifted Torero*) in 1955: it shows the overpowering might of a bull with a monstrous, archaic muzzle lifting up the disjointed body of the toreador, whose costume of light has become his shroud. The nudes he painted then are among the most beautiful he ever produced: monumental women of broad, architectonic construction, depicted sitting or reclining, and all the more magnificent as the artist's frenzied libido seems now to be at peace.

His major work, though, was the mural commissioned in 1957 by UNESCO to decorate the reception hall of its new adminstrative headquarters. The project called for a monumental painting of over 1000 square feet, almost three times as vast as *Guernica*. But would he still be able to work on the scaffolding? The problem had already arisen when he undertook the murals of the Temple of Peace in Vallauris. Although now in his seventy-sixth year, he was not about to entrust someone else with the execution of his design after a scale model. His solution was to paint the composition in his studio on individual panels measuring 3 x 8 ft. and then assemble the whole on site. The resulting work, entitled *The Fall of Icarus*, was inaugurated on 3 November 1958.

In fact, the main theme of the composition was bathers: we see five youthful figures bathing and sunning themselves, and a falling figure in the middle made up of a white «skeleton» enclosed by an envelope of black «skin.» This hapless figure, which keys the scene in a mythological mode, plunges headfirst into a blue wave that seems as high as a mountain, while the other figures unconcernedly indulge in their sunbathing. It is a very dramatic scene, but it was not exactly the sort of mural that his UNESCO patrons were expecting. Nor was it very advantageously installed, for the spectator could view the composition in its entirety only from a distance of several feet, after having passed between cement pillars and under a low footbridge that blocked off the middle section of the mural. This awkward approach, however, allowed the visitor to discover the work gradually and, finally, chimed in appropriately with the «disjunctve» conception of the scene.

Vallauris, March 1958: presentation of The Fall of Icarus intended to decorate the hall of the UNESCO headquarters. From left to right: Picasso, Jean Cocteau and Maurice Thorez.

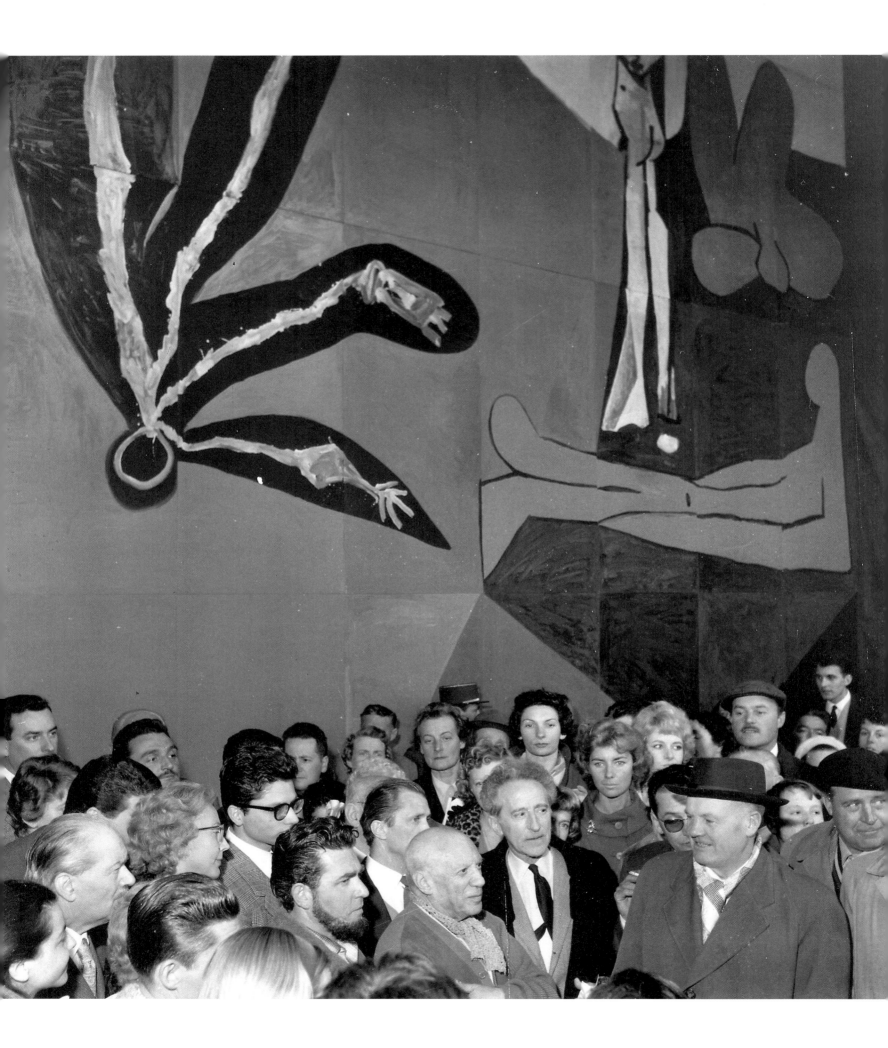

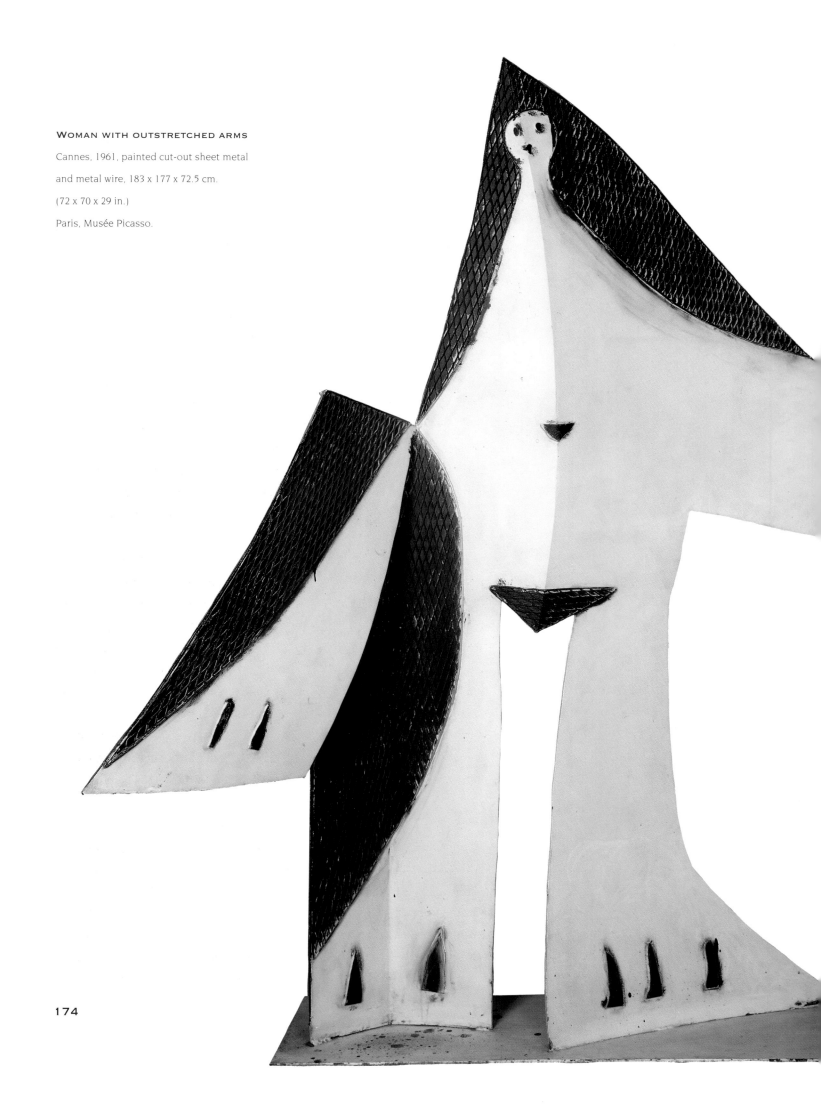

WOMAN WITH OUTSTRETCHED ARMS

Cannes, 1961, painted cut-out sheet metal
and metal wire, 183 x 177 x 72.5 cm.
(72 x 70 x 29 in.)
Paris, Musée Picasso.

174

Needless to say, Picasso was by then no longer at the cutting edge of the pictorial avant-garde, as he had been in 1907. No more than Monet had been during the 1920s, painting his *Water Lilies* for the Orangerie while Surrealism was the talk of the day. During the postwar years, the main innovative movements were Abstract Expressionism, Tachism and Pop Art. Yet, like Matisse in his late period, Picasso was still working with the freshness of a newcomer.

Further proof of his undying creativity may be seen in the painted sheet-metal works and terracotta heads which he produced in the following years. The first represented female figures with outstretched arms and heads in frontal or profile position. Like Matisse's cut-outs from pieces of gouache-coated paper, they were cut out of flat sheet metal, and again like Matisse's works, they re-invented the relationship between sculpture and space. With their bevelled and angled planes, they produced negative volumes which induced a greater sensation of three-dimensionality than marble or bronze. The terracotta heads, done somewhat later, consisted of faces painted on discarded bricks, with the artist demonstrating endless ingenuity in making the most of the cracks and broken edges.

The painted sheet-metal figures resulted in a number of monumental sculptures, including the famous head in Chicago, which is almost fifty high. Made of corten steel, it was installed on a low plinth to heighten its monumental effect. It was enthusiastically received by the people of Chicago who argued at length as to what it acually represented, some maintaining that it was a bird, and others, a female head. This thematic ambiguity went hand in hand with the free treatment of the forms. Another monumental sculpture was to have been erected near the old port in Marseilles, but when the backers of the project insisted that it be made out of Mediterranean marble, Picasso refused. Instead, a sculpture made of engraved marble and directly inspired by the painted sheet-metal works was installed in the courtyard of a high school in that same city.

Tired of living in «La Californie,» whose ornate architecture and well-groomed garden suddenly seemed the epitome of bourgeois kitsch, the artist bought the Château de Vauvenargues in 1959. This noble dwellling was located on a wooded 2000-acre estate at the foot of the Montagne Saint-Victoire. In one stroke he was able to satisfy his love for Cezannian landscapes and his desire for solitude: the endless round of parties and socializing had become nothing but a chore. After restoration work was completed, he moved in with his new wife several months later.

175

CAT DEVOURING A BIRD

Le Tremblay-sur-Mauldre, April 1939,

oil on canvas, 96.5 x 128.9 cm. (38 x 51 in.)

New York, collection of Mrs. Victor W. Ganz.

Overleaf

FAMILY PORTRAIT

Mougins, 19 June - 19 October 1962,

lithography touched up with oil pastels,

56 x 76 cm. (22 x 30 in.)

Paris, Musée Picasso.

He was not to stay there very long, however, for the isolation and harsh climate hindered his work, and he ended up painting less and less. In 1961, he moved to a new abode, the Mas Notre-Dame-de-Vie, a comfortable villa on the outskirts of Mougins.

His pleasure in painting revived, and he turned out scores of portraits of Jacqueline, seated and reclining nudes, and women with cats, repeating some subjects over and over again in dozens of examples. Back in 1939, Picasso had painted two versions of a *Cat Devouring a Bird*. With their razor-sharp claws, skewed heads and obtuse bodies, these cats were among the cruellest figures he had ever painted. Only a dog-lover like Picasso, who always had a dog in his life, could have portrayed cats as bogus wild beasts, cunning, sham "tough-guys" preying on easy game. Yet his many scenes of women with cats also depict velvet-pawed kittens of the most lovable and playful kind.

There may have been more youthfulness in these celebrations of budding felinity than in the pictures he devoted in 1963 to the subject of

the painter and his model. In this long series, we see an aging dauber – Picasso himself – sometimes wearing a broad-brimmed hat, sitting at his easel with brushes and palette in hand, contemplating a nude woman, his gaze alternately vacant and absorbed. Was this a form of protest against Academic art, which treated the nude with insipid sentimentality, or an indirect hommage to Frenhofer, the quixotic balzacian hero who lost himself in the inferno of art? Probably a little of both, for while certain pictures seem only languourous, others are imbued with a rare power. This is the case with such works as *The Painter and His Model* from 25 October1964, and the two versions of this same subject dated 16 October and 3 November 1964, in which we see the painter's head and his model in close-up, scrutinizing each other closely.

Picasso spent his old age working, surrounded by a few close friends, honoured by retrospectives of his works in major museums throughout the world. Then, in the fall of 1967, came an event which, more than any other, profoundly moved him.

The Basel Kunstmuseum had been one of the first art museums in Europe to create a collection of modern painting in the aftermath of the First World War. Now, it was on the verge of losing two of Picasso's early works – the *Two Brothers* from 1906 and the *Seated Harlequin* from 1923 – which had long been deposited on loan. Their owner, Peter Staechelin, who also owned Balair, a local airline, was obliged to put them up for auction to raise money to compensate the relatives of the victims of a recent air crash. To prevent this loss, the Grand Council of Basel decided to purchase the two paintings and arranged for a budget of six million Swiss Francs.

But a local garage owner who felt that these public funds were more urgently needed for other purposes managed to collect the thousand signatures necessary to call for a cantonal referendum. He hoped that a popular vote would revoke what he considered an unwarrantable decision.

On 17 December, the votes were counted and showed a majority in favour of the purchase, with 27,000 «nays» against 32,000 «yeas.» On the eve of the referendum, the Kunstmuseum organized a huge party, complete with fanfares and drums – the same drums to the beat of which the troops of Basel had marched into battle for centuries – while children went out into the streets to collect the money required to make up the total sum. Upon hearing the results of the vote, Picasso said: «This is the first time in history that the public has imposed its own will in matters of art and culture.» The *Seated Harlequin* and the *Two Brothers* thus remained on the walls of the museum, next to other canvases by the painter already in its collections. They were joined soon after by four new works donated by the artist as a token of gratitude.

THE PAINTER AND HIS MODEL

Mougins, 10 and 12 June 1963,

oil on canvas, 195 x 130.5 cm. (77 x 51 in.)

Munich, Staatgalerie Moderner Kunst.

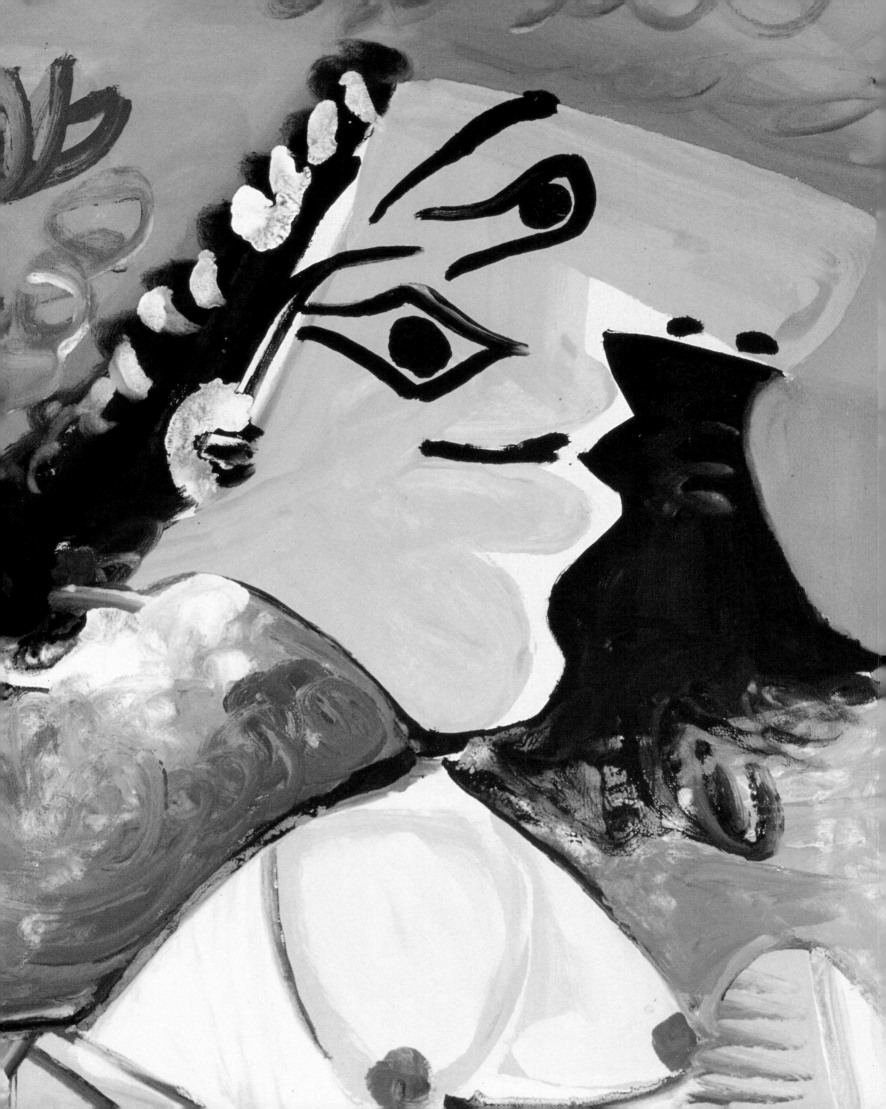

6

THE LAST BLOOMS

IT TAKES A LONG TIME TO BECOME YOUNG

Much nonsense has been written about the last years of Picasso's career. He is said to have come to a creative dead end and to have merely repeated himself, endlessly rehashing the libidinous fantasies of an impotent, dirty old man who had been reduced to little more than a voyeur. Some have described his late work as «painting in heat,» and spoken of senile sadism, not to mention pornography. Even one of his closest biographers wrote that the sight of young women in the streets of Cannes was a source of constant delight for Picasso. Ever the same fascination with sex that supposedly haunted him ever since he was «very little.»

These allegations have little basis in fact, however. If anything, they seem to have been inspired by such works as the *Woman Urinating* (*La Pisseuse*), a medium-format picture painted on 16 April 1965, and the series of erotic engravings that he etched after Degas' monotypes depicting prostitutes and madams waiting for their clients.

To be sure, *La Pisseuse*, which shows a woman crouching with her skirts raised, leaning slightly forward and completely absorbed in the satisfaction of a most natural need, was a far cry from a *Bathsheba* or the

WOMAN URINATING (LA PISSEUSE)
(detail)
Mougins, 16 April 1965, oil on canvas,
195 x 97 cm. (77 x 38 in.)
Paris, Musée national d'Art moderne,
Centre Georges Pompidou.

WOMAN URINATING

Mougins, 16 April 1965, oil on canvas,

195 x 97 cm. (77 x 38 in.)

Paris, Musée national d'Art moderne,

Centre Georges Pompidou.

Rembrandt

WOMAN URINATING

Etching.

Paris, Bibliothèque nationale.

Pilgrims of Emmaus. Yet this subject was a direct allusion to Rembrandt, who had once represented it in an etching. In any case, this used to be a familiar sight in the country and even in the city; only fifteen years ago, on Place de Clichy, a florist could be seen standing upright with her legs spread, unabashedly relieving herself on the sidewalk. The open-crotch panties celebrated by Toulouse-Lautrec were in fact made with that purpose in mind. One of Proust's heroines leaving a party at the Guermantes pauses to urinate after having put one foot on the edge of the sidewalk and the other on the step of the coach she is about to enter. In *Amarcord*, Fellini contributed to the genre by filming Volpina pissing on the beach.

Picasso measured himself against Rembrandt as he had done with Courbet, Delacroix and Velázquez. Here again, what mattered to Picasso was painting, and nothing else but painting. His own words, transcribed by Hélène Parmelin during his last years, expressed this perfectly[1]. On abstract painting: «For example, imagine an abstract hunter. What can he do? In any case, he does not kill anything.» On personality: «If you have to look for it, then you don't have any. And if you find one, then it's a false one. As for me, I can do nothing else but what I do.» On creation: «The terrible thing is that we are all the eagle to our own Prometheus: both the devourer and the devoured.» Such statements as these were anything but the senile ravings of a lecherous old man.

On the contrary, the most striking thing about this last period was Picasso's sound mental health and his inexhaustible capacity for work. During his last four years alone, from 1969 to late 1972 – from the age of eighty-eight to ninety-one – he painted no less than three hundred and seventy pictures of small, medium and large formats, in other words, an average of one painting every four days. Nor was this production limited to risqué subjects: apart from a few nudes – some superb, others monstrous – we see mostly a procession of matadors, harlequins, hirsute musketeers, men with swords, rifles or pipes, heads decked with garlands, faces of all kinds and embracing couples.

In his series of the *Painter and His Model* and *Woman with a Cat*, respectively from 1963 and 1964, we can see that the painter had long come to terms with female sexuality. We are far from the explosive savagery of the *Demoiselles d'Avignon* or the brutal distortions of his nudes from the 1920s. The twenty pictures dealing with the subject of a woman

1. Hélène Parmelin, *Picasso dit*, Denoël, Paris, 1966.

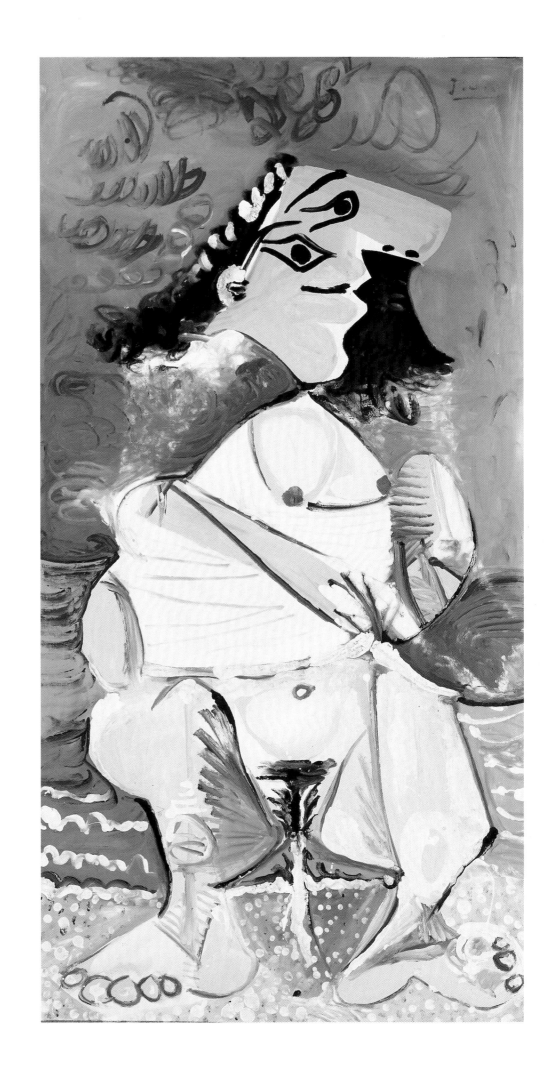

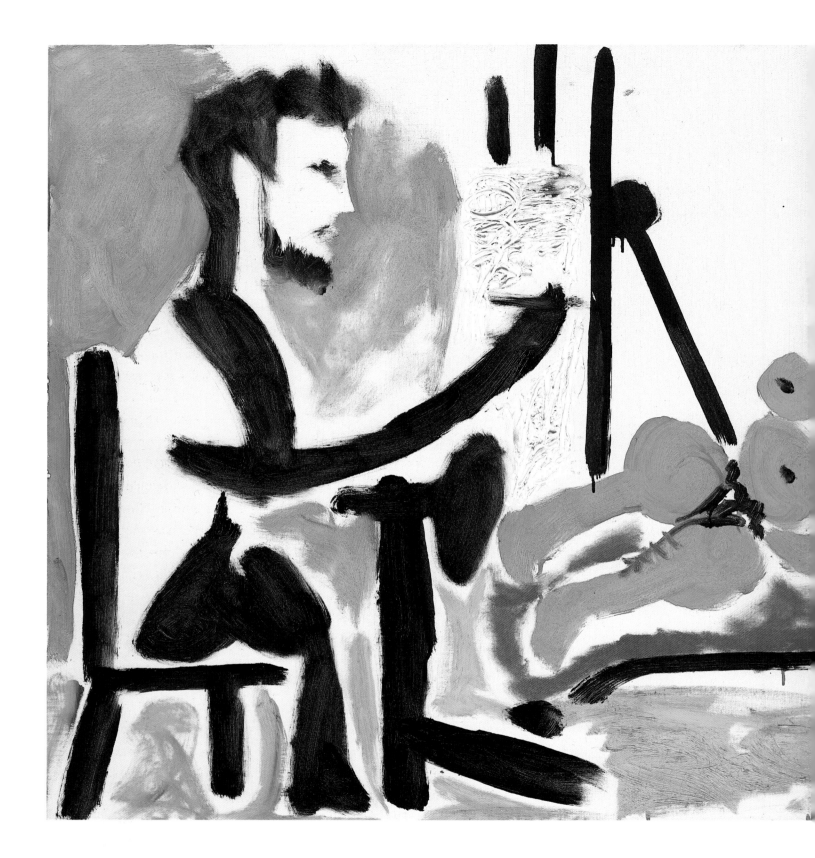

THE PAINTER AND HIS MODEL

Mougins, 1963, oil on canvas,

73 x 92 cm. (29 x 36 in.)

Private collection.

with a cat were inspired by a simple incident at Notre-Dame-de-Vie: a black kitten wandered into the garden one day and so amused Picasso and Jacqueline with its pranks that they decided to adopt it. To interpret it as a woman's «pussy» – as some have done – can only mean that one has either not seen the paintings, or that one is somewhat sexually obsessed oneself.

Other examples of pictures poles apart from sexual fantasy include the depictions of large heads locked in passionate embrace, kissing mouth to mouth, nostrils dilated, profiles intertwined, lips and tongues meshed, as in *The Kiss* from 24 October 1969. These were simply pleasant manneristic scenes, full of tenderness and tumult, playing on *forma serpentina* in the style of Bronzino or Salvati.

In an interview with Herbert Read published in the London *Times* in 1956, Picasso explained himself, saying: «When I was these childrens' age, I drew like Raphael. It has taken me my entire life to learn how to draw like they do.»[1] He expressed this same idea later when he remarked: «It takes a long time to become young.» His comparison with Raphael was a provocation, naturally, for, at the age of eighteen, Pablo Ruiz was no more than a good academic draftsman and his brio would have passed unnoticed had it not been for his precociousness. What these two statements revealed, however, was that his father's insistence had been a burden and that he had had to pursue his artistic career *in reverse*, as it were. He had had to break though the veil which the conventions of painting had drawn not just between himself and reality – the constant goal of his efforts – but also between himself and himself. Amazingly enough, he persevered in this struggle right up to and including his very last works.

Although he had never shared the Surrealists' fascination for the art of the mentally ill – hallucination never having seemed to him to be a valid basis for true creation – his interest in children's art went back to the days of *Guernica*. As we have already seen, one of the first preparatory sketches for this famous picture, executed on 1 May 1937 on blue stationery paper, showed a sort of hobby horse with a potato-like body and rodent's head rather like the ones small children love to draw.

But the following sketch, which took up the same subject and was drawn on the same day, was a pose study in the purest academic tradition. The horse is shown slumped on the ground, its neck and back

1. Klaus Gallwitz, *Picasso*, 1945-1973, Denoël, Paris, 1985, p. 183.

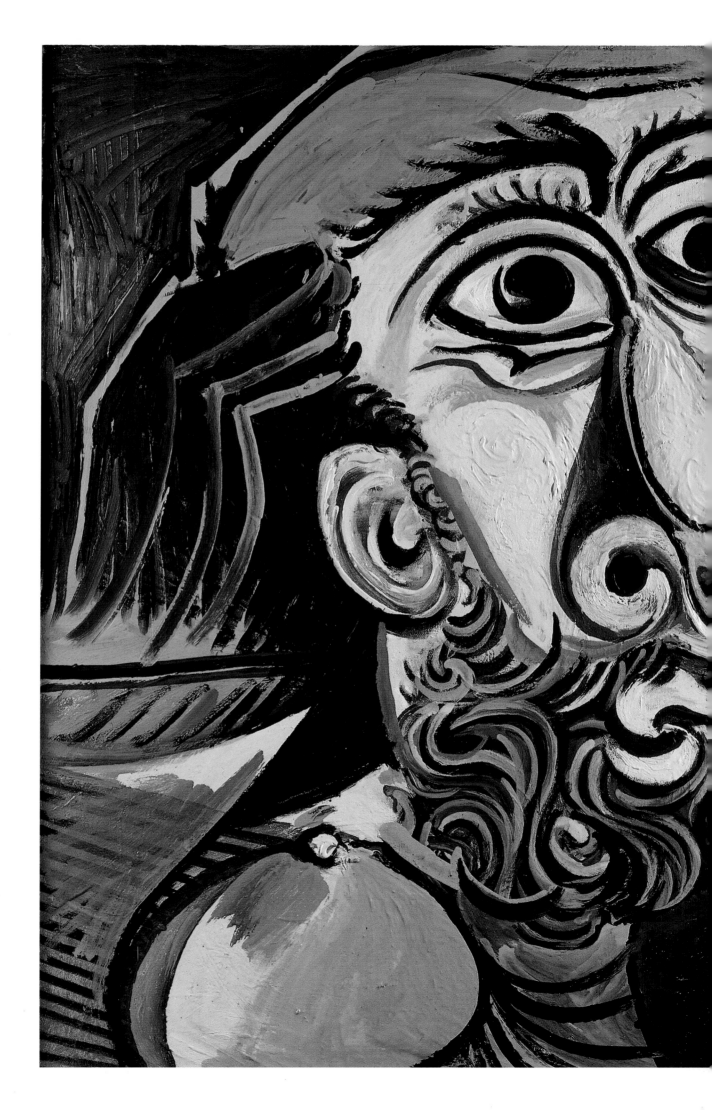

painfully stretched, its mane heavily underscored. The whole demonstrates a total mastery of line. We can see the muscles straining and almost hear the cracking of the bones; taken one step further, Picasso would have produced a completely naturalistic figure. *Guernica* was the result of a tension between these two poles, and in the end, there was nothing, or almost nothing «childlike» to be seen. The picture may have been instinctive, primitive and archetypal, but the pictorial handling displayed great virtuosity.

This was not the case with his last works, in which his brushwork had become «artless» and his colour schemes deliberately off-key. We see reds overlapping purples, sky-blue and pale pink touched up with white or beige, mauves and greys combined with faded green, bright orange and pale yellow. He persistently played havoc with chromatic harmony and the result was an iconoclastic, gleeful farce, an immense peal of laughter in paint.

It is difficult to single out a particular picture from this comical gallery of portraits, but the series of musketeers was perhaps the most spectacular of the lot. It seems to have been inspired by Alexandre Dumas' famous novel *The Three Musketeers*, which the artist glossed rather than illustrated. He added here a pipe, there a vase of flowers, placed a bewildered cupid on the knees of his manly figure – *Musketeer and Cupid* from 18 February 1969 – foreshortened the faces, while stretching, compressing and dismembering the bodies. Dumas himself was a very prolific writer, with nearly three hundred volumes to his credit. His productivity, his picaresque verve and his unbridled style must surely have appealed to Picasso.

A masterpiece among the other works of his late period was the *Large Heads* dated 16 March 1969. The lines were more intertwined and the colours – contrasts of reds and oranges, tentative blues, whites and mauves – more offhandedly applied than anywhere else. The same could be said of *The Man with a Golden Helmet* (8 April 1969), which, like *La Pisseuse*, had been inspired by Rembrandt, but handled in a more kitschy, flashy and bombastic manner; or of the more subdued and melancholic *Seated Man* of 27 June 1971. As Picasso himself boasted: «I do worse every day!» But with what genius!

Children draw and paint in order to achieve symbolization. As we know, this begins with scribbles, sun-shapes, heads with arms and legs, but no bodies – the well-known «tadpole» figures – and progresses until complete human figures and houses are depicted. The objective world

Previous overleaf

THE KISS

Mougins, 26 October 1969, oil on canvas,

97 x 130 cm. (38 x 51 in.)

Paris, Musée Picasso.

SEATED MAN

Mougins, 27 June 1971, oil on canvas,

100 x 81 cm. (39 x 32 in.)

Private collection.

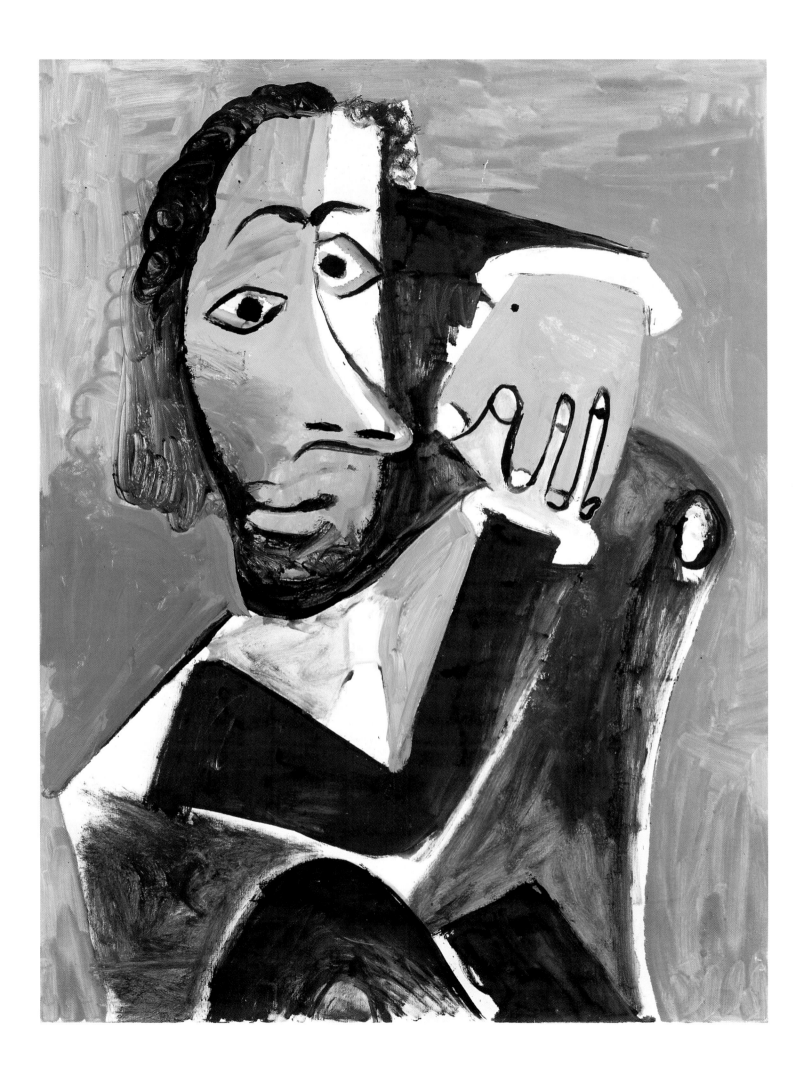

Overleaf

LARGE HEADS

Mougins, 16 March 1969, oil on canvas,

194.5 x 129 cm. (77 x 51 in.)

Aachen, Ludwig Collection.

MUSKETEER AND CUPID

Mougins, 18 February 1969, oil on

canvas, 194.5 x 130 cm. (77 x 51 in.)

Cologne, Ludwig Museum.

Opposite

SEATED OLD MAN

Mougins, 26 September 1970,

oil on canvas, 144.5 x 114 cm. (57 x 45 in.)

Paris, Musée Picasso.

194

gradually takes shape. But only up to a certain point, for there are many gaps in this world. At first, the nerve connections are not fully established and motor coordination is faltering, as can be seen by the movements of infants. Genetic psychology has shown that the child's construction of reality remains incomplete and unstable. It is less of a deconstruction than a *preconstruction*. And so it is easy to see how much this process could have fascinated someone who, as far as his artistic ability was concerned, was born «adult». If Picasso produced childlike or infantile paintings, it was only insofar as these two worlds, the deconstructed and the preconstructed, combined and *complemented* each other.

REMEMBER DEATH!

Many painters before Picasso had been keen observers of their own likenesses. Van Gogh's self-portraits show someone alternating between extremes of depression and enthusiasm, someone who strove to define himself during an all-too-brief life. Then there was Rembrandt, clean-shaven in his youth, openmouthed and somewhat aghast, seeking less to resolve the enigma of his own nature than to document the slow decline brought on by age, as it gradually swelled the skin and dissolved the features. The painter Kokoschka recalled: «I was looking at Rembrandt's last self-portrait: a horrible, unsightly, broken and desperate face – but so marvellously painted. And I understood: to be able to look at oneself and vanish into the mirror – to seen nothing more – to paint oneself as a void, the negation of a man. What a miracle, and what symbolic force.»[1]

Indeed, the mirror, which was invented in the fifteeenth century, was to become much more than the counselor of feminine graces. The reflecting surfaces used previously, such as water, or polished silver and bronze, had only given a vague image, whereas the true mirror, as painting and literature attest, utterly revealed man to himself. Its importance was so decisive that Jacques Lacan gave the name of «Mirror Stage» to that point in child development when the child recognizes its own reflection for the first time, at around eighteen months, a discovery which marks the birth of the ego.

The young Picasso began to investigate the lineaments of his ego very early on, but in his last self-portraits he scrutinized the signs of his own ageing almost to the point of obsession. This was already evident in

1. Quoted by Pascal Bonafoux, *Rembrandt, autoportrait*, Skira, Geneva, 1989, p. 127.

SELF-PORTRAIT

Mougins, 2 July 1972, pencil and chalk,

65.7 x 50.5 cm. (26 x 20 in.)

Private collection.

many pictures from 1965, such as the *Seated Man (Self-portrait)* dated 3 and 4 April 1965. In another work dated 26 September 1970 and entitled *Seated Old Man*, his body and his painting seemto be liquefying reciprocally.

This process is clearly visible in the two pictures I have just mentioned. The gaze, bearing of the head, and seated posture with hands laid flat on the lap are indeed those of an old man, but expressed by an *erasure* of the forms and colours which alone reveals the full truth of old age. The first painting shows a bald-headed Picasso in a striped shirt – as we have come to know him through countless photographs – but looking strangely absent. The second, painted six years later, further stressed the decrepitude of his face and body. These were the paintings of an old man executed by a man who had aged externally, for there was nothing senile about his painting. Picasso remained in full possession of his creative powers until the very end, and in his nineties had a freedom and inventiveness that many artists lack even at twenty. Each of us has an ideal image of ourselves, which the mirror inevitably shatters. Picasso went even further than Lacan: preconstruction and deconstruction culminated in the artist's self-destruction.

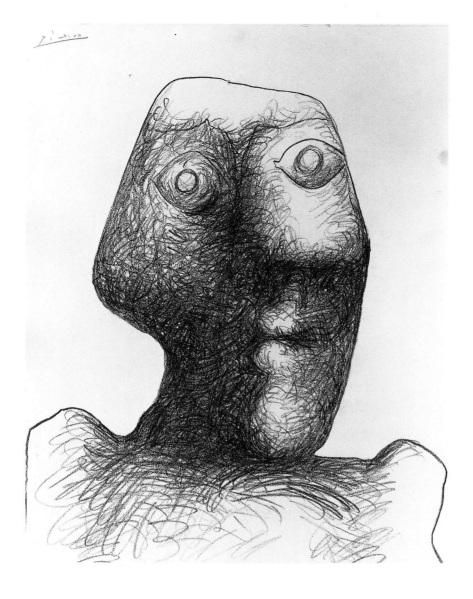

SELF-PORTRAIT

Mougins, 3 July 1972, pencil,

65.7 x 50.5 cm. (26 x 20 in.)

Private collection.

Picasso reached this extreme point in the summer of 1972, in a series of drawings titled *Self-portrait at Death*, already mentioned in the introduction, which are noteworthy because the face – with its ever-intense, piercing eyes – takes on the form of a skull. Pierre Daix recalls that, during one visit to Mougins, Picasso took him into his studio and told him, almost incidentally: «I did a drawing yesterday, and I think I'm on to something.... It doesn't look like anything that's been done before.» Three months later, during another visit, Daix saw that he had underscored the lines and added colours, and Picasso again observed: «You see, I've really got something there,» in a very clear, neutral voice, as if he were speaking about some impersonal work[1].

For the last time, we see the oscillation between inside and outside which had so often characterized his work. The mirror as scalpel of the soul: Picasso looked at himself in the mirror and saw a corpse within. He died in the following spring, on 8 April 1973.

It was a Sunday. Back in February, Picasso had contracted a bout of

1. Pierre Daix, *Picasso créateur*, Le Seuil, Paris, 1987, p. 378.

flu from which he had never fully recovered, and had spent a very bad night. On the previous evening, he was still working on a picture showing a *Female Nude and Head*, putting on the finishing touches, when he was suddenly overcome by total exhaustion. Early the next morning Jacqueline called his physician, Dr. Bernal, who, by the time he arrived from Paris by plane, found Picasso in bed, his chest heaving, struggling to catch his breath. He was given an injection, but the auscultation revealed an acute pulmonary congestion in the left lung accompanied by rale. «Where is Jacqueline?» Picasso asked anxiously. She was in the adjacent room, waiting for the doctor's verdict, and rushed to his bedside. Increasingly, he gasped for breath, mentioning Apollinaire, Modigliani and several other friends from the Bateau-Lavoir days. Another injection. Then he held his hand out to Jacqueline and, his eyes still open, calmly passed away at eleven forty-five in the morning. He was ninety-one years and seven months old.

A fine drizzle began to fall on Mougins. At three in the afternoon the news was announced in a flash bulletin on television; immediately the little town was swamped with reporters and ordinary people drawn by mere curiosity. The last of the sacred monsters who had initiated the revolution of modern art at the beginning of the century was dead. The next day, his life story hit the front pages of dailies throughout the world, and in the following week, scores of magazines devoted articles both to Picasso the man and to his outstanding creative work.

Two days after Picasso's death, his body was transferred to Vauvenargues and inhumed in the presence of his close family and friends. He was buried on the terrace of the castle, at the foot of the stone stairs leading up to the main entrance, where for two years he had spent long hours contemplating the Montagne Saint-Victoire – «Cézanne's view,» as he called it. On his tomb was erected a bronze sculpture from 1934 representing a woman holding a vase.

SELF-PORTRAIT

Mougins, 30 July 1972, coloured pencils,

65.7 x 50.5 cm. (26 x 20 in.)

Tokyo, Fuji Television Gallery.

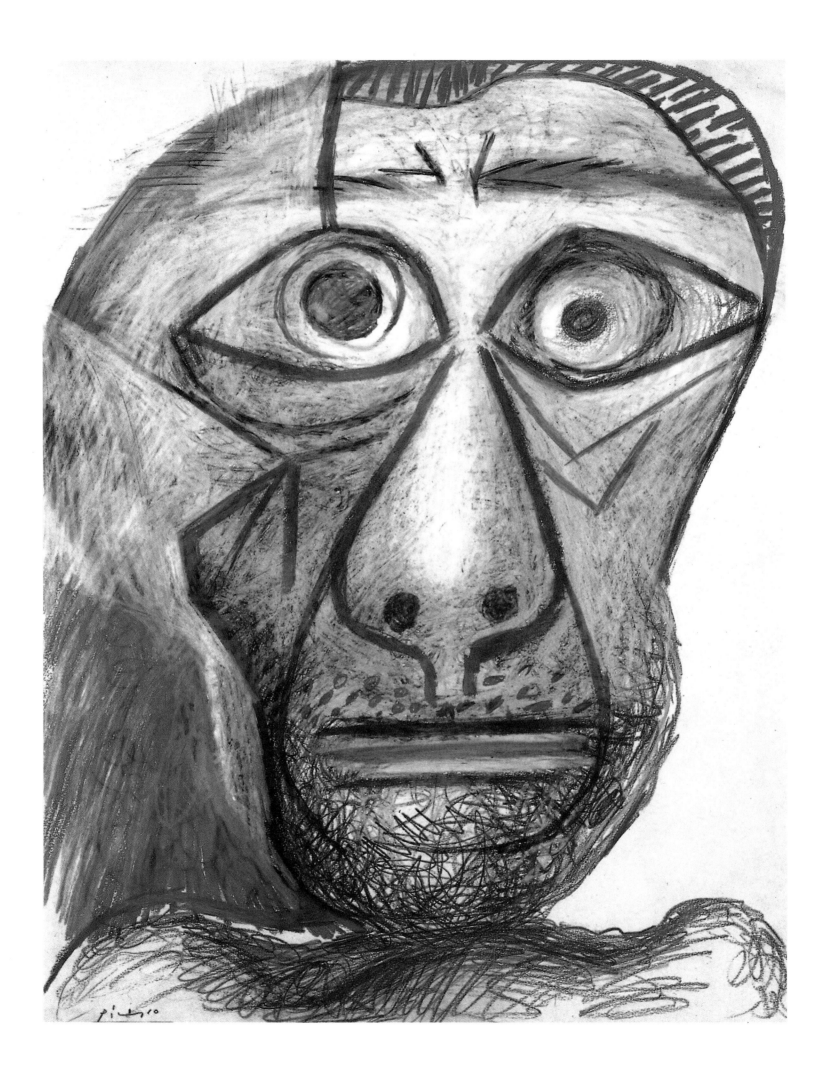

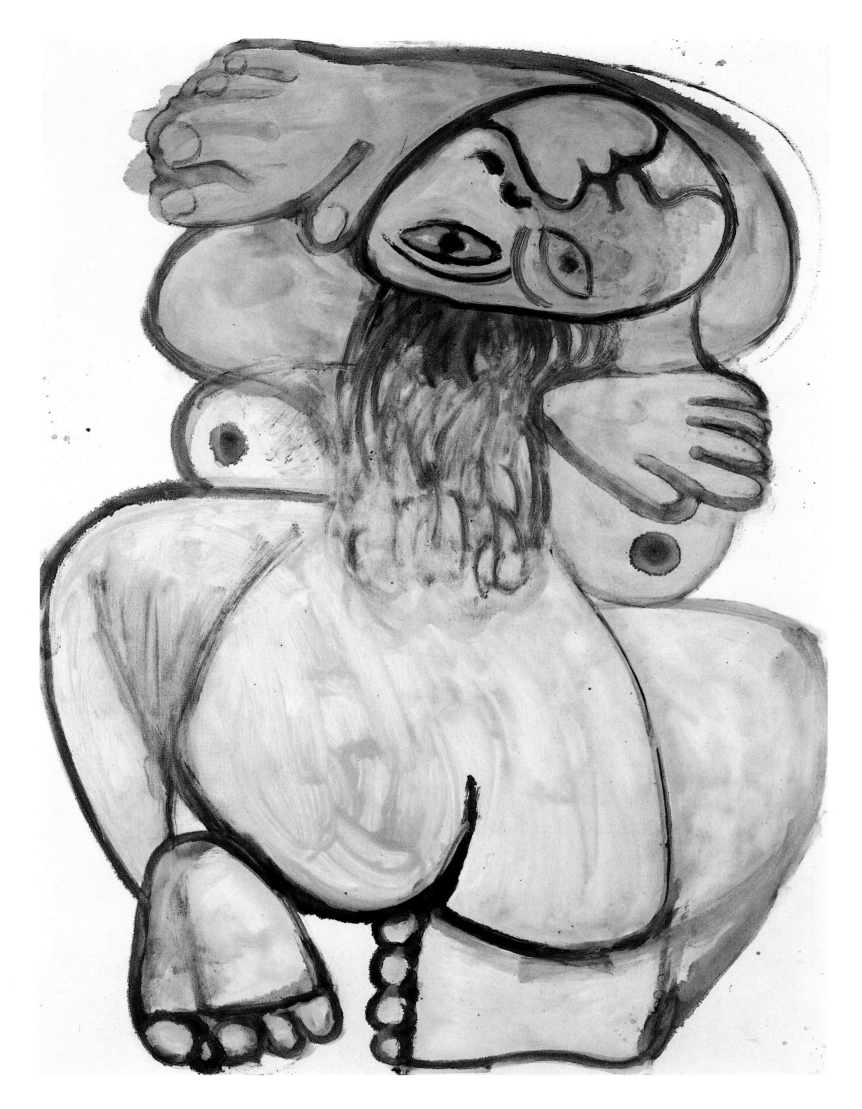

A CRITIQUE
OF (PURE) PAINTING

Claude Roy very aptly summarized Picasso's work as a critique of (pure) Painting[1]. Not in the sense that the artist consistently rejected pure – or abstract – painting, but in a more radical sense analogous to Immanuel Kant's *Critique of Pure Reason*.

Around the end of the eighteenth century, the reclusive philosopher from Koenigsberg completely reformulated the philosophical problem of knowledge, a contribution so great that some have compared it to a Copernican revolution. He was the first to demonstrate what is, today, common accepted: that all knowledge is relative, humanly conditioned, and that beings otherwise constituted would have an utterly different notion of reality to our own. This completely obviated the notion of objectivity. It rendered equally obsolete the metaphysical notion which posited the existence of a absolute reality independent of the human observer.

A century and a half later, Picasso effected a similar critique in the realm of art. Thanks to him, objectivity ceased to be the primary and ultimate goal of painting. Instead, the painter's subjectivity became the focus around which the objective world revolved; it was his subjectivity

CROUCHING NUDE

26 July 1971, oil on canvas,
116 x 89 cm. (46 x 35 in.)
Private collection.

1. Claude Roy, *La guerre et la paix*, Cercle d'art, Paris, 1954, p. 149.

that called the world into question, transformed it, and organized it at will. The artist was no longer subject to the objective world's dictates, as had been the case in traditional painting. Of course, the world was never absent from Picasso's work, but thanks to his efforts, it has become illusory to ask whether a picture *resembles* reality or not, for this question no longer has any meaning.

Claude Picasso experienced this new situation in his own way: as a boy living on the Riviera, he was familiar only with the paintings of his father, and those of such friends as Matisse, Léger and Chagall, whom they sometimes visited. But one day, when they were in Paris, his father took him to the Louvre, where he saw the works of Poussin, David and Delacroix for the first time. He could not believe that this also was a form of painting; for him, it was like seeing a motionless film; he kept expecting the scenes depicted in the paintings to start moving.

Truth indeed comes out of the mouths of babes. One does not go into a Picasso exhibition with the same expectations that one has when going to a movie. In place of the pictorial-spectacle of Academic tradition, Picasso developed the pictorial-equation. André Salmon grasped this point fully. In the final analysis, it is perhaps this which distinguishes Picasso from all the other artists who had preceded him.

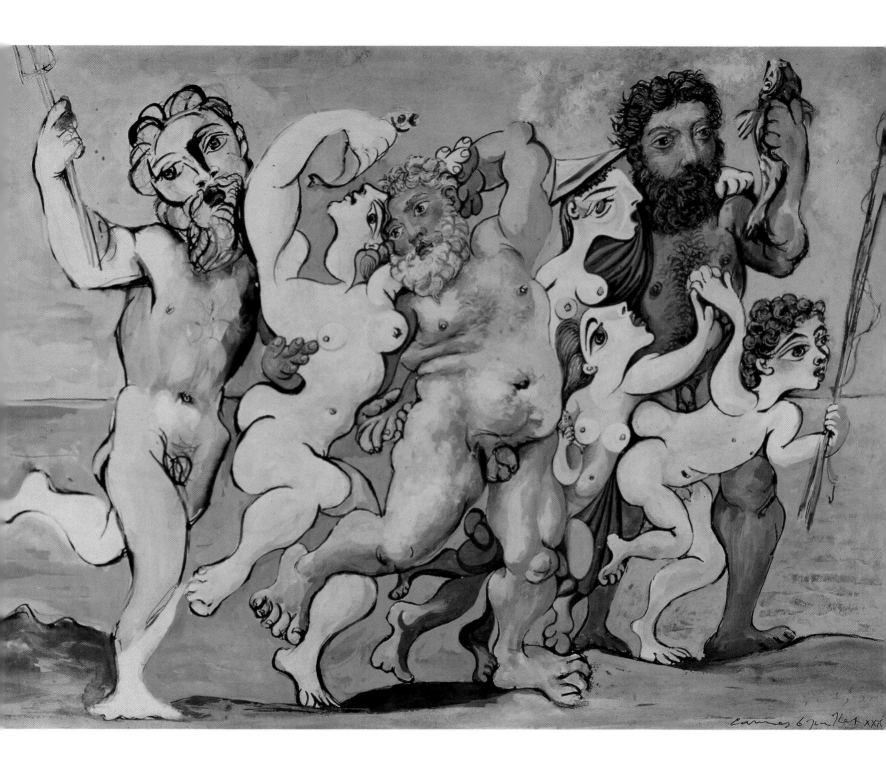

SILENUS WITH DANCING COMPANIONS

Cannes, 6 July 1933, gouache and Indian ink on

paper, 34 x 45 cm. (13 x 18 in.)

Geneva, Heinz Berggruen Collection.

BIOGRAPHY

1881 25 October, birth of Pablo Ruiz Picasso in Málaga, the first child of Don José Ruiz Blasco and Maria Picasso Lopez. His father, a painter, also taught at the local art school.

1891 The Family moves to La Coruña, in Galicia. He takes courses at the «Da Guarda» School of Arts and Crafts. First paintings done under his father's direction.

1895 Brief stay in Madrid in the summer. The family moves to Barcelona. Enrolls in the «La Lonja» Art Academy, where his father was awarded a professorship. Admitted to the advanced drawing class.

1897 His painting *Science and Charity* receives an honorary mention at the Fine-Arts Exhibition in Madrid. He joins the bohemian group frequenting the «Els Quatre Gats» tavern. In October, he is admitted to the advanced class of the San Fernando Academy in Madrid.

1898 Leaves Madrid in the spring. Contracts scarlet fever, convalesces at Horta de Ebro.

1900 First drawings published in the *Joventut* literary review. First exhibition at Els Quatre Gats. October-December: first trip to Paris; the art dealer Berthe Weill buys three of his sketches.

1901 In Madrid in the spring, works as illustrator and artistic director of the *Arte Joven* review. Exhibits pastels in Barcelona. End of May, second trip to Paris. June: first exhibition at Ambroise Vollard's gallery in Paris. Adopts his mother's maiden name and signs «Picasso» (he previously signed with «P. Ruiz Picasso» and variants). Returns to Barcelona around New Year.

1902 October, third trip to Paris. Meets Max Jacob.

1903 Returns to Barcelona at the beginning of the year.

1904 April, leaves Barcelona to establish himself definitively in Paris. Lives and works at the Bateau-Lavoir at 13, rue Ravignan.

1905 Meets Guillaume Apollinaire. First sales of paintings to Gertrude and Leo Stein and the Russian collector Sergei Ivanovich Stchukin. Liaison with Fernande Olivier.

1907 Meets Braque, Derain and Kahnweiler, who opens an art gallery. Paints *Les demoiselles d'Avignon*.

1909 Moves to 11, boulevard de Clichy. Summers at Horta de Ebro. First exhibition in Germany (Tannhauser Gallery, Munich).

1912 Meets «Eva» (Marcelle Humbert). Moves from Montmartre to Montparnasse. First exhibition in England (Stafford Gallery, London).

1913 Death of his father in Barcelona.

1914 Summer in Avignon with Braque and Derain. His picture *Les Bateleurs* («The Clowns») sells for 11,500 francs at the Hôtel Drouot auction rooms.

1916 Moves to the Parisian suburb of Montrouge.

1917 Travels to Rome with Cocteau in February. Designs stage sets and costumes for Cocteau's *Parade* performed by Diaghilev's Ballets Russes (music by Erik Satie). In Rome, meets Stravinsky and Olga Kokhlova. Excursions to Naples, Pompei and Florence.

1918 Marries Olga Kokhlova. Moves to 26, rue de La Boëtie. Trip to Barcelona. Summers in Biarritz.

1921 Birth of son Paulo. Summers in Fontainebleau.

1924 Paints the stage curtain for *Le train bleu*, a ballet written by Jean Cocteau with music by Darius Milhaud and sets by Henri Laurens. Summers at Juan-les-Pins.

1925 Participates in the first Surrealist painting exhibition in Paris.

1927 Meets Marie-Thérèse Walter.

1930 Awarded the Carnegie Prize (Pittsburgh, U.S.A.).

1931 Illustrates Vollard's edition of *The Unknown Masterpiece* by Balzac. Thirty engravings for Ovid's *Metamorphoses* published by Albert Skira.

1932 Installs a studio at the small Château de Boisgeloup (bought in 1930), near Gisors. Major retrospectives in Zurich and Paris.

1935 Separation from Olga Kokhlova. Stays at Boisgeloup. Birth of his daughter Maya.

1936 Travelling exhibition of his works in Spain. At the outbreak of the Spanish Civil War, he is symbolically appointed director of the Prado Museum. Liaison with Dora Maar.

1937 Publication of *The Dream and Lie of Franco*. Sets up his studio at 7, rue des Grands-Augustins, where he paints *Guernica* for the Spanish pavilion at the Paris World's Fair.

1939 Major retrospective at the Museum of Modern Art in New York. Death of his mother in Barcelona.

1940 Spends most of the year at Royan, then returns to Paris under Nazi occupation.

1942 Writes *Le désir attrapé par la queue* («Desire Caught by the Tail»).

1944 After the Liberation of Paris exhibits at the Salon d'Automne and joins the French Communist Party.

1946 Liaison with Françoise Giot. Summer at Golfe Juan. Autumn in Antibes. Donates many recent works to the Grimaldi Museum in Antibes.

1947 Birth of son Claude. Begins to work with ceramics in Vallauris.

1948 Settles at Vallauris in the villa «La Galloise.» Opening of the Picasso Museum in Antibes. Trip to Poland.

1949 Birth of daughter Paloma.

1950 Exhibits at the Venice Biennale. Named «honorary citizen» of Vallauris.

1953 Major retrospectives in Rome, Milan, Sao Paolo and Lyons. Separation from Françoise Gilot.

1954 Meets Jacqueline Roque.

1955 Winter in Paris. Moves to «La Californie,» a villa in Cannes. Exhibitions and publications on his works throughout the world. Death of Olga Picasso.

1958 Exhibits the series of works after *Las meninas* by Velázquez at the Louise Leiris Gallery in Paris. In New York, *Mother and Child*, a picture from the Blue Period sells for 150,000 dollars.

1959 Appears in Cocteau's film *Le Testament d'Orphée*.

1961 Marries Jacqueline Roque, the subject of some seventy portraits. Celebrates his 80th birthday in Vallauris. Moves to the villa «Notre-Dame-de-Vie» in Mougins.

1962 Awarded the Lenin Peace Prize.

1963 Opening of the Museo Picasso in Barcelona.

1966 Picasso celebrates his eighty-fifth birthday. Many exhibitions throughout the world. André Malraux inaugurates two retrospectives at the Grand Palais and Petit Palais in Paris.

1967 Two hundred Catalonian intellectuals and students honour Picasso. Refuses the Order of the Legion of Honour.

1970

1971 Picasso celebrates his ninetieth birthday. Eight pictures by Picasso exhibited in the Grande Galerie in the Louvre, inaugurated by French President Georges Pompidou. Celebrations in Vallauris and at the Palais des Sports in Paris (organized by the Communist Party). In Barcelona, an exhibition entitled «Hommage to Picasso» is forbidden and a demonstration brutally put down by the police.

1973 8 April, Picasso dies at Mougins and is buried in the park of the Château de Vauvenargues two days later.

1985 Inauguration of the Musée Picasso in Paris.

BIBLIOGRAPHY

BARR Jr., Alfred H., *Picasso: Fifty Years of His Art*, Arno Press, New York, 1966.

BERGER, John, *The Success and Failure of Picasso*, Harmondsworth, Middlesex (G.B.), 1965.

BOECK, Wilhelm and SABARTÉS, Jaime, *Picasso*, Harry N. Abrams, New York, n.d.

CABANNE, Pierre, *Le siècle de Picasso*, Gallimard, Paris 1992.

CABANNE, Pierre, *Pablo Picasso: His Life and Times*, William Morrow, New York 1977.

CIRLOT, Juan Eduardo, *Pablo Picasso: Birth of a Genius*, Praeger, New York 1972.

DAIX, Pierre and BOUDAILLE, Georges, *Picasso: The Blue and Rose Periods*, New York Graphic Society 1967.

DAIX, Pierre, *Picasso créateur*, Le Seuil, Paris 1987.

FERRIER, Jean-Louis, *De Picasso à Guernica*, Denoël, Paris 1985.

FERRIER, Jean-Louis, *L'aventure de l'art au XXe siècle*, Chêne-Hachette, Paris 1988.

GALLWITZ, Klaus, *Picasso 1947-1973*, Denoël, Paris 1985.

GILOT, Françoise and LAKE, Carlton, *Life with Picasso*, McGraw-Hill, New York, 1964.

PALAU I FABRE, Josep, *Picasso en Cataluña*, Ediciones Poligrafia S.A., Barcelona 1966.

PALAU I FABRE, Josep, *Picasso, cubisme, 1907-1917*, Albin Michel, Paris 1990.

PARMELIN, Hélène, *Picasso dit*, Denoël, Paris 1966.

PARMELIN, Hélène, *Voyage en Picasso*, Laffont, Paris 1980.

PAULHAN, Jean, *La peinture cubiste*, Tchou, Paris 1970.

PENROSE, Roland, *Picasso: His Life and Work*, Harper & Row, New York 1973.

RICHARDSON, John, *A Life of Picasso*, vol I, 1881-1906, New York 1991,

ROY, Claude, *La guerre et la paix*, Cercle d'art, Paris 1954.

VALLENTIN, Antonina, *Picasso*, Albin Michel, Paris 1957.

WARNCKE, Carsten Peter, *Picasso*, Taschen, Munich 1992.

ZERVOS, Christian and Yvonne, *Pablo Picasso: Catalogue of Paintings and Drawings*, 33 vols., Cahiers d'Art, 1932-1972.

PHOTO CREDITS

A PUBLISHING RÉVOLUTION ON HIGH-QUALITY PAPER

Since it was founded in 1990, Terrail has taken up the challenge of making high-quality artbooks available to the general public .

Each title in our catalogue is an original work. Our entire team, including our talented authors and iconographers, editorial and artistic directors, and the publisher himself, is united in pursuing a single aim: to bring the world of art to the widest possible public while maintaining the most rigorous standards of quality. All our books feature outstanding reproductions, matt art paper, sewn sections, and soft-paper jackets with flaps.

Worldwide distribution in several languages and correspondingly large print runs are major reasons behind our astonishingly low selling price.

The Publisher

This book is printed in
ITALY - Grafiche Zanini - Bologna